GEORGE OVERBURY "POP" HART

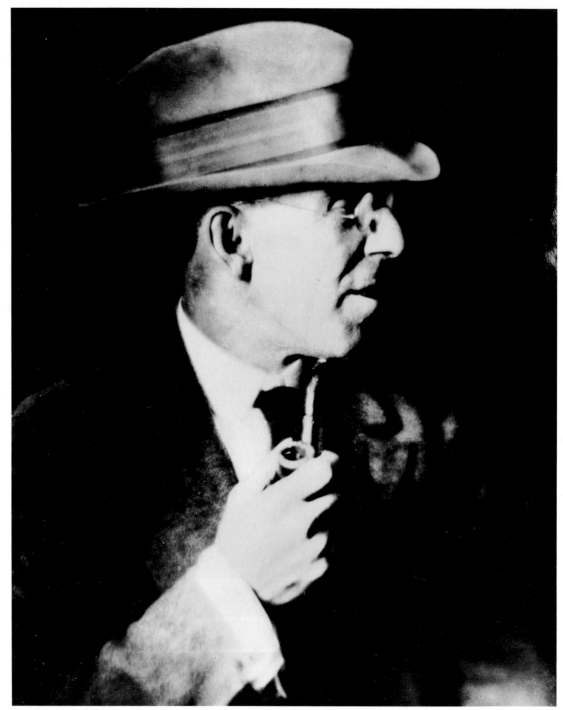

George Hart, 1920s

Gregory Gilbert

GEORGE OVERBURY "POP" HART

HIS LIFE AND ART

Rutgers University Press
New Brunswick and London
Co-published with
The Jane Voorhees Zimmerli Art Museum

This publication was supported in part by The National Endowment for the Arts.

Unless otherwise noted, all photography for this catalogue was done by Victor Pustai, Victor's Photography.

Library of Congress Cataloging-in-Publication Data

Gilbert, Gregory.
 George Overbury "Pop" Hart.

 Bibliography: p.
 Includes index.
 1. Hart, George Overbury, 1868-1933.
2. Artists—United States—Biography. I. Title.
N6537.H36G5 1986 760'.092'4 86-24861
ISBN 0-8135-1200-X

This book is dedicated to
Jeane Overbury Hart, whose
strong devotion to her
uncle has preserved his art
for posterity.

CONTENTS

LIST OF ILLUSTRATIONS

PREFACE

IN 1983, THE ESTATE of Jeane Overbury Hart was donated by its executors to the Zimmerli Art Museum. In essence, the Estate is comprised of an immensely rich collection of approximately 5000 watercolors, drawings, prints, and a number of paintings by her uncle George Overbury "Pop" Hart. Pop Hart was a prolific American artist much appreciated and collected during the early part of this century, but largely forgotten since his death in 1933. As a printmaker and watercolorist, he recorded his unique impressions of America and his travels throughout much of the world.

For almost half a century, while the world of American art was going through one aesthetic transition after another, Jeane Hart watched over, documented, promoted, and preserved her uncle's art. With this publication and with the exhibition that accompanies it, the veil of obscurity, which has hidden for so long the art of Pop Hart, has been lifted once and for all. The dedication to and respect for Hart's art by his niece allows us today to evaluate thoroughly the accomplishments and the life of this important American artist.

When not traveling, Pop Hart spent much of his life as a New Jersey resident. It is, therefore, appropriate that the largest repository of his art be located at the art museum of the State University of New Jersey. Equally important, but not coincidental, is the fact that a major emphasis of the Zimmerli Art Museum is early twentieth-century American graphics. With this knowledge, Richard Arnold, Capital Campaign Manager for the Rutgers University Foundation, who had known Jeane Hart and her desire to find a suitable home for her collection, brought the Zimmerli Art Museum into contact with the executors of her Estate, Edward Chase, Virginia MacInnes, and the attorney for the Estate, Robert Seaman. Rutgers is greatly indebted to these long-time friends of Jeane Hart for selecting the Zimmerli Art Museum as the recipient of her Estate.

The Estate made it possible for Gregory Gilbert to dedicate more than three years of his time and energy in the preparation of the present monograph. As a Ph.D. candidate in the Rutgers Department of Art History, Gregory Gilbert is a young scholar whose focus on early twentieth-century American art pays much attention to the medium of printmaking and works on paper and their role within the broad activities of avant-garde art.

I am most grateful to Mr. Gilbert for clearly and succinctly placing Pop Hart in context with such contemporaries as Arthur B. Davies, Maurice Prendergast, and Walt Kuhn, and with art of the American Scene. Hart emerges as an artist of substance rather than the isolated, untrained figure hitherto believed, and as a sophisticated artist actively involved with the people, organizations, and movements current in early twentieth-century American art.

Patricia Eckert Boyer, Curator of Prints and Drawings, served as Gregory Gilbert's advisor and confidante throughout this entire project, while Cindy Villa ably assisted in the enormous task of cataloguing the Pop Hart material. This publication could not have been achieved without further support from the Estate of Jeane Overbury Hart, as well as

support from The National Endowment for the Arts and the Rutgers University Press. Finally, we at the Zimmerli Art Museum are very proud to be the caretakers of this impressive body of art and to have the opportunity to present to the public the world of Pop Hart as it stretched from New Jersey to Samoa, from Haiti to Mexico, including the many stops in between, wherever he could record the lively spirit of humanity.

Phillip Dennis Cate
Director

ACKNOWLEDGMENTS

WRITING A MONOGRAPH on an artist whose career has not been thoroughly studied has meant relying on the assistance and advice of many individuals, all of whom I would like to gratefully acknowledge. Helen Farr Sloan, Irving Stone, Reuben Nakian, Paul S. Nakian, Jeffrey Owen Jones, and Leroy Davis provided me with valuable historical information through their correspondence. I would like to extend my thanks to Dr. Grant Holcomb for guiding me to information on Jerome Myers, and to Janet Flint, whose expertise on American printmaking was of help in researching Hart's graphics. Special thanks also go to Antoinette M. Kraushaar and George Price for sharing with me their personal reminiscences of Hart.

In researching biographical information on Hart, the following individuals were extremely helpful in providing information and materials: Louise P. Ogg, Cairo Public Library; Jeanne Mino, Rochester Public Library; Nancy Schneiderman, Rochester Historical Society; Bob Gullo, Library, St. John Fisher College; Karl Kabelac, The University of Rochester Library. Much appreciation is due to Elizabeth D. Hoover, Registrar, The School of the Art Institute of Chicago, and to R. Cellier, Assistant Director of the Académie Julian—Ecole Supérieure D'Arts Graphiques, for information on Hart's attendance at these institutions. Rita Altomara, Library Director of the Fort Lee Public Library, Barbara Malone of The American Film Institute, and John M. Cahoon of the Los Angeles County Museum of Natural History assisted me with information on Hart's involvement with the New Jersey motion picture industry.

Other individuals who have been generously helpful with information on specific works and who have provided photographic materials include Calvert Coggeshall; Mrs. Richard Crooks; Genetta Gardner, Indianapolis Museum of Art; Abigail Booth Gerdts, National Academy of Design; Jonathan Greenberg, Kennedy Galleries, New York; Colleen Hennessey, Archives of American Art, Washington, D.C.; David Henry, Spanierman Gallery, New York; Jerry M. Mallick, National Gallery of Art, Washington, D.C.; Paul McCarron, McCarron Gallery, New York; Garnett McCoy, Archives of American Art, Washington, D.C.; Dorothy Canning Miller; Peter B. Rathbone, Sotheby's, New York; Richard L. Tooke, Museum of Modern Art.

My research on Hart was also aided by the helpful assistance of various staff members at the following archival institutions and art libraries: Archives of American Art, New York; Library, The Museum of Modern Art; Ryerson and Burnham Libraries, The Art Institute of Chicago; Art Library, Rutgers University; Library, The School of the Art Institute of Chicago; Special Collections/Archives, Rutgers University; Library, The Whitney Museum of American Art. I owe special thanks to Roberta Waddell, Curator of Prints, Department of Prints, The New York Public Library, for her kind assistance in guiding me through material on Hart. William J. Dane of the Art and Music Department, Newark Public Library, and Alice F. Fullam, Trenton Free Public Library, were also very generous with their time in researching material for me.

In preparing material for this study, particularly the list of museum

collections containing work by Hart, I was given important information by the following individuals: Jane E. Falk, Akron Art Museum; Sonia M. Lismer, Allen Memorial Art Museum; Anselmo Carini and Milo M. Naeve, The Art Institute of Chicago; Jan Howard, The Baltimore Museum of Art; Monsieur Royet, Bibliothèque Nationale, Paris; Frances Carey, The British Museum; Barry Walker, Deirdre Lawrence, Barbara Dayer Gallati, and Linda Konheim-Kramer, The Brooklyn Museum; C. Sniger, The Butler Institute of American Art; Stephanie L. Stein, Cincinnati Art Museum; Louise S. Richards, William Robinson, The Cleveland Museum of Art; Nanette V. Maciejunes, Columbus Museum of Art; Linda C. Simmons, The Corcoran Gallery of Art; Kathleen A. Erwin and Nancy Rivard Shaw, The Detroit Institute of Arts; Karin Breuer, Achenbach Foundation for the Graphic Arts, California Palace of the Legion of Honor, and Marc Simpson, M. H. de Young Memorial Museum, The Fine Arts Museums of San Francisco; Donald Keyes, Georgia Museum of Art; Cynthia Jaffee McCabe, Hirshhorn Museum and Sculpture Garden; Sanna Saks Deutsch and Joseph Feher, Honolulu Academy of Arts; Phylis Floyd, Hood Museum of Art, Dartmouth College; Jayne C.F. Johnson, Indianapolis Museum of Art; Alisa Dean, J.B. Speed Art Museum; Carol Pulin, The Library of Congress; Michael Quick and Pamela C. Tippman, Los Angeles County Museum of Art; Norris J. Fergeson, Marion Koogler McNay Art Museum; Patricia Anderson, Memorial Art Gallery of the University of Rochester; Helen B. Mules and David Kiehl, The Metropolitan Museum of Art; George Keyes and Rosamond Hurrell, The Minneapolis Institute of Arts; Alejandro Andreus, The Montclair Art Museum; Ellie Vuilleumier, Museum of Art, Carnegie Institute; Laura Genninger and Lora S. Urbanelli, Museum of Art, Rhode Island School of Design; Theodore Stebbins and Sandra M. Mongeon, Museum of Fine Arts, Boston; Nancy L. Swallow, Museum of Fine Arts, Springfield; Riva Castleman, Wendy Weitman, John Elderfield, and Kathleen S. Curry, The Museum of Modern Art; Felipe Garcia Beraza, Instituto Mexicano Norteamericano de Relaciones Culturales; Nicolai Cikovsky, Jr. and Carlotta J. Owens, The National Gallery of Art, Washington, D.C.; Henry Adams and George L. McKenna, The Nelson-Atkins Museum of Art; Gary A. Reynolds, The Newark Museum; Jane Darnell, The New Britain Institute of American Art; Paula Foley, New Jersey State Museum, Trenton; Robert Arthur Harman, The Pennsylvania Academy of the Fine Arts; Eliza Rathbone, The Phillips Collection; Holly Wilson, The Santa Barbara Museum of Art; Vicki Halper, Seattle Art Museum; George W. Neubert, Sheldon Memorial Art Gallery, University of Nebraska; Gillian Saunders, Victoria and Albert Museum, London; Patterson Sims and Heidi D. Shafranek, The Whitney Museum of American Art; Howard DaLee Spencer, The Wichita Art Museum; Carol Knauss, World Heritage Museum, University of Illinois at Urbana-Champaign; Richard S. Field, Juliana D. Flower, and William Cuffe, Yale University Art Gallery.

In the Department of Art History at Rutgers University, Dr. Olga Berendsen and Dr. Matthew Baigell provided support and encouragement while I worked on this project; Dr. Baigell was particularly helpful in offering insights into the material. I want to thank Nicholas J. Capasso for his helpful contributions to my bibliographic research, and I would like to extend my appreciation to my graduate student colleagues in the Department of Art History at Rutgers University for their interest in this study and their encouragement.

I would like to acknowledge the enthusiasm and support of Leslie Mitchner and Barbara Kopel of the Rutgers University Press, and call attention to the contributions of Gerda Spirig for her handsome book design, and Victor Pustai for his excellent photography, whose efforts add substantially to the presentation of Hart's work in this monograph.

Very special thanks are reserved for Meredith Arms for her good-humored support throughout my work on this monograph and for her kind and able assistance with many facets of this project.

Finally, I would like to thank the staff at The Zimmerli Art Museum, Rutgers University: Phillip Dennis Cate, Patricia Eckert Boyer, Jeffrey Wechsler, Mairen Place, Marguerite Santos, Marilyn P. Tatrai, Anne Schneider, Stephanie Grunberg, Ferenc Varga, E. A. Racette, Dorothy Hoogland Verkerk, Barbara Trelstad, Roberto Delgado, Carol Donnelly, and Barbara Miller for their assistance and support during my tenure as a research fellow for the Hart Collection. I am extremely grateful to Anne

Schneider for her patient and thorough editing, and to Mairen Place for her help in the preparation of the manuscript. I owe a good deal of gratitude to Cindy Villa and Sabrina Tu, who invested large amounts of time over the past several years in assisting me with the cataloguing of the vast Hart Collection. I am particularly indebted to Patricia Eckert Boyer, Curator of Prints and Drawings, for her guidance, insight, and encouragement throughout each phase of this extensive project; her participation ranged from suggestions for research, assistance with the selection of works to be reproduced, and editing of the manuscript. As Curator of Prints and Drawings, she also oversaw the complicated task of cataloguing and organizing the Hart Collection, which contains approximately five thousand objects. My deep appreciation goes to Phillip Dennis Cate, who entrusted me with this project three years ago while I was still a somewhat untried master's degree candidate; his confidence in my abilities and his support have been constant.

Gregory Gilbert

GEORGE OVERBURY "POP" HART

INTRODUCTION

IN HIS BOOK *Off the Wall,* Calvin Tompkins related that in 1962 Henry Geldzahler, who was then a young assistant curator at the Metropolitan Museum of Art, asked the Metropolitan's director, James Rorimer, for permission to speak at a Museum of Modern Art symposium on Pop Art.[1] Rorimer, who was unfamiliar with the nascent Pop Art movement, gave his consent; Geldzahler later discovered that Rorimer had thought the symposium's topic of discussion was to be "Pop" Hart. In the course of preparing material for this monograph, I encountered the opposite problem: in telling people of my study of "Pop" Hart, they invariably thought I meant Pop Art. This confusion makes clear just how well known the Pop Art phenomenon has become since the early 1960s, but more importantly, it demonstrates how "Pop" Hart's reputation has declined over the past several decades.

However, during the 1920s and 1930s there was a great deal of interest in Hart's work among critics, museum curators, and art historians. In the twenties, the artist enjoyed a wide public following and became something of a celebrity, as a large number of newspaper and popular magazine articles recounted the details of Hart's colorful travels and exploits. Many articles with such headlines as "Hart Mystified Mexicans by Painting During Revolt" and "Pop Hart Caught in Meshes of Love by Indian Princess" publicized the more sensational and private aspects of the "vagabond painter's" life.

Although Hart's work began to be exhibited intermittently in galleries in the mid-1910s, by the 1920s his art was featured regularly in well-publicized and well-received one-man shows (see Selected List of Exhibitions). During these years several prominent collectors of American art, such as Preston Harrison, John Quinn, and Abby Aldrich Rockefeller, started to purchase Hart's work; in fact, in 1928, Mrs. Rockefeller chose to make her debut as an important collector of contemporary American art by organizing an exhibition of Hart's art which was culled from her own collection. In addition to galleries and private collectors, such prestigious institutions as the Metropolitan Museum of Art, the British Museum, the Victoria and Albert Museum, the Museum of Modern Art, the Art Institute of Chicago, the Smithsonian Institution, and the Brooklyn Museum also began to exhibit and acquire Hart's watercolors and prints. In 1928, a hardcover monograph on his work was published, an honor that few of his more prominent contemporaries had received. As further evidence of "Pop" Hart's popularity and importance during the twenties and thirties, prominent writers on art such as Edward Alden Jewell, Thomas Craven, Sheldon Cheney, Alfred H. Barr, Jr., and Holger Cahill made reference to Hart in their written surveys of modern American art, citing him as a significant figure in the New York Realist and American Scene movements.[2]

On the occasion of Hart's death in 1933, numerous obituaries appeared in newspapers and art journals.[3] One writer noted that in printing his obituary, many newspapers devoted as much space to Hart as a statesman usually received.[4] The majority of these notices were article-length tributes that summarized the artist's career and listed the many

awards and honors that he received during his lifetime. Hart's amiability and unassuming nature endeared him to many writers, and all of the written eulogies expressed a genuine regret at his passing and a keen appreciation of his art. For example, Marie Sterner wrote in the *Art Digest* that:

> The death of "Pop" Hart affects one more than that of any other artist since George Bellows. Although his span of life was about twice that of Bellows, it was nevertheless, even at his age, a loss that all those who knew him feel poignantly, from the point of view of his work as well as his personality.[5]

Writing in the *New York Times,* Edward Alden Jewell adopted a similar tone of personal loss in discussing Hart's death:

> Pop Hart, beloved vagabond and great artist is gone. He died…not quite in harness, although years of physical agony had failed to break that fine, courageous spirit….For the present let it suffice that we acknowledge with deep, purifying sadness the passing of this brave spirit, then lift the head and go on— "pronto," yet remembering….That would be "Pop's" way.[6]

A large number of galleries and museums including the Downtown Gallery, the Marie Sterner Gallery, the Grand Central Gallery, the Art Institute of Chicago, the Brooklyn Museum, the New York Public Library, and the Detroit Institute of Arts celebrated Hart's artistic achievements by mounting memorial exhibitions of his work. In fact, Helen Appleton Read, who was an art critic for the *Brooklyn Daily Eagle,* wrote in December of 1933 that, "Since his death last summer his memory is being honored by a greater number of memorial exhibitions than has been the case with any other American artists who have died in the years that I have been an observer and commentator on art events in this country."[7] Hart's art continued to enjoy an enthusiastic following after his death and several writers suggested that his tragic passing served to enhance his popularity and critical standing. As proof of this posthumous vogue, Hart's works were included in some nine museum and gallery shows in 1934 and 1935. Also, in 1935, the Newark Museum mounted a massive retrospective exhibition of Hart's work that was comprised of over 240 examples of his art. Popular interest in Hart was still so great during the late thirties that the author Irving Stone, who wrote best-selling biographies of such masters as Michelangelo and Vincent van Gogh, even contemplated writing an account of Hart's career.[8]

In examining the history of Hart's critical reception, one can see that during his lifetime (and for almost a decade afterward) the artist was recognized and revered by many as an important talent. Indeed, in a large number of art publications that date from the 1920s and 1930s, Hart was often discussed in conjunction with artists Edward Hopper, Jules Pascin, George Bellows, Charles Burchfield, John Marin, Arthur B. Davies, Charles Demuth, and Rockwell Kent, placing his work on an equal footing with the art of these now venerated historical figures.[9] Yet, mention of Hart virtually disappears from most of the major American art surveys that were published after the mid-forties. This change in critical fortunes can be linked actually to several factors, the most important and the most obvious being vicissitudes in critical and art historical tastes. Many of the tendencies and aesthetic issues that Hart's work can be related to—the American Scene movement, genre and regional themes, and graphic art concerns—simply fell out of favor in the 1940s and 1950s as critical and scholarly interests shifted to the development of the abstract expressionist movement. This author also believes that Hart's death in 1933 was an untimely event that coincided with the rising popularity of American Scene painting. For much of his career, Hart had been devoted to the kind of regionalist subject matter that was beginning to gain currency during the late twenties and early thirties. Shortly before his death, Hart also produced several works that reflected his awareness of the social conditions and cultural climate that existed in the United States during the Depression era; in fact, Hart's work was included in a major exhibition of Social Realist art that was held at the John Reed Club in New York in the spring of 1933.[10] Given Hart's active

interest in regionalist subjects and the humanistic orientation of his art, it is quite possible that he would have been viewed as a notable figure within the American Scene movement had he lived and continued to work in this manner during the thirties. As a result, Hart's position in the history of modern American art would no doubt have been more firmly established. Moreover, in the 1920s and 1930s, the more anecdotal and spectacular aspects of Hart's life tended to overshadow his achievements as a fine artist; in many of the articles that highlighted "Pop" Hart's exotic travels and colorful eccentric behavior, his art too often became a secondary consideration. In the early forties, after his death, when interest in Hart as an engaging personality began to fade, interest in and knowledge of Hart's work declined as well. Another factor that has possibly contributed to the lack of research on Hart is that the artist worked almost exclusively in watercolor, pastel, and printmaking—media that were long regarded as minor art forms. Excluded from many earlier art historical studies, these processes have only begun to receive more serious scholarly attention in the past two decades.

Despite Hart's declining reputation since the 1940s, his contributions have not been entirely overlooked in more recent art historical studies. For instance, Hart was cited in several survey histories of American art from the 1950s and 1960s including Oliver Larkin's *Art and Life in America*, E.P. Richardson's *Painting in America: The Story of 450 Years*, and Lloyd Goodrich's *American Art of Our Century;*[11] Hart's work also was included in William H. Pierson, Jr.'s and Martha Davidson's comprehensive pictorial survey *Arts of the United States*.[12] In the past two decades, Hart has been featured in such specialized surveys as Una Johnson's *Golden Years of American Drawings, 1905–1956*, Theodore H. Stebbins' *American Master Drawings and Watercolors*, and William H. Gerdts' *Painting and Sculpture in New Jersey*.[13] Writing in his history of New Jersey art, Gerdts maintained that Hart was perhaps the finest American watercolorist who employed the type of naturalistic, reportorial style that was favored by the artists associated with the New York Realist movement.[14]

In addition, since the 1920s there have been a sustained interest in Hart's work in the more specialized field of graphic art studies, particularly in the area of American prints. Indeed, Hart's critical reputation and historical importance have been based largely on his innovative efforts in printmaking. During his own lifetime, Hart was regarded as a significant graphic artist by many critics and scholars. In the twenties, his works were cited in several major surveys of American and European printmaking, such as Frank Weitenkampf's *American Graphic Art* and James Laver's *A History of British and American Etching*.[15] Also, in the late twenties and early thirties, Hart's lithographs and intaglio pieces were included in most of the major print exhibitions and annuals. Even after his death, the artist continued to be recognized as an important figure in American printmaking, as his graphic works were discussed in Carl Zigrosser's 1937 study *Prints and Their Creators*, and in Alfred H. Barr's and Holger Cahill's 1939 survey *Art in America*.[16] During the 1960s and 1970s, when there was a resurgence of interest among art historians in prints and printmaking, Hart's graphics were re-examined and discussed in several noteworthy studies: in Wilhelm Weber's *A History of Lithography*, Hart was listed as a prominent figure associated with the revival of fine art lithography in the United States in the 1920s, and Fritz Eichenberg noted in his book *The Art of the Print* that Hart was one of the more important American artists—along with Maurice Prendergast, John Sloan, and Abraham Walkowitz—who experimented with monotype printing during the early twentieth century.[17] In the present decade there has been a burgeoning interest among scholars as well as the general public in American prints, and Hart's reputation has benefited from this trend, as in the past several years his graphic works have appeared in many exhibitions and publications on American printmaking. For example, Una Johnson devoted a long passage in her 1980 book *American Prints and Printmakers* to a discussion of Hart's graphics, and in the catalogue that accompanied the exhibition "The Gloria and Donald B. Marron Collection of American Prints," which was shown at the Santa Barbara Museum of Art in 1981, a separate essay was printed on Hart (written by Patricia Eckert Boyer, this two-page essay was perhaps the longest scholarly piece that had appeared on the artist since the 1930s).[18]

In 1985, Hart's work was included in an exhibition of important modern American prints ("American Prints: 1914–1941") that was mounted at the Boston Museum of Fine Arts, and in her study of the same year, *American Impressions: Prints Since Pollack*, Riva Castleman wrote that along with Max Weber, Hart was among the few eminent pioneers working in color printmaking in the United States in the 1920s and 1930s—before the rapid growth of color graphics during the WPA era.[19]

Although Hart has been cited in a large number of art historical studies over the past four decades, little information exists on his life and art. Even in many publications that have singled him out as being a notable figure, the references to his work and its historical value are often cursory and uninformed. To date, knowledge of Hart's artistic activities has been largely visual, since his art has frequently been exhibited and reproduced, but has not heretofore been the subject of a full-length monograph. Given Hart's acknowledged historical importance and the continued interest in his work, there is clearly a need for a more thorough study of his career. Moreover, the recent wave of scholarly interest in American art and printmaking from the 1920s and 1930s—and even the current figural and expressionist tendencies in American art—make the mid-1980s a propitious period for re-examining and re-evaluating Hart's artistic achievements.

The aims of this study are primarily those of an introductory monograph, as most of the research has concentrated on more general problems relating to biographical information, stylistic development, and questions of artistic influence. These issues are often taken for granted in the case of more established artists, but have not been considered fully in relation to Hart's career. Much of the biographical information that has appeared on Hart has been incomplete and, in some cases, contradictory. While this monograph is not intended to be an artist's biography, it has been necessary to conjoin a fairly large amount of biographical information with a discussion of Hart's oeuvre. This biographical information is used primarily to facilitate the art historical analysis, since it is difficult to consider what influences might have shaped the development of Hart's work if one does not know where he was or what his activities were

during a given period. In researching material for this monograph, a large number of previously unpublished documents were consulted, many of which were in the estate of Jeane Hart, the artist's niece (these documents are now in the Special Collections and Archives Department of the Archibald S. Alexander Library of Rutgers University). Also studied was material in other archival collections, in order to assemble what is to date the most extensive amount of biographical information available on Hart. Further, the biographical material that appears in the text is supplemented by a chronology which outlines significant dates and events in Hart's career that are not always cited in the text.

In discussing Hart, scholars and critics have most often referred to him as being an adherent of both the New York Realist and American Scene movements.[20] While Hart's work was closely aligned with these tendencies throughout a large portion of his career, he also experimented with a variety of modernist vocabularies such as Impressionism, post-Impressionism, Tonalism, and Expressionism. During various phases of his career, Hart also developed highly personal styles by modifying certain aspects of these tendencies to suit his own aesthetic interests. Even for those who are familiar with some of Hart's more progressive works, his brief forays into such radical idioms as Cubism and Fauvism should come as an interesting revelation. Also, Hart's choice of subject matter and themes relates his work to many important currents in late nineteenth- and early twentieth-century American art, such as the American Renaissance movement, the Ashcan School, American Symbolism (à la Arthur B. Davies), and the American Scene movement. One of the chief aims of this study is to make clear the diversity of Hart's artistic pursuits, and thus broaden the accepted view of his oeuvre.

In addition, since Hart's graphic works have been reproduced and exhibited more frequently than his paintings, his artistic efforts in black and white are more widely known; even the various watercolors and oils that have been reproduced have generally been printed in black and white; however, Hart was a skilled colorist in both painting and printmaking, developing highly creative coloristic effects by experimenting with different mixed media techniques. The watercolors and tinted graphics

reproduced in color in this book present in printed form this lesser-known facet of Hart's artistic production.

Although Hart has been associated with various developments, most writers have tended to take an ahistorical view of his art, regarding his paintings and prints merely as a diaristic visual record of his travels, rather than works of art that could be subjected to critical and art historical analysis. As indicated previously, the more sensational aspects of Hart's life oftentimes obscured or drew attention away from his activities as a fine artist; however, a sufficient amount of time has passed since Hart's death and it is now possible to look beyond the purely biographical and anecdotal content of his art and place it within a wider historical context. As one writer asserted, "The legend has had time to wither on the vine, and whether he did or didn't arrive at some far-off place with seventy-five cents in his pocket isn't such a burning issue anymore...."[21]

Although the body of critical and scholarly literature on Hart is not extensive, it is possible to take issue with much of it. In writing on Hart, several generations of critics and scholars have perpetuated certain myths about the artist which originated during his lifetime. In the twenties and thirties, many newspaper and magazine writers maintained that Hart had received little formal instruction in art, and they often described him as an amiable hermit who shunned any contact with the professional art world.[22] Because Hart was often strongly anti-theoretical in his artistic statements and did not openly subscribe to a particular aesthetic doctrine, he was also considered to be independent from—or only casually connected with—any prevailing artistic currents. In later years, when discussing Hart, critics and scholars simply restated these earlier views of the artist, since his career had not been thoroughly researched and re-evaluated.[23] Given that Hart has been viewed largely as an untutored, reclusive figure who was removed from the artistic mainstream, it is not surprising that many writers have tended to adopt a somewhat ahistorical attitude towards his work.

This attitude prompted one writer to go so far as to dismiss Hart as a "long dead folk artist."[24] Other writers, however, have taken a more positive view of Hart's supposed independence from modernist developments. Oliver Larkin, for example, in his *Art and Life in America,* saw the expressive qualities of Hart's work in the 1920s as an important continuation of an emotional, humanistic orientation in art during a period that was dominated by formalist abstraction:

Two personalities of the time stood in contrast with the passionate Marin and the imperturbable Sheeler: Louis Elshemius, with his eccentric blend of the primitive and the sophisticated, and the raucous, incorrigible George Overbury Hart.... Hart in his late fifties came to be recognized as a Yankee in the old boisterous genre tradition; and his sprawling script was a relief among the neat Spencerians.... The unpredictable Elshemius and the rowdy Hart were exceptions whose warmth only emphasized the prevailing coolness of the post-Armory climate.[25]

Other writers have voiced stronger opinions on Hart's artistic independence, such as Edgar Cahill, who asserted, "He is not trying to imitate anyone.... He has followed no art fashions, and he has worshiped no idols, excessively."[26] Another wrote that he was "self-taught and scornful of all aesthetic theories."[27] However, these assessments have been responsible for limiting the scope of inquiry into the possible tendencies that were influential in shaping his work. One of the major purposes of this study is to address this problem. Rather than the untutored, reclusive figure portrayed in much of the literature, Hart emerges as an aware, diverse talent whose works, based on a highly personal synthesis of realist and modernist concerns, are a significant contribution to the history of twentieth-century American art.

This book is divided into sections that address Hart's experimentation with a variety of styles. The section covering his career from 1900 to 1910 focuses upon his adoption of impressionist and tonalist techniques. The discussion following deals with the years 1910 to 1920 and Hart's exploration of various aspects of post-impressionist art, Fauvism, and

geometric abstraction. One point made throughout the second half of the book is that while Hart did experiment with various modernist idioms, he, like many other American artists during the 1910s and 1920s, attempted to adapt these vocabularies to his strong commitment to realist and figural values. Throughout his career, the realist impulse in his work was strong and, despite an interest in more advanced styles, he never became devoted to purely formal values or complete abstraction. Much of his work represents a synthesis of realist and vanguard tendencies, which is a major aspect of a large amount of the modernist work that was produced by progressive American artists in the first decades of the twentieth century. A large portion of the final section of this book focuses on a culmination of these interests in Hart's work, as he developed an expressionistic, caricatural, figural idiom (related to Pascin's work) that combined his interest in the figure with creative, modernist distortions of form.

The relating of Hart's work to various tendencies and to the work of other artists is not based solely on stylistic and thematic affinities as Hart's involvement with a number of artists' groups and his association with specific figures—e.g., Jules Pascin, Walt Kuhn, Gus Mager, Jerome Myers, Arthur B. Davies—has been outlined in order to speculate more accurately on possible artistic influences. This monograph should be seen as a first step in analyzing Hart's career. Since it is intended as an introductory monograph, more specific issues, worthy of detailed study, have not been covered in depth. For example, Hart's relation to the tonalist movement, American Symbolism, and the American Scene deserves more detailed attention. Also worthy of further consideration is the impact of various artists' work (Arthur B. Davies, Walt Kuhn, Honoré Daumier, Thomas Rowlandson) upon Hart. His innovative efforts in the graphic arts could easily be extended into a separate study. It is hoped that this monograph will stimulate further research into the many intriguing issues surrounding Hart's career.

CHAPTER
ONE

1868–1900

GEORGE OVERBURY HART was born on May 10, 1868 in Cairo, Illinois. Although little information exists on the first three decades of his life, it is possible to piece together a brief history of his early family background and young adult years. At the time of Hart's birth, his father, Henry L. Hart (fig. 1), was employed as a dispatcher.[1] In 1870, Henry Hart moved his family to Rochester, New York, where he worked as a railroad engineer. In 1876, he changed careers, establishing a successful printers' roller business which he ran until his death in the late 1890s.[2]

Little is known of the artist's mother, Emma Wood Hart, who was born and raised in England, the daughter of a tea merchant. She immigrated with her family to the United States sometime before the 1860s, settling in the Rochester area.[3] Apparently, Emma Wood had been introduced to Henry Hart through her brother Thomas, who served in the same company of the Union army with Henry Hart during the Civil War.[4] According to extant documents, it appears that the couple was wed in either 1866 or 1867.[5]

George Hart was the eldest child in a family that included two brothers, Charles and William, and a sister, May. He was educated in the public schools of Rochester and was also tutored by his grandfather, Samuel Overbury Hart (fig. 2), who had studied for the ministry at Oxford University.[6] Samuel Hart was a gifted amateur artist, and when he discovered that his grandson had an aptitude for drawing, he began to give him sketching lessons.[7]

Although one writer has maintained that as a youth Hart attended an art school in Rochester, no records or other written statements exist that support this claim.[8] In fact, Hart once noted that his parents were too poor to give him any formal instruction in art.[9] Aside from his grandfather's drawing lessons, Hart's early interest in art might also have been nurtured by the various public art collections and programs that were being established in Rochester in the 1870s and 1880s. During these decades, civic officials and wealthy patrons were intent on developing the city's cultural resources, particularly with regard to the visual arts. As the

fig. 1 Henry L. Hart, c. late 1800s

historian Blake McKelvey noted in his study *Rochester, the Flower City, 1855–1890:*

> Many of the broadening influences active in religious and intellectual circles likewise contributed to the ripening of Rochester's interest in the fine arts. The wide diversity of tastes which sprang from the cosmopolitan population, the fresh evidences of talent budding up from the same source, and the more abundant patronage of the arts by wealthy and common folk alike greatly enriched the Flower City's cultural life. In a modest fashion, Rochester followed the example of Italian cities during their own renaissance, maintaining galleries ..., borrowing art treasures and inspiration from older centers and nurturing local creative efforts.[10]

In the mid-1870s, such important institutions as the Powers Gallery and the Rochester Art Club were founded. While the Art Club tended to exhibit and promote the work of local artists, the Powers Gallery

fig. 2 Samuel O. Hart, c. mid-1800s

contained an extensive collection of European paintings, most notably copies of old master works as well as original examples of nineteenth-century French art. The general public took an active interest in the Powers collection, which McKelvey wrote few American cities could match in the 1880s. Several of Rochester's leading newspapers, like the *Democrat and Chronicle* and the *Union and Advertiser,* often devoted long articles to the gallery's major holdings.[11]

As a child, George Hart drew incessantly, sketching portraits of his classmates in the margins of his textbooks and drawing imaginary landscapes and figures on the walls of his father's printing factory. Although Samuel Hart encouraged George's artistic pursuits, Henry Hart was not sympathetic with his son's interest in art, insisting that he prepare himself to enter the family business. In a brief written reminiscence of his childhood, George Hart commented on this situation:

> Had a liking for pictures and drawing as far back as I can remember. My parents gave but little encouragement....Besides I was needed to help my folks at an early age ... myself working in my father's glue factory—I taking the place and saving the salary paid for a young man that had worked for father some years.[12]

When George Hart was in his late teens, his father began training him to run the various operations in his printers' roller factory. George's first assignment was to monitor the production of binding glue, which was manufactured in large, pressurized vats. Whenever Henry Hart would leave the factory, George would spend the time sketching while he oversaw the making of the glue. On one such occasion in 1886, when Hart was eighteen years old, he became so absorbed in his drawing that he failed to check the controls on the vats. As a result, the glue mixture exploded, destroying the vats and a large portion of the factory. When Henry Hart returned, he severely reprimanded his son, but he became even more infuriated when George expressed more concern over his ruined drawings than with the damaged factory equipment.[13] This

incident forced Henry Hart to realize that his son was not only ill-suited to the printers' roller business, but that George's commitment to art was not going to be swayed by any parental directives to pursue a more practical line of work. Shortly afterwards, Henry Hart informed his son that he thought it best that he leave home and become independent, giving him a small amount of money to establish himself and, possibly, to begin art studies. Because of the conflicts and tensions that Hart had experienced in his childhood home, he remained estranged from his family long after his father's death and only re-established close contact with them in the 1910s.

Little information is available on Hart's life from the time he left Rochester in 1886 to the early 1890s. But, it appears that shortly after leaving his family, Hart worked in a feed mill in a nearby town before finding employment in a lithographic plant in New York City.[14] One source indicates that in the late 1880s Hart worked as a shipping clerk in New York, but he was fired from this position for spending too much time drawing—a habit that he had obviously retained from his working days in Rochester.[15] Hart then held a series of part-time jobs, earning enough money so that he could periodically quit work and attend art classes.[16]

In either the late 1880s or early 1890s, Hart traveled to London, working free passage on a cattle boat that departed from New York. However, after arriving in London, Hart was unable to find employment and remained in the city only two weeks before stowing away on a cargo ship that was returning to New York.[17] Although Hart's first trip abroad was brief, it instilled in the artist a strong desire to travel. Indeed, throughout the majority of his career, Hart would often spend the better part of each year residing in different foreign countries, favoring more tropical and arid regions, whose climates were conducive to sketching and printing out-of-doors.

Upon returning to New York, Hart then journeyed to Buffalo, where he worked for a short period of time in a printing plant.[18] While in Buffalo, Hart was influenced by the "go west, young man" sentiment of the day and decided to travel by lake steamer to Chicago.[19] It was in Chicago that Hart first received payment for his artistic skills, as he was commissioned by a sign company to paint banners and campaign portraits for James G. Blaine, who served as secretary of state under Benjamin Harrison in the 1880s and 1890s.[20] Although it is not known exactly when Hart arrived in Chicago, this fact places him in the city as early as 1892, since it was in this year that Blaine ran unsuccessfully for the presidential nomination at the 1892 Republican convention.[21] For the remainder of his stay in Chicago, Hart earned his income chiefly through sign painting—an occupation that he continued to pursue until the early 1910s; in fact, one source indicates that Hart was hired as a sign painter for the World's Columbian Exposition that was held in Chicago in 1893.[22]

While a number of writers have noted that Hart studied at the School of the Art Institute of Chicago in the 1890s, no information has ever been published on the specific dates that he attended the School; however, Institute records list Hart as having been enrolled during the 1894–95 academic year and again in 1896–97.[23] In 1894–95, Hart was enrolled in the evening division, taking an advanced antique class under Louis O. Jurgensen, who had studied abroad at the Académie Julian with Gustave Boulanger and Jules Lefebvre.[24] This course followed a traditional academic program and dealt with the drawing and painting of architectural ornaments as well as heads and figures from casts of ancient sculptural masterpieces. In 1896–97, Hart took a Saturday class that involved lessons in object drawing and instruction in various media, such as charcoal, crayon, colored chalk, watercolor, and oil. The Saturday sessions also included the sketching of live and stuffed animal specimens and tours of the Art Institute's collection.

Although Hart attended the School for only a brief time, the institution has recognized him as one of the more distinguished artists affiliated with its program: in 1979 Hart was included in a centennial exhibition at the Art Institute of Chicago that featured work by one hundred of the School's notable alumni.[25]

Hart attended the Institute School when it was under the directorship of William M.R. French. French was a dynamic and farsighted administrator, who exerted a strong influence on the direction of the School's educational policies.[26] In his history of the Institute School, *Over*

a Century, Roger Gilmore wrote that French's education in the classics at Harvard University may partially account for the strongly European, academic orientation of the School's program during its early years.[27] French restructured and patterned the institution's curriculum after that of the Dusseldorf School, which favored a division of three classes or levels: the elementary form, the preparatory class, and the top form. Like many of the European art academies of the period, the school's introductory classes involved basic instruction in drawing and shading from printed reproductions, and lessons in elementary perspective. The preparatory form included more advanced courses, introducing the students to drawing and painting the figure from antique casts. Once the student had successfully advanced through the first two divisions, he or she was allowed to enter the top form, which emphasized drawing and painting the figure from life. There were also top form classes in landscape and still-life painting in both oil and watercolor.

Evidently, Hart was not entirely satisfied with his instruction at the Art Institute, finding the School's highly formal academic curriculum too rigid and stultifying. Yet, it is important to note that while Hart attended only two courses, he did receive thorough instruction in a variety of fundamental technical skills which he later strengthened through additional academic training in Europe in the early 1900s. Shortly after completing his second course at the School, Hart decided to continue his artistic education outside of an official academic setting, electing to take more informal life drawing classes with a progressive and liberal-minded French instructor who had established a private atelier in Chicago. As Hart once remarked on his early artistic training in Chicago:

> I went to art school nights they would stick big plaster casts of feet in front of me to draw in charcoal—Every week they gave me a different view of it—"most interesting." A fellow told me a man from Paris had started a new Art School had a real life nude girl for models any body could go that paid six bucks a month I lost no time getting there and made arrangements with the professor to start right in. I will never forget the first time I

sat down before that Peacherino to study real Art. I wondered if her mother knew it—if the cops would find out and raid us...but...[the instructor assured him]...that all the great Art schools in Europe had nude models. I never missed a night—I got a lot of experience and improved my art.[28]

Apparently, Hart also attempted to continue with his studies outside the classroom by hiring models to pose for him in his boarding-house room, but his landlady objected. Consequently, he and three other students from his class decided to rent studio space, where they lived and worked for a brief period of time.[29] Although no dated works by Hart are known to have survived from this period, there are a large number of undated figure studies that may have been executed during these years.[30] For example, the drawings reproduced here (figs. 3, 4), which depict female nudes in somewhat studied and contrived poses, are the kind of studio exercises that Hart might have produced in his life drawing classes of the 1890s. While these studies were rendered in a vigorous, sketchy manner, they have an anatomical exactitude that suggests they date from early in Hart's career, before he developed his more personalized, expressionistic figural style. If these drawings do indeed date from the 1890s, they not only show the young artist to be a skilled draftsman, they are also an early indication of his interest in employing an energetic, expressive method of drawing, one of the chief trademarks of his mature graphic style.

It was during his Chicago phase, when Hart was first exposed to a more formal and rigorous approach to art making, that he became more seriously committed to his work and even began to affect the manners and mode of dress of aspiring young artists of the day. In his book *Garrets and Pretenders,* a history of bohemianism in America, Albert Parry noted that during the 1890s Hart self-consciously cultivated the image of the bohemian artist, growing a Vandyke beard and wearing a long flowing tie, a velvet coat with pearl buttons, and a large broad-brimmed hat, a foppish costume that had actually been favored a decade earlier by American expatriate followers of Whistler.[31]

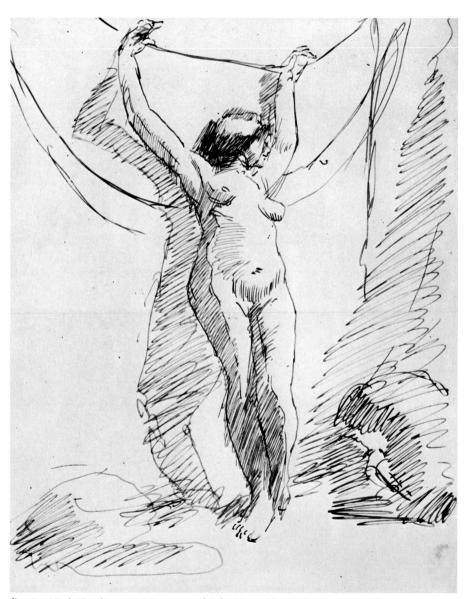

fig. 3 Nude Study, c. 1890s, pen and ink, 10 × 8″

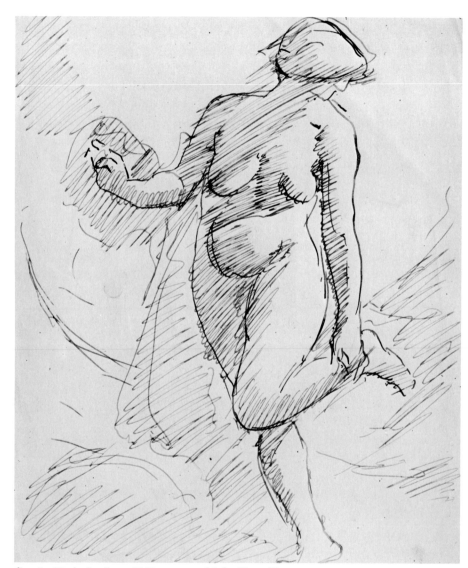

fig. 4 Nude Study, c. 1890s, pen and ink, 19 × 8″

Little information exists on Hart's life in the late 1890s, but it appears that, at some point between 1897 and 1900, the artist left Chicago and settled for a brief period in St. Louis before traveling on to Louisville, Kentucky.[32] While living in Louisville, Hart purchased a houseboat and decided to sail down the Mississippi River to New Orleans. During this period, he worked as an itinerant sign painter, specializing in advertisements for toilet preparations and quack medicines. Upon arriving in New Orleans, Hart sold the houseboat and remained in the city to work as a sign painter. According to one source, Hart apparently left New Orleans and returned to the New York City area sometime around the turn of the century.[33]

TWO

1900–1910

THE DECADE 1900 to 1910 is the first period of Hart's career from which a large number of dateable works have survived, thus making it possible to begin an examination of his oeuvre. It is clear that during these years Hart began to experiment with several major tendencies, as many of his pieces are tinged with impressionist and tonalist qualities. This decade is also important from the standpoint that one can detect the early development of certain stylistic traits and thematic concerns that were to remain fairly constant throughout his career. For example, a large number of Hart's works from the early 1900s were executed in a loose, expeditious manner, an approach that was to serve as the basis for many of his painting and drawing techniques in the 1910s and 1920s. Moreover, Hart visited over ten foreign countries during this period and established a lifelong pattern of devoting the major part of his artistic output to his travel experiences. Although he underwent a second phase of academic instruction in Europe in 1907, he never became attracted to the working conditions and the formal preoccupations of academic, studio-based art. Rather, Hart's works from the early 1900s reflect a kind of proto-Ashcan School sensibility, since he preferred to view his art as being a vital record of lived experience.

When Hart returned to New York in c. 1899–1900, he met a young artist named Charles Sarka.[1] In his memoirs, Sarka noted that he became acquainted with Hart in New York—apparently around 1900—and that they traveled together in Egypt that same year.[2] Born in Chicago in 1879, Sarka studied for a brief period during the 1890s at the School of the Art Institute of Chicago.[3] He arrived in New York in 1899 and worked as an illustrator for the *New York Herald;* in later years, Sarka became a well-known newspaper and magazine illustrator and contributed frequently to periodicals, including *Collier's, Scribner's,* and *Harper's.*[4] In his unpublished memoirs, Sarka wrote that in the early 1900s Hart was familiar with such artists as the painter F.L.A. Pinxt and Gus and Rudolph Dirks (Rudolph was the creator of the "Katzenjammer Kids" cartoon strip).[5] In fact, it was Rudolph Dirks who introduced Hart to Sarka.[6] It is also possible that through Rudolph Dirks, Hart became associated with a circle of artists and illustrators known as the "Bunch," a group that included the cartoonist Tom Powers and the illustrator and painter Gus Mager.[7]

According to Sarka, in the early 1900s, Hart maintained a studio on Twenty-third Street in New York, in the same building in which the painter Ernest Lawson, who later became a member of the influential realist group, The Eight, also had a studio.[8] Sarka states that at this time Hart was trying to abandon his commercial art work and pursue a career as a fine artist, embarking on several ambitious projects, among them a large-scale mythological scene:

Pure painting then, was not considered painting unless done with meticulousness…the object…was to carry technique further and further to such a point of finish that would make it difficult to tell whether the finished product had been painted with a camel's hair brush or an atomizer.…Bougereux [sic] was the pattern, and smooth nudes, with flesh the color and

transparency of eyeglass were the popular subjects....To this background Pop was introduced at one fell swoop. Despite its hairshirt quality of torture, his self-confidence never deserted him and though he might have quailed after hearing all the pros and cons of a profession which was wrapped up in that little beguiling word "Artist" he never let the outer world suspect for a moment any timidity on his part....[he tried] his hand at nudes, nymphs, sylphs and woodland dryads. He got himself a large canvas and a live model, worked industriously a month or more before Pan was finished. With the nymphs that gamboled in the background his technical difficulties increased. The mermaids were too Van Dykish...so said the critics, so Pop discontinued the Greek project and returned to round Roman capital letters.[9]

During the late 1800s and early 1900s (a period of American culture that is generally referred to as the American Renaissance), there was a marked interest among many artists in French academic painting and mythological, neo-pagan subjects. Although the work by Hart, which Sarka described, is not known to have survived, it appears that Hart was responsive to this turn-of-the-century trend.

In 1900, Hart left New York and traveled to Italy and Egypt. Although Charles Sarka did not report in his memoirs whether or not he traveled with Hart to Italy, several other sources indicate that Hart visited Naples in 1900, en route to Egypt.[10] While in Naples, Hart stayed in a sailors' mission and spent a considerable amount of time studying art in the city's museums.[11] He then departed for Egypt where, apparently, he had made arrangements to meet Sarka and, together, the two artists embarked on a sketching expedition to Alexandria, Cairo, and Luxor. Unfortunately, there are few, if any, extant examples of Hart's work from this period, but a large number of Egyptian watercolors by Sarka have been exhibited in recent years.[12] One work by Hart that may date from this period is a pencil sketch of Sarka reading a newspaper in what appears to be the interior of a train (fig. 5). During their sojourn in Egypt,

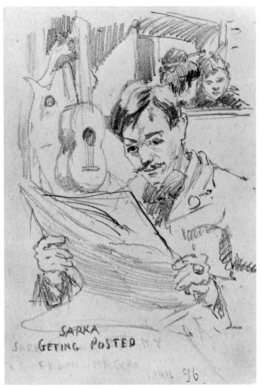

fig. 5 *SARKA GETTING POSTED,* c. 1897, pencil, 8⅞ × 6″

Hart and Sarka made plans to travel together to the South Seas, particularly to Tahiti, a venture that was not realized until 1903.[13] While in Egypt, Hart's funds ran out, forcing him to return to the United States; Sarka, however, remained in Egypt and later visited Morocco with another artist named Sigurd Skeu.[14]

After leaving Europe, Hart spent from 1900 to 1903 touring the United States, Cuba, Central America, and Mexico.[15] By 1903, he had made his way to California, where he resided for a brief period in Los Angeles and San Francisco.[16] While in San Francisco, Hart decided to sail to Tahiti. Cleverly, he secured free passage from the Oceanic Steamship

Company in exchange for his promise to forward paintings of the island, which the firm would use in its advertising.[17] His abrupt change in plans resulted in the following letter, dated June 1903, urging Sarka, with whom he had originally planned to travel, to join him in the South Seas:

> Am sorry that I leave here Thursday for Tahati [sic] without my old reliable side partner but will await patiently your arrival in Tahiti. But don't see why you should want so much money as there is no chance to spend it over there as we will get plenty of bread fruit just for the picking and plenty of fishing....I expect to do most of my stuff in oils this trip and don't expect to come back for at least two years....I am going to give all my stuff to Steamship Co to use for exhibition and adv[ertising] purposes and when I come back to the States I am to have all the originals back....Next boat leaves about July 4th will expect you on it.[18]

Sarka, however, did not join Hart in Tahiti until the fall of 1903, meeting him in the port city of Papeete. At this time, Hart was living in a small cottage on the outskirts of Papeete, but after Sarka's arrival, the two artists decided to lodge together in the nearby village of Faaa, moving into an old abandoned bake shop that they converted into a studio.[19] This studio was used primarily as a base to which Hart and Sarka returned periodically during their extensive travels around Tahiti and the neighboring island of Moorea. The artists made short excursions to many of the native villages clustered around Papeete and explored a large part of the island on foot, hiking as far as the coastal settlement of Tautira which is situated on the rugged, northeastern side of the island. While on these expeditions, Hart recorded his experiences in a series of impressionistically rendered watercolors, the majority of which are portrait studies and casually observed scenes of Polynesian life (figs. 6, 7, 8, 9).

In his unpublished travel journal, "Tahiti Nui: Narrative of an Artist in the South Seas," Sarka wrote that during their travels, he and Hart often boarded with different native families, taking part in their rituals and festivals and becoming immersed in the daily activities of Tahitian

fig. 6 Untitled, c. 1903–1904, pencil and watercolor, 9¾ × 6⅞″

15

fig. 7 Untitled, c. 1903–1904, pencil and watercolor, 13⅞ × 7⅛″

fig. 8 Untitled, c. 1903–1904, pencil and watercolor, 8 × 10″

16

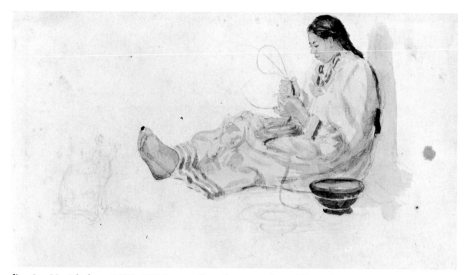

fig. 9 Untitled, c. 1903–1904, pencil and watercolor, 5½ × 9¾″

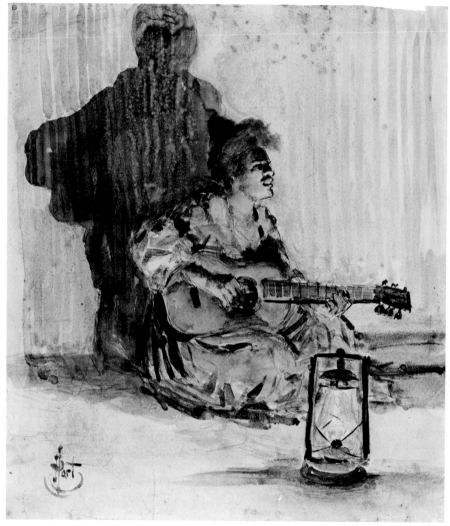

fig. 10 Untitled, c. 1903–1904, pencil and watercolor, 14¾ × 12¾″

life. Sarka also noted that their native hosts often refused to take money from the artists for their food and lodging, but that they would sometimes accept a portrait sketch as payment.[20] One of Hart's more notable efforts in portraiture from this period is a bust-length, profile-view of a native girl, possibly the daughter of a tribal chieftain. In this work, executed in pencil and watercolor, Hart used light tracings of graphite to render the girl's features, painting her facial tones and the texture of her hair and garment in delicate, translucent washes of color. He successfully rendered the effect of the soft sheen of light on her hair by freely brushing on watery pigments and allowing them to blend together in a diffused manner, a technique that gained greater prominence and expressive force in his watercolors of the 1910s and 1920s.

Most of Hart's South Sea portraits were executed as full-length studies in which his figures are posed in natural settings; some of them even border on more naturalistic genre, as the artist captured his native subjects engaged in such prosaic, albeit exotic, activities as weaving baskets and washing clothes in tropical streams. Another subject genre that appears frequently from this period is figures playing musical instruments, based no doubt on the many evenings that Hart and Sarka were entertained by native musicians during their travels (figs. 10, 11). Sarka noted in "Tahiti Nui" that whenever he and Hart stayed with a

While most writers have regarded Hart's South Sea watercolors as merely visual documents of his travels, it is possible to relate these works to broader cultural and aesthetic tendencies. Indeed, many of his pieces can be discussed quite specifically within the context of several turn-of-the-century artistic and literary trends. For example, during the period of the American Renaissance (which extended from the 1870s to the 1920s), the United States witnessed an unprecedented growth in its national wealth and political significance, and began to exercise its influence as a major international and commercial power. Diplomatic and trade expeditions to such distant regions as Europe, the Orient, and North Africa fostered an interest in foreign cultures that was reflected in the art of the period. While this trend revealed itself most strongly in a fascination with subjects that focused on European culture and history,[22] there was also among many artists an active interest in non-Western cultures. As Douglas Dreishpoon and Susan E. Menconi pointed out in their study *The Arts of the American Renaissance:*

> If the quest for power and historical significance in the political realm frequently assumed the proportions of imperialism and commercial exploitation, within the arts, political motivation was superseded by the desire for new cultural experiences and exotic subjects. By the 1890s the American Indian coexisted with the Samoan chief, Moroccan concubine, and Japanese geisha.... Foreign cultures provided the impetus for an iconography outside the mainstream of Western art. Enhanced by their popular demand, exotic subjects offered a venue for the nation's dreams and fantasies; as a means of escaping one's own time and culture, they furnished a rich alternative to classical allegory, mythology, and history.[23]

One of the more important consequences of this phenomenon was the adoption of oriental aesthetics among members of the European and American avant-garde which, in turn, led to the formation of the *Japonisme* movement in many branches of the visual and decorative arts.

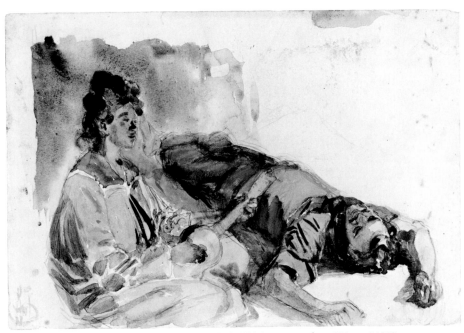

fig. 11 *WOMAN SERENADING*, c. 1903–1904, watercolor, 9⅝ × 14⅝″

Tahitian family, the entire village would often gather with the artists at the end of the day for a communal meal that was usually followed by a musical performance.[21] These gatherings featured both Polynesian and Western music and, on many occasions, the two artists accompanied the native musicians—Sarka on guitar and Hart playing a primitive percussion instrument called the "bones" (fig. 12). One of these musical subjects, an untitled work that depicts a Polynesian woman playing a guitar, is of particular interest, chiefly because of Hart's assured figural draftsmanship and his attempt to render the pale, artificial glow of a kerosene lamp by painting the scene in an unusual palette of chalky ochres and greens; these novel, somewhat nonnaturalistic tones anticipate Hart's experimentation with more unconventional hues in his quasi-fauvist watercolors of the late teens and early twenties.

Yet, this interest in non-Western cultures also prompted the development of more purely thematic concerns as can be seen in the works of such artists as Robert Blum and John La Farge. In 1890 and 1891, La Farge undertook a journey to the South Seas with the writer Henry Adams, traveling to Tahiti, Samoa, and Fiji. During this expedition, La Farge documented his travel experiences in a series of watercolors and journal entries that were later published under the title *Reminiscences of the South*

fig. 12 George Hart playing bones, c. 1910s

Seas.[24] In the majority of his South Sea watercolors, La Farge was intent on recording Polynesian rituals and practices. But, he also produced more informal portraits that show natives posed in their natural surroundings, a treatment that may have influenced Hart's approach to his Polynesian figure studies. Several writers have actually compared Hart's South Sea watercolors to those of La Farge, and there are certain formal parallels that suggest Hart might have looked to La Farge's works as models for some of his own paintings.[25] For instance, in many of Hart's works, single figures are positioned either in front of palm trees or framed by tropical foliage, a compositional formula that also appears in several of La Farge's pieces. Further, in painting his South Sea watercolors, Hart utilized a technique that was similar to La Farge's: both artists worked in an impressionistic style, rendering their scenes in an expeditious manner while capturing a fairly large amount of descriptive and atmospheric detail. It is quite possible that Hart was familiar with La Farge's works, since one of his early associates, the painter F.A.L. Pinxt, had a studio in New York adjacent to La Farge's, and many of La Farge's Polynesian watercolors were exhibited and published in the late 1890s.[26] Moreover, Hart might have learned of La Farge's works through Charles Sarka. Sarka recalled that at the time of the two artists' travels in Tahiti he knew of La Farge's painting expedition to the island in the previous decade.[27]

On the other hand, if Hart was aware of La Farge's works and sought to emulate them, he did not study his Polynesian subjects as rigorously as La Farge, who observed and transcribed native customs with an ethnographic exactitude that is largely absent from Hart's examples. In many of Hart's impressionistic vignettes of native life, his figures become almost secondary elements in works whose principal motifs are expressively rendered light and atmospheric effects (see figs. 6, 8). Even if one might conclude that Hart was not influenced by La Farge, both artists' South Sea works can be linked to the same turn-of-the-century preoccupation with exotic subject matter and non-Western cultures.

In addition to the strong interest in distant countries and foreign peoples shown by artists during the American Renaissance era, a large number of writers explored similar concerns at this time. In *American*

Renaissance 1876–1917, Richard Guy Wilson commented on this tendency, writing that

> In American literature there was, towards the end of the century, an increasing flood of travel sketches, novels set in foreign lands, and historical accounts of non-American subjects. The earlier Yankee distrust of Emerson and Twain disappeared to be replaced by the word pictures of William Dean Howells, F. Marion Crawford, F. Hopkinson Smith, Edith Wharton, Henry James, and Richard Harding Davis.[28]

One author whose writings were closely associated with this phenomenon is Robert Louis Stevenson.[29] As Roy Albert Riggs noted in "The Vogue of Robert Louis Stevenson in America 1880–1900," Stevenson's travel literature, particularly his South Sea adventures like *Treasure Island* and

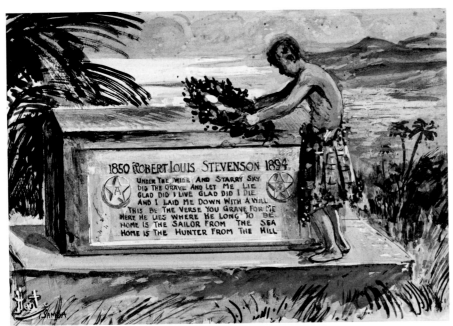

fig. 13 Untitled, c. 1904, pencil, pen and ink and gouache, 11¾ × 17¼"

The Beach of Falesa, enjoyed tremendous popularity in the United States during the last two decades of the nineteenth century.[30] In the late 1880s, Stevenson had traveled to the South Seas to gather material for his writings and decided to remain in the islands, settling on a tropical estate in Samoa. He spent the remaining years of his life there and, after his death in the early 1890s, he was buried on top of a mountain near his estate. In 1904, Hart visited the site of Stevenson's grave and executed a painted sketch of it in *grisaille* (fig. 13). This work also shows a native figure paying tribute to Stevenson by placing a wreath on his tomb, which is inscribed with lines from his famous "Requiem" (clearly legible in Hart's rendering). Stevenson's South Sea tales were widely available in magazine form and pirated editions in the 1890s, and Hart surely would have been acquainted with them.[31] Indeed, Hart's choice of Stevenson's grave as the subject for a painting and his memorialized treatment of this view would seem to indicate that he was familiar with the author's work and reputation, and the popularity of Stevenson's South Sea literature may have been one factor in stimulating Hart's interest in visiting the Polynesian islands.

As noted previously, in executing his South Sea watercolors, Hart worked primarily in an impressionistic mode. Yet, the technique and the formal characteristics of these paintings typify those of American Impressionism rather than the native French approach. French impressionists, such as Manet and Monet, were intent on developing an advanced form of optical naturalism, and sought to capture the general appearance of a scene by rendering the transient effects of light and atmosphere. In executing their generalized, fleeting views of natural phenomena, these impressionists focused on the descriptive capabilities of color, light, and shadow. Because of their interest in rendering these ephemeral, surface qualities, their works often lack the traditional emphasis on clear plastic and spatial definition; as a result, solid forms are often flattened and their edges appear to dissolve and blend into their spatial surrounds. Moreover, spatial divisions tend to be ambiguous, as foreground and background areas often read as a continuous space. The optical concerns of the French impressionists were translated into a painting technique that relied on

intense color and generally consisted of short, uniform brushstrokes and broad masses of fractured color describing forms that were usually devoid of firm outlines and modeling.

American artists, on the other hand, who experimented with the optical naturalism of the French impressionists, were never as fully committed to the formal precepts of the movement and, in many cases, only adopted some of the more superficial aspects of the style. During the 1880s and 1890s, many American artists were influenced by Impressionism, embracing a lighter palette and a sketchier method of painting. Yet, even when American artists attempted a more serious application of the idiom, their painted forms tend to retain a greater sense of solidity than those of the French, and there are often a larger number of distinct spatial references in their works. Several art historians have noted that in many American impressionist paintings, the artists merely embellished more conventionally rendered forms with an energetically painted overlay of impressionist texture.[32] As one scholar has remarked, "the Americans often appear to be impressionizers rather than Impressionists."[33] Their resistance in adopting the more radical methods of the French impressionists has generally been linked to a longstanding American regard for the integrity of the object, and to the fact that American artists have traditionally placed more emphasis on material than on purely perceptual reality.[34] It has also been noted that many American painters who experimented with Impressionism during the late 1800s had received most of their training in Parisian art schools. Since they had been subjected to rigorous academic instruction in drawing and painting the figure, they were unwilling to abandon or compromise their hard-earned skills.[35] This also may have been an important factor in the development of Hart's more modified impressionist techniques, as his first exposure to Impressionism probably coincided with his early academic training.

In style, Hart's South Sea watercolors can be related to an American impressionist sensibility, to the extent that one can be said to exist. Some stylistic features of an untitled watercolor from the early 1900s can be used to illustrate this point (plate 1). In this work that depicts two native boys and a fishing boat on a tropical beach, Hart utilized a bright palette and a sketchy method of painting which were clearly inspired by French impressionist art. In order to convey the intense, pervasive tone of the tropical sky and water, the artist used a vivid blue throughout the scene, and painted the beach and expanse of sea in broken patches of color. Nevertheless, while executed in an impressionistic manner, the inclusion of penciled outlines and the careful placement of tones give the painted forms, particularly that of the boat, a fairly strong three-dimensional quality. Furthermore, Hart painted the background area of the scene in lighter tones, relying on the traditional device of atmospheric diminution to suggest a clear recession into space. This work, with its depiction of forms drenched in sunlight and the division of the scene into clearly defined horizontal bands of sand, water, and sky, also recalls the bright coloration and pictorial structure of many of Winslow Homer's tropical watercolors of the 1890s.

Hart was probably first introduced to the impressionist aesthetic during his student days in Chicago in the 1890s. Although Impressionism emerged as a major movement in Europe during the 1870s, impressionist art was not studied or collected seriously in the United States until the late 1880s and early 1890s. While several landmark exhibitions of impressionist painting had been organized in New York and other eastern cities in the late 1880s, in the 1890s, Chicago became one of the more active centers in the United States for both the collecting and viewing of impressionist art. The impressionist movement became particularly popular in America after the World's Columbian Exposition in Chicago in 1893, where it won a great deal of critical acclaim and public acceptance.[36] While some examples of French Impressionism were displayed at the Exposition, American Impressionism was particularly well represented by a large number of works by Mary Cassatt, Childe Hassam, William Merritt Chase, Theodore Robinson, and John Twachtman. As an aspiring artist working as a sign painter at the Exposition, Hart, no doubt, attended the fair's art exhibitions, where he would have encountered many examples of impressionist painting. Moreover, during 1895 and 1896 when Hart attended the School of the Art Institute of Chicago, the Institute sponsored several shows that highlighted impressionist art.

For example, the "Seventh Annual Exhibition of American Paintings" that was held in October of 1894 included a large number of impressionist canvases and, in 1895, the museum mounted an exhibition of works by the French impressionist masters Manet and Monet.[37] In the 1890s, Chicago was also home to one of the most avid collectors of impressionist art in the United States, Mrs. Potter Palmer. During this decade, she amassed a large and notable collection of late nineteenth-century French and American paintings. The Palmer collection was open to the public, "which it presumably helped to educate in the art of the Barbizon and Impressionist schools."[38] The impressionist cause was further supported and popularized in Chicago in the 1890s by the writer Hamlin Garland, who moved to the city in 1893 and became a chief proponent of the tendency.[39]

fig. 14 Untitled, c. 1903–1904, watercolor and charcoal, 6½ × 8⅝"

The majority of Hart's South Sea works are portrait and figure studies, but he also produced several noteworthy landscapes. Charles Sarka wrote in "Tahiti Nui" that, while he and Hart were most interested in figural subjects, they often turned to landscape views whenever the Polynesians were reluctant to pose for them.[40] Many of Hart's landscape pieces are impressionistic essays in watercolor that he executed quickly and spontaneously during his travels in the Polynesian islands. One untitled work from this period shows Hart to be a skilled landscape watercolorist and reveals his interest in developing a more individualistic impressionist painting style (fig. 14). In this work, which depicts a canoe with two figures in a tropical inlet, Hart rendered the distant mountains and the expanse of water in broad, fluid washes of color. As in many of his South Sea watercolors, he applied pigments with a large amount of water, a method that caused his painted passages to bleed together and coalesce into wavering veils of color. In the case of this work, the amorphous, indistinct quality of the painted forms allowed the artist to suggest the humid atmosphere of this tropical setting. In rendering this scene of a tranquil bay, Hart used a golden, luminous palette and large, softly contoured forms, resulting in a sense of poetic quietude.

Although most of Hart's South Sea landscapes were executed in an impressionist mode, he did experiment with several other, closely related landscape styles. During his sojourn in the Polynesian islands, he exploited the expressive means of various formal approaches in order to convey his different emotional responses to the South Sea milieu. For example, in one small untitled landscape from either 1903 or 1904, Hart painted a narrow view of a jungle valley surrounded by mountains (fig. 15). Despite the intimate scale of this piece and the fact that it was executed in an impressionistic manner, the majestic forms of the mountains and the dramatic treatment of the clouds recall the grand, romantic landscape statements of the Hudson River School painters, particularly the works of Thomas Moran. As in the previous example, Hart painted this scene in loose, watery strokes and, as a result, the various mountain formations and the clouds merge together in a blur of dark pigment. Hart used his method of soft blending in many of his South Sea watercolors to

give his works a lyrical and somewhat idyllic feeling. But, in this piece, the artist employed the technique with much greater expressiveness to reflect his more intense, awestruck reaction to this sublime tropical vista.

Another untitled tropical watercolor that also dates from the early 1900s reveals Hart's exploration of Tonalism (fig. 16). Like the impressionists, tonalist artists (James A. McNeill Whistler was the chief practitioner of the style) were also interested in rendering the fleeting effects of light and atmosphere. But, in their works the tonalists did not juxtapose intense, primary colors in the manner of the impressionists, favoring instead more subtle tonal modulations. Their works tend to be painted in monochromatic color schemes that are based on more muted hues such as gray, gold, and blue. Tonalist paintings often depict scenes of dawn and dusk, and landscape views are generally colored with mist. This allowed the artists to emphasize subtle tonal harmonies in their works and to transform reflective highlights and landscape forms into shimmering patches of color. While the impressionists were primarily interested in an objective study of natural phenomena, the tonalists were more concerned with poetic evocations of mood, and used limited color and hazy images to create subjective, dream-like visions. While Hart's landscape contains fairly clear topographic details and is not as abstracted as most tonalist views, it does have certain formal traits that may reflect his awareness of and interest in the tonalist aesthetic. For example, this distant view of a native settlement—seen against a mountainous backdrop—appears to have been glimpsed through a thin veil of mist, as many of the landscape elements have been rendered in delicate, translucent washes, giving them a slightly diffused quality. Most importantly, Hart has painted this scene using a restricted palette of muted blues, enlivening the composition with a few secondary accents of sienna. Although the work's compositional scheme is expansive and almost panoramic in scope, the depiction of the still, mist-enshrouded village and the relaxed labor of two small, isolated figures creates a mood of quiet intimacy that is in keeping with the thematic character of tonalist art. Most of Hart's South Sea landscapes are direct, brightly colored transcriptions of tropical scenery and atmosphere; however, in painting this blue-toned view, Hart deviated

23

fig. 15 Untitled, c. 1903–1904, pencil and watercolor, 8 × 10″

fig. 16 Untitled, c. 1903–1904, watercolor and pencil, 11¾ × 16⅝″

somewhat from naturalistic color and adopted a tonalist solution so that he could produce a more personal, contemplative record of his South Sea experience. Tonalist works appear infrequently in Hart's oeuvre (see figs. 99, 100) and, apparently, he would only rely on the idiom whenever he felt compelled to convey a more introspective response to a particular locale.

In considering some of Hart's landscape pieces from this period, it can also be noted that while his use of bright tonalities and his interest in rendering atmospheric effects are characteristic of the impressionist aesthetic, his reliance on soft, freely brushed washes is more closely related to the painting methods of Tonalism. These works can, perhaps, be considered an important early indication of the direction his art would take in the ensuing decades—that is, synthesizing a direct observation of visual reality with a personalized, expressive mode of execution.

In March of 1904, Hart left Tahiti and traveled to the Samoan islands. According to a letter that Hart had sent his brother a month before his departure, Charles Sarka's funds had been depleted in Tahiti, necessitating his return to the United States.[41] Although Hart was receiving a small monthly salary for sending tropical sketches to the Oceanic Steamship Company, he also supported himself through the establishment of a sign painting business in Samoa.[42] While in Samoa, Hart spent time on the islands of Tutuila and Upolu.

One of the few works that is firmly dated and labeled as having been executed in Samoa is a small painting entitled *Study of a Native* (fig. 17). This work, which was executed in pencil and watercolor, depicts a female figure standing next to a small campfire on a strip of beach. She is posed with her back to the viewer, and was painted with a thin film of chalky pigment in quick, expressive strokes; in fact, her body is only denoted through the massing of several irregularly shaped splotches of color. Hart incorporated the figure into the scene by simply superimposing it over a darkly colored landscape form (a rock or foliage), using the tone of this existing form to indicate shadows and delineations in her anatomy. While *Study of a Native* can be viewed as an experiment in rendering the effect of firelight on the human form, the image of the figure has a strange, otherworldly quality which suggests that Hart might also have been

trying to deviate from immediate perceptual experience; because of the figure's suggested incorporeality, it appears to inhabit a realm somewhere between the real and the imagined. Indeed, the figure appears to be almost transparent and, because of its ephemeral quality, one could almost read it as an hallucinatory or fantastic vision. Although Hart has been called the "Yankee Gauguin," his works lack the highly subjective, primitivized character and supernatural aura of Gauguin's South Sea essays. Yet, Hart's *Study of a Native* may represent an effort analogous to Gauguin's to explore some of the more mystical aspects of Polynesian culture. In "Tahiti Nui," Sarka wrote that during his sketching expeditions in Tahiti, he actually may have had several mystical or transcendental experiences, one of which involved drawing an imagined figure that was later described to him as being a mythical island being:

I came upon a deep green, silent pool, by a rock, with a buttressed tree rising directly above its bank....Imagination

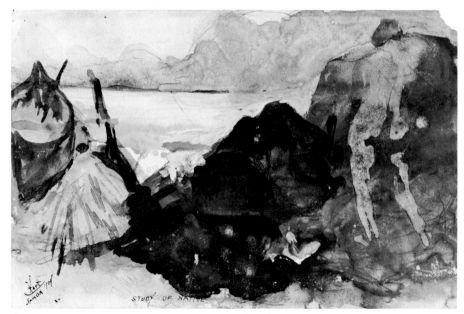

fig. 17 *STUDY OF A NATIVE*, 1904, pencil and gouache, 6¼ × 9¾"

suggested a nymph-like figure leaning over a large rock about to reach for a fallen leaf floating on the surface of the pool. As I glanced up from time to time, I was suddenly aware of a large white bird floating on the silent water. Its sudden wraith-like appearance was startling. Then when I looked again, it had disappeared.... [the natives] said the pool was the home of a certain *tupapau* (water spirit), which rose up to the surface at different times and dragged down anybody passing near it. When I showed them the nymph picture I had made, they believed that I had actually seen the water spirit.[43]

It is possible that Hart had similar experiences in the Polynesian islands and, in light of Sarka's account, *Study of a Native* can perhaps be interpreted as Hart's interest in depicting a fanciful encounter with an exotic native apparition. Samoa was much less westernized than Tahiti at the time of Hart's visit there in the early 1900s, and this work might have resulted from his more direct contact with the Polynesians' folklore and mystical beliefs. While this kind of equivocal scene is a radical departure from his more factual studies of the early 1900s, it actually looks forward to some of his visionary, symbolist subjects of the next decade—the majority of which depict female nudes in idealized seaside settings (see fig. 91; plate 13).

Sometime in 1904, Hart left Samoa and sailed to Hawaii, where he purchased land in Honolulu and built a small cabin.[44] As he had in Tahiti, Hart became quite familiar with the natives and devoted the bulk of his work to depicting their activities (fig. 18). While in the South Seas, Hart had grown a long, full beard. When he returned to the United States, his friends felt that it made him look considerably older and they began to refer to the thirty-seven-year-old artist jokingly as "Pop"—a sobriquet that he retained (even after he shaved off the beard) for the remainder of his life.[45] As Hart explained, "I thought it would be nice to have a beard—a Van Dyke, you know, like an artist. Well it didn't make the desired effect on my friends. They started calling me 'Pop.' I shaved off the beard but I couldn't shave off 'Pop.'"

According to several sources, he returned to the United States in 1905 for a brief period before embarking on another extended trip abroad, this time to Cuba, Iceland, and Europe.[46] While in Havana, Cuba, he executed a watercolor sketch of El Morro, a famous colonial fortress (fig. 19), rendering it in the upper section of the sheet while, in the bottom half, he inscribed the name and location of the site, a format that appears in many of La Farge's travel sketches. The exact chronology of Hart's travels between 1905 and the summer of 1907 is not certain. But it is known that after his visit to Cuba, he sailed to Europe, and it appears that either in the late winter or early spring of 1907, he traveled to Iceland from Stockholm.[47] Hart journeyed through Iceland with his cartoonist friend Rudolph Dirks, and both artists executed paintings during the trip.[48] Several of Hart's Iceland works are extant, and one is in the Zimmerli Art Museum collection, a painted portrait in oil from 1907 that is titled *Runwig Stevenson, Iceland*.

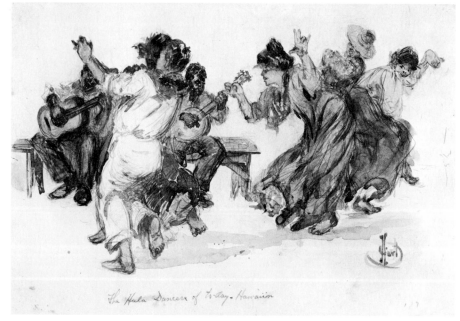

fig. 18 *HULA DANCERS OF TODAY–HAWAII*, c. 1904, pencil and watercolor, 12 × 18″

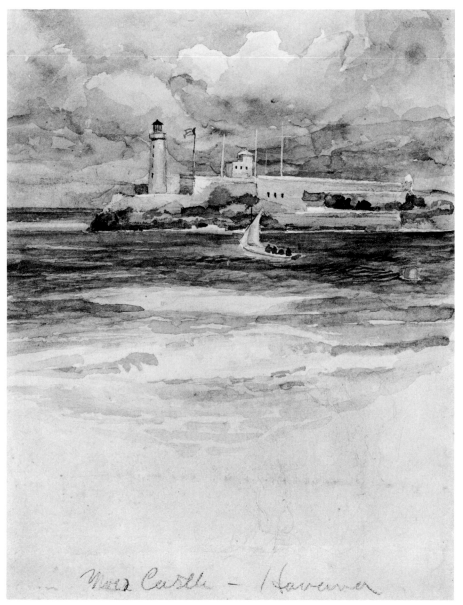

fig. 19 *MORRO CASTLE–HAVANA*, c. 1905, pencil and watercolor, 10⅞ × 8⅜"

One of the most important aspects of Hart's 1907 European sojourn was his brief period of study at the Académie Julian in the summer of that year.[49] The school was founded in 1868 by the minor painter and former wrestler Rodolphe Julian, and its faculty was comprised of such renowned artists as Jules Lefebvre, Jean-Paul Laurens, Gustave Boulanger, Raoul-Charles Verlet, and Adolphe William Bouguereau.[50] From its inception, the Académie catered to foreign students, many of whom had difficulty passing the stringent entrance examinations of the Ecole des Beaux-Arts. Unlike the Ecole, the Académie Julian had no entrance requirements, and while many of the students were content to pursue their studies in this more liberal environment, others viewed their classes there simply as a training ground for meeting the admission standards of the Ecole. The students were granted a great deal of freedom and worked independently for the most part. Instructors appeared in the classroom only periodically to offer guidance and criticisms. Since Hart had been dissatisfied with the rigid curriculum and teaching methods at the School of the Art Institute of Chicago, it is possible that the more informal policies of the Académie Julian attracted him to the school. In addition, one of his primary instructors at the Institute School, Louis O. Jurgensen, had studied at the Académie, which might also have influenced Hart's decision to attend the school.

Most of the studio instruction at the Académie was based on an exacting study of the figure. As the Irish critic and novelist George Moore commented on his training at the Académie Julian:

> …we needed not to think of anything but the studio model; the world in the fields and the streets, that living world of passionate colour and joyous movement, was but an illusive temptation; the studio model was the truth, the truth in essence; if we could draw the nude, we could draw anything.[51]

The school's official method of instruction stressed rendering the figure in masses of light and shade.[52] This is particularly interesting in reference to Hart, as several writers have noted that the artist tended to construct his

pictures by juxtaposing areas of light and dark tonalities.[53]

While in Paris, Hart supplemented his more technically oriented education at the Académie Julian by studying masterworks in the Louvre.[54] Although the instruction at the Académie Julian was informal by European standards, Hart's brief attendance at the school convinced him of his earlier view that he was not interested in the teaching methods nor the artistic principles associated with academic training.[55] He quickly became disenchanted with his traditional studies at the Académie and, as a result, he became interested in some of the more contemporary artistic developments that were occurring in Paris in the first decade of the twentieth century.[56] In Holger Cahill's 1928 monograph on Hart, the artist discussed his first exposure to modern art in Paris: "I saw the modern galleries…, but I didn't understand modern art at first. It didn't take me long to fall for it. I met some artist friends who had been connected with the modern movement. They told me a lot of things and I believed I was on the right track."[57] During the period that Hart attended the Académie, post-Impressionism and Fauvism were the dominant vanguard tendencies being studied and practiced by both European and American artists in Paris. Many American artists were able to gain knowledge of avant-garde developments by attending exhibitions at the Salon d'Automne and the Salon des Indépendants and by viewing works at the Vollard and Bernheim-Jeune galleries. The Salon d'Automne and the Salon des Indépendants were also important forums for displaying advanced art by the Americans. The art historian Carol Arnold Nathanson has explained that the excitement and the outrage that many American artists in Paris expressed over French modern art helped to produce an environment in which a number of Americans—even those not sympathetic to avant-garde art—were curious about such radical currents as post-Impressionism.[58] While Hart noted that he was interested in the modern styles that he encountered in Paris during the early 1900s, he did not produce any works in 1907 (or shortly afterward) that reflect an immediate conversion to a more progressive vocabulary; however, Nathanson has noted also that although many American artists who studied in Paris in the early 1900s did not readily embrace post-

Impressionism and Fauvism, their initial contact with these styles proved to be an important stimulus in their later acceptance and experimentation with them.[59] In the mid-1910s, Hart *did* adopt various formal devices that can be related to post-Impressionism, but this could have resulted from his exposure to post-impressionist art in the United States, particularly the work of Maurice Prendergast. Yet, with regard to Nathanson's comments, Hart's contact with various avant-garde developments during his brief period of European study in 1907 was no doubt an important factor that facilitated his adoption of a more modernist, post-impressionist style in the middle of the next decade.

One of Hart's Parisian works from 1907, that is known to have survived, is an oil painting entitled *Cup of Tea*, showing a female nude seated on a bed in a dark interior (fig. 20). Hart's treatment of this subject, which was particularly popular in French art from the late 1800s and early 1900s, is actually quite reminiscent of Anders Zorn's etched depictions of female nudes in boudoir settings. The subject of a female nude appears infrequently in Hart's oeuvre, but he did return to it several times throughout his career, most notably in 1923 when he produced a lithograph, also entitled *Cup of Tea*, that was based on this 1907 oil.

During his career, Hart executed only about twenty-eight works in oil, eighteen of which are in the Hart Collection of the Zimmerli Art Museum.[60] Most of his oil paintings tend to lack the visual appeal and the artistic quality of his efforts in watercolor and printmaking. In many respects, oil painting was an inappropriate vehicle for displaying Hart's technical skills and aesthetic interests, since the more exacting methods of working in oil and the contrived nature of studio art were simply antithetical to his concern for *plein air* effects and expedient execution, and for capturing immediate action. In more practical terms, Hart's frequent travels and his penchant for working out-of-doors required that he use materials like crayon, pastel, and watercolor, which offered greater portability and technical ease. Hart's graphic sensibility did not transfer successfully to oil painting and, furthermore, his work in the medium was not sustained enough to grant him a technical proficiency that was comparable to his practiced efforts in watercolor and the graphic arts.

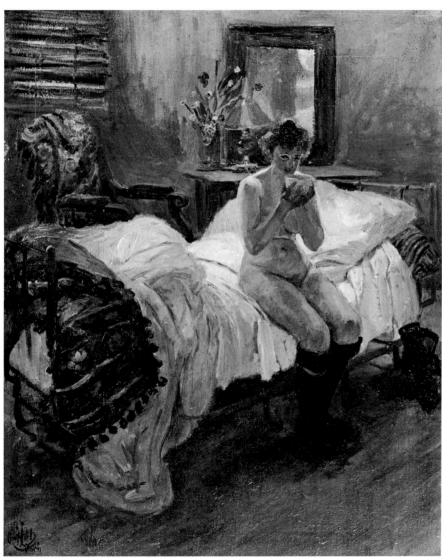

fig. 20 *CUP OF TEA*, c. 1907, oil on canvas, 28¼ × 23¼″

fig. 21 Sign painted by George Hart, c. 1907–1912

Hart once remarked on his preference for working in watercolor: "...I came to the conclusion that if a man had any ideas to express he can express them just as well with watercolor on a piece of paper as he can with oil paint on a big canvas in a gold frame, the way you see them at the exhibitions. I've painted about twenty oils..., but I think you can say as much in water color."[61]

During the fall of 1907, Hart left Paris and journeyed to such towns in France as Oise, Meulan, and Etaples, where he produced impressions of his travels, one of which, a painting entitled *Sandscape–Meulan*, was entered in the 1908 Carnegie International exhibition in Pittsburgh.[62] It has also been recorded that Hart traveled through Germany for a brief period in the fall of 1907 before returning to the United States in the latter part of the year.[63] Apparently, Hart's younger brother William visited him

while he was residing in Paris and agreed to send the artist fifty dollars a month to help with his educational and living expenses; however, William Hart, who had taken over their father's printing business, was attempting to finance a new factory in 1907 and, after only several months, he had to discontinue his payments to his brother in Europe—something which was, no doubt, one of the determining factors in Hart's return to the United States in the fall of 1907.[64]

Upon returning to the United States, Hart settled in Coytesville, New Jersey. He sold his property in Hawaii and used the money to purchase a small tract of land in Coytesville, where he built a modest stucco and frame cottage which he used as both a place of residence and a studio. For the remainder of his life, this cottage was his permanent home, and although he resided there for only half of the year, it served as his

headquarters between travels. Hart resumed his sign painting business once he had become established in New Jersey, receiving many commissions to paint signs and placards for restaurants and sideshows at the Palisades Amusement Park in Fort Lee (figs. 21, 22).

In his *Painting and Sculpture in New Jersey*, William Gerdts noted that in the first decades of the twentieth century, the Coytesville/Fort Lee area became almost a veritable artists' colony, as such artists as Van Dearing Perrine, Hart, and Walt Kuhn maintained homes and studios there, and other artists such as John Sloan, Jules Pascin, and Gus Mager made frequent visits to the region and produced some of their works within the vicinity of Fort Lee and the Palisades.[65] Hart, actually, was quite active in the artistic circles in and around Fort Lee and became a close friend of some of the artists who were based in this area like Walt Kuhn and Gus Mager. Hart's move to this region and his subsequent friendship and professional association with these and other artists was to have important consequences for his later career and artistic development.

fig. 22 Sign painted by George Hart, c. 1907–1912

CHAPTER
THREE

1910–1920

HAVING SETTLED IN Coytesville, New Jersey, in the previous decade, Hart had become involved with several artists, most notably Walt Kuhn and Gus Mager, who either lived in or visited the nearby town of Fort Lee. Together they frequented Albigs Pavilion, a restaurant on the Palisades at Fort Lee which was a favorite meeting place for a number of New Jersey artists in the 1910s. There, Hart, Kuhn, and Mager drank and socialized and occasionally mixed their revelry with thoughtful discussions about art.[1] A photograph, taken in 1912, shows the three artists playing musical instruments at Albigs and serves to document their association (fig. 23).[2]

It is not known exactly when Hart became acquainted with Kuhn and Mager. While it could have been as early as 1900, at least in the case of Mager, one source indicates that by 1910 all three were part of a circle of artists and illustrators that included Rudolph Dirks, Tom Powers, and Morgan Robertson.[3] Although Charles "Gus" Mager is not well known today, he was a figure of some significance during the early twentieth century. Mager began his artistic career in the early 1900s as a cartoonist for the *Journal* and *World* newspapers, creating such cartoon series as "Groucho the Monk" and "Hawkshaw the Detective."[4] However, he began to devote himself seriously to painting in the 1910s and was particularly influenced by post-impressionist art, emulating the styles of Cézanne and van Gogh. Mager was well known among many of the leading painters of his day and enjoyed close friendships with George Bellows, William Glackens, and John Sloan. He was acquainted with other noted artists including Robert Henri, Ernest Lawson, and Leon Kroll. Through his

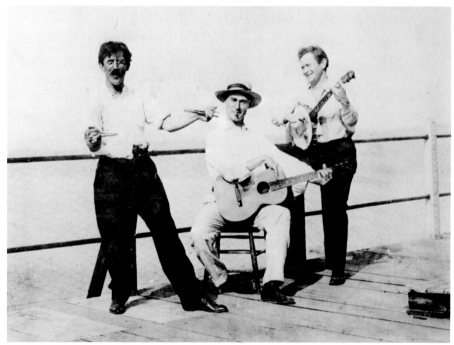

fig. 23 George Hart, Walt Kuhn, and Gus Mager playing musical instruments at Albigs Pavilion, Fort Lee, New Jersey, c. 1912. Walt Kuhn Papers, Archives of American Art, Smithsonian Institution. Photo credit: Archives of American Art

friendship with Walt Kuhn, Mager was persuaded to exhibit two of his works in the famous Armory Show.

Kuhn was one of the more significant figures with whom Hart came into close contact during the course of his career, although their friendship has only been cited in a few sources.[5] Yet, from the standpoint of this study, their association was an important one that deserves to be more thoroughly studied and documented.

Born in New York City in 1877, Kuhn's given name was William, but like Hart, he adopted a more informal sobriquet early in his career and began to refer to himself as Walt about 1900 when he started illustrating magazines in San Francisco. Several aspects of Kuhn's early life paralleled Hart's and might have helped to stimulate their friendship. As a young man, Kuhn delighted in tales of distant travel and, in the 1890s, he embarked on a journey to the American West, earning his way by working as a sign painter.[6] Between 1901 and 1903, Kuhn studied at several art academies in Europe, returning around 1905 to New York City, where he worked until 1914 as an illustrator and cartoonist. During this period, he spent the summer of 1906 in Fort Lee and later, in 1908, joined the faculty of the New York School of Art, which held its summer classes in Fort Lee. In 1909, Kuhn set up residence in Fort Lee and remained there until 1919. According to Adams, "For [Kuhn] the town was a quiet retreat on the brink of the Palisades, far enough away from the brawling, hectic Manhattan, where he went only when business required."[7]

Although Kuhn achieved some fame as a painter in the 1920s and 1930s, and has been regarded by many art historians as a notable figure in the history of American modernism, he is still largely remembered for his participation in organizing the Armory Show that was held in New York City in 1913. Sponsored by the Association of American Painters and Sculptors, it was a massive survey of the recent history of avant-garde art in Europe and the United States, and was probably the most important American exhibition of the century, since it was the first large-scale showing of modern art in this country to be viewed by the general public (the exhibition later traveled to Boston and Chicago).[8] As secretary of the Association of American Painters and Sculptors, Kuhn was one of the principal organizers of the Armory Show. Along with Arthur B. Davies, he traveled abroad in 1912, collecting material for the show and, together, the two painters were largely responsible for shaping the character and focus of an exhibition that many felt gave too much prominence to European modern movements. Although the show was a *succès de scandale* with the general public and created a furor in the popular press, it was a catalytic event that served to spur on avant-garde artistic activity in the United States.

Although the Armory Show featured works by European artists, Kuhn had also selected a large number of pieces by American modernists such as John Marin, Alfred Maurer, Marsden Hartley, Morton L. Schamberg, Charles Sheeler, Stuart Davis, and Morgan Russell. Despite Hart's and Kuhn's close association at this time, there were no works by Hart in the exhibition. This is somewhat unusual considering that several artists who were friends of both Kuhn and Hart, like Rudolph Dirks, Gus Mager, Jerome Myers, and Wood Gaylor, were all represented in the show. It is possible that Hart was hesitant to exhibit his art in the early 1900s, since he had only shown his work once before in 1908 at the Carnegie International exhibition. But, in 1914, only a year after the Armory Show, Hart's work was shown in an exhibition at the Daniel Gallery, an exhibit that also included pieces by Ernest Lawson, Leon Kroll, Charles Demuth, Stuart Davis, William Zorach, and Maurice Prendergast.[9] The gallery was run by an eccentric former cafe proprietor named Charles Daniel, whom many artists also referred to affectionately as "Pop"; Kuhn had become familiar with Daniel in the early 1910s and it is possible that the gallery dealer was alerted to Hart's work through Kuhn.[10] Although none of Hart's work was displayed at the Armory Show, Charles Sarka included an amusing reference in his memoirs that linked Hart to the exhibition. Sarka, who was obviously unsympathetic to the avant-garde developments that Kuhn highlighted in the Armory Show, humorously speculated that the modern works in the exhibit were simply Hart's turn-of-the-century academic paintings that Kuhn had cut up and rearranged in visually disorienting, non-objective compositions:

[Kuhn returned]...with a steamship load of modern art at the time when the two schools of high art—the academic and non-

academic were on the verge of having a blood transfusion. This *faux pas* on Walt's part disrupted the operation before the transfusion was completed and the battle then became a bitter psychological one. For a score or more years after the Armory became a proving ground for abstractions in paint, I had the greatest difficulty in putting aside a suspicion that Walt had unearthed—Pop's "Pan and Nymphs" after the war, went to Paris, had it cut apart and copies made, then put the pieces together again helter-skelter, stacked the Armory Show with the infinite variety and sat back to watch the fur fly. My suspicions were further aroused by Pop's actions when he walked along 57th Street, his eloquent Mona Lisa smile telling all his friends, "You see, you thought my nudes were cockeyed but what do you think of these my fine friends and Philistines, you un-believers, didn't I tell you so?"[11]

While it is not known whether Kuhn had actually approached Hart about participating in the Armory Show, he did prove to be instrumental in promoting Hart's work and having it shown in other exhibitions later in the decade. For example, in 1916, according to one source, Arthur B. Davies was helping to arrange an exhibit of modern art at the Montross Gallery in New York and asked Walt Kuhn if he knew of any other artists whose works should be included in the show. Kuhn suggested he consider adding "Pop" Hart to the exhibit; Hart, however, was traveling in the West Indies at the time. Kuhn and Davies had to break into his home in Coytesville in order to select examples of his work for the Montross exhibition.[12] In another effort to help launch his career, Arthur B. Davies purchased the first painting from Hart's inaugural one-man exhibition at the Knoedler Gallery in 1918, and also persuaded the collector Dikran Kelekian to acquire one of Hart's works.[13] Kuhn later commented that both the Knoedler exhibit and Davies' and Kelekian's purchases "started the ball rolling," helping to stimulate a greater critical and commercial interest in Hart's work.[14]

In 1911, Kuhn became a close friend of John Quinn, the noted collector of avant-garde art, and began to act as his art advisor.[15] Together they often toured New York galleries, purchasing artwork. In the late 1910s, Quinn acquired three works by Hart, a decision that was undoubtedly guided by Kuhn.[16] These works, the present location of which is unknown, included a watercolor of 1903 titled *Head of a Woman* (Tahiti), an undated watercolor titled *Souvenir of Trinidad,* and *Bowling Night,* an oil painting from 1915 that was one of Hart's rare exercises in geometric abstraction (see fig. 46).

Later, in 1925, Kuhn was active in organizing the American section of the "Exposition Trinationale," an international survey of modern art that focused on works by French, English, and American artists.[17] The show first opened in Paris at the Durand-Ruel Galleries, and later traveled to London, and then to New York, where it was shown at the Wildenstein Gallery. Kuhn included Hart in the impressive roster of artists whose work was selected for the exhibition; American entries included Arthur B. Davies, Jo Davidson, William Glackens, Charles Sheeler, Max Weber, and Charles W. Hawthorne. In his 1930 book on modern art, *Apples and Madonnas,* the critic C. J. Bulliet commented on the American representa-tion at the "Exposition Trinationale," reserving his greatest praise for the works of Hart, Kuhn, and Weber, which, he wrote, supplied "what...guts there [were] in the exhibition."[18]

Kuhn counted among his friends such prominent art critics as James Gibons Huneker, who wrote for the *New York Times* and the *World,* and Frederick James Gregg, the dynamic and prolific critic for the *New York Sun.*[19] It is possible that his relationship with these critics was beneficial to the advancement of Hart's career, as Gregg wrote a lengthy and laudatory review of Hart's first one-man show at the Knoedler Gallery in 1918.[20] Kuhn, himself, attempted to give more prominence to Hart's work by writing an article about him using the pseudonym James How. The article appeared in the January 1922 issue of the *Art Review* magazine.[21]

Throughout his career, Kuhn was extremely active in promoting European and American avant-garde art in the United States, and sought to instill in dealers, collectors, and the general public an intelligent appreciation for experimental trends. Along with such important figures

as Alfred Stieglitz and Juliana Force, Kuhn was one of the principal champions of the avant-garde during the 1910s and 1920s, when it elicited little interest and support from American critics and dealers. In addition to his general advocacy of the modernist cause, he attempted to provide individual artists with more opportunities to exhibit their work, and devoted considerable energy to furthering the career of his friend "Pop" Hart.

Kuhn's influence on Hart's artistic career, however, extended beyond promotional activity. His own artistic pursuits were surely an important stimulus or reinforcement for Hart's interest in experimenting with various modern styles. For example, during 1910 and 1911, Kuhn was working in a vigorous, impressionistic manner, painting his scenes in bright hues which were applied to the canvas in broad, thick strokes of clotted impasto, an unusual approach that is also quite typical of Hart's oil paintings from this period. At this same moment, Gus Mager also was using rich colors and thick, heavily worked layers of pigment, suggesting that both he and Hart were aware of Kuhn's painting techniques or, alternately, that these similarities were the result of a shared influence that led to the formation of a common idiom. In 1915, Kuhn began to explore the radical formal solutions of cubist art, creating pieces that were derived from the decorative, collage-like vocabulary of Braque and Gleizes. Although Kuhn was not firmly committed to the tenets of Cubism, he once remarked that he felt compelled to experiment with the style in order to better comprehend its implications "first hand."[22] It was during 1915 that Hart also produced several paintings which reflect a cubist approach (see figs. 46, 47, 48). Yet, these humorous, albeit progressive, statements do not appear to have been inspired by the analytical abstractions of the French cubists, since he created forms that are more reminiscent of the figural-geometric hybrids found in vorticist art. In the late 1910s, both Hart and Kuhn were attempting to incorporate aspects of Fauvism into their works, but in the case of Hart, his experimentation with this style was largely restricted to the use of vibrant tonalities that served to invigorate and intensify the visual impact of his more representational depictions (see plate 8).

During the early part of the 1910s, Hart continued to work as a sign painter, reserving Sundays for his own fine art projects. But, in 1912, he abandoned the sign painting business and began to free-lance as a set designer and painter for various film companies that were based in the Fort Lee area.[23] The most important film studio with which Hart was affiliated was World Pictures, a successful company in Fort Lee that was run by the flamboyant production tycoon Lewis Selznick.

In the earliest years of the industry (1900–1905), New York City was the major center for filmmaking. During this early period, interior scenes were always shot on a set and exterior scenes were usually filmed against a backdrop. Filmmakers soon discovered that it was not only cheaper to shoot outdoors, but filming on location gave their movies an illusion of reality that was impossible to achieve in the confines of the theater. The expansion in film topics and the audience's growing interest in more novel settings demanded the depiction of different locales that were difficult to simulate on a set. Consequently, New York-based film companies began to search out locations in Long Island, upstate New York, Connecticut, the Hudson Valley, and the Catskills; however, with its varied range of topography and its close proximity to New York City, New Jersey proved to be the ideal center for outdoor filming, and many companies such as the Goldwyn Pictures Corporation, William Fox, the Solax Company, and World Pictures established major studios in the state.[24] A large number of New Jersey sites were chosen for studios, but the Fort Lee-Edgewater-Leonia area was, by far, the most popular.

World Pictures was founded in 1914, the same year that the industry witnessed the dramatic shift from the production of short one- or two-reel movies to full-length feature films. During its history, World Pictures produced films featuring such renowned silent film stars and stage performers as Clara Kimball Young, Lillian Russell, and Marie Dressler. It also launched a number of important movie careers, including that of Clarence Brown (later a leading director for MGM who made some of Greta Garbo's best known pictures) and the legendary Joseph von Sternberg. Hart was hired by World Pictures around 1916 and, while employed there, he became a close friend of another set designer, Thomas

Kimmwood E. Peters, who also worked as a technician at the studio and who, in later years, distinguished himself by inventing the aerial film camera.[25] Hart designed and constructed sets for many of World Pictures' major releases, among them *The Great Ruby, Little Comrade, Scheherazade,* and the 1917 film *Trilby,* which starred Clara Kimball Young. World Pictures was known for its artistic productions, which were often based on exotic or period subjects that required the designing of elaborate sets. This emphasis must have appealed to Hart. The company employed some of the more creative figures in the business including Maurice Tourneau, who had actually trained as an artist under Rodin and Puvis de Chavannes in the late 1800s. Since the studio's production schedule was concentrated during the warmer spring and summer months (it was too costly to heat the large film sets in winter), the technical staff was usually employed for only half the year—a flexible arrangement that allowed Hart to travel during the winter. He continued to work for World Pictures and various other New Jersey studios until around 1921, when most of the major film companies relocated to California, where the warmer climate allowed them to maintain production throughout the year.

Few examples of Hart's film art have survived, the exceptions being two preparatory sketches for sets used for the film *Madame Butterfly—Marked Woman* (figs. 24, 25). The oriental structures depicted in these

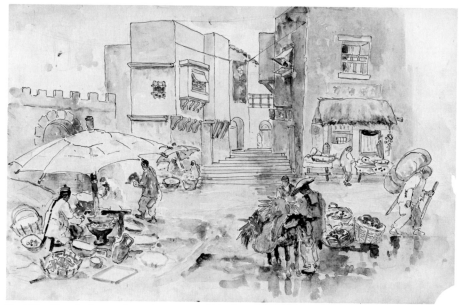

fig. 25 Sketch for motion picture set: "Madame Butterfly—Marked Woman," c. 1912–1920, watercolor and pen and ink, 14½ × 23¼"

fig. 24 Sketch for motion picture set: "Madame Butterfly—Marked Woman," c. 1912–1920, watercolor and pen and ink, 14½ × 23¼"

drawings were conceived most likely as flat backdrops which would have been executed by set painters such as Hart. The economical manner of these drawings, which were rendered in quick gestures of pen and ink and colored wash, is typical of Hart's graphic style in the late 1910s. Another extant film piece is a large mural-sized painting that Hart actually produced as a prop for the film *The Great Ruby.* This painting, dated 1917, which was originally owned by Hart's film associate Thomas K.E. Peters and later by the art historian Dorothy C. Miller, is now in the collection of the Newark Museum.

During the first decade of the twentieth century, Hart's journeys had been extensive, taking him to a wide range of countries in different hemispheres; but, in the 1910s, his travels abroad were concentrated in the region of the West Indies. Since Hart preferred warmer climates, he was attracted to the West Indies and often departed for this area in the late fall in order to avoid the harsh New Jersey winter. In the first half of the decade, his travels were confined to Trinidad, but, in the latter part of the 1910s, he also visited Santo Domingo and Dominica.

As had been the case with Hart's earlier voyages to the South Seas and Europe, those to the West Indies were primarily artistic expeditions in which his travels were chronicled in a series of vividly painted impressions.[26] The subject matter of these works remained consistent with those of his South Sea period, as many of his travel pieces from the 1910s are extemporaneous sketches of native life (fig. 26) and *plein air* landscape studies (fig. 27; plate 7). In one work from 1918, titled *Most of the People in San Fernando Are East Indians* (fig. 28), Hart attempted to convey the

bustling activity of a crowded market place by filling the composition with fragmentary views of moving figures. Executed in crayon and gouache, the scene is painted in thick touches of bright, opaque pigment on brown-toned paper, a technique that duplicates the striking visual effect of the brilliantly colored native garments. During his stay in the West Indies, Hart was fascinated by market and street scenes and took a strong interest in rendering the pictorial effects of large, fast moving crowds.[27] Attempting to transcend the more particularized, reportorial character of *Most of the People...*, Hart executed a more abstracted

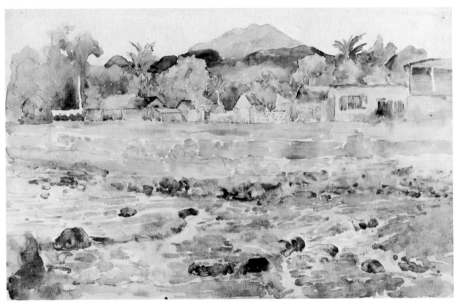

fig. 27 Untitled, c. 1912–1920, charcoal and gouache, 12⅛ × 19⅝″

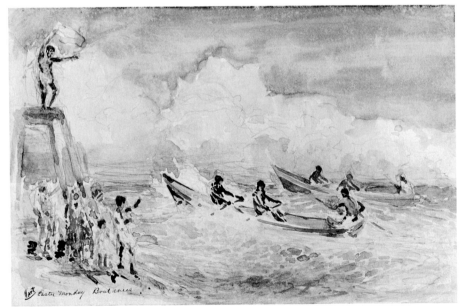

fig. 26 *EASTER MONDAY BOAT RACES*, c. 1912–1920, pencil and gouache, 6 × 9½″

market view in which the visual excitement and dynamism of a native throng is evoked through a dense massing of brightly colored, gestural splotches of paint (fig. 29).

While residing in the Polynesian islands and the West Indies, Hart had become particularly interested in recording the picturesque domestic activities of the native inhabitants. One such subject that emerges as a

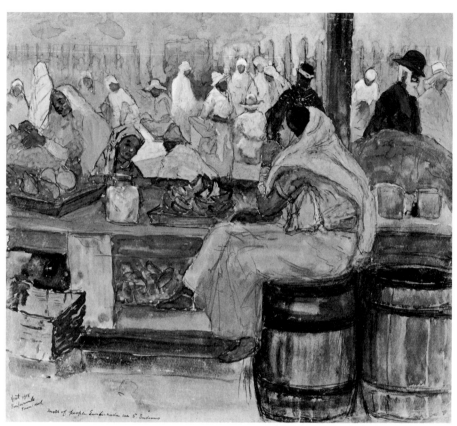

fig. 28 *MOST OF THE PEOPLE IN SAN FERNANDO ARE EAST INDIANS*, 1918, gouache and crayon, 12⅞ × 14¾"

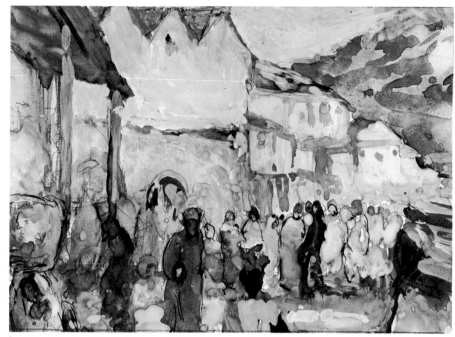

fig. 29 Untitled, late 1910s, crayon and gouache, 5⅞ × 8½"

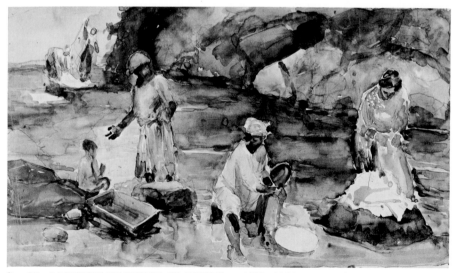

fig. 30 *NATIVES WASHING CLOTHES*, c. 1912–1920, watercolor 12 × 22½"

principal theme in his watercolors of the early 1900s and 1910s is the depiction of natives laundering in tropical streams, most likely because it allowed the artist to combine his strong interest in both figure and landscape painting. In many of these works, such as *Natives Washing Clothes* (fig. 30), the figures dominate the foreground space and the details of the surrounding landscape are reduced to a sketchily painted, intensely colored backdrop which draws the viewer's attention to the more clearly delineated activity of the figures; however, in several other depictions of this theme, executed in the West Indies in the 1910s, the

forms of the laboring natives are rendered more as incidental elements that are almost subordinate to the expressively rendered and lushly colored tropical settings (figs. 31, 32). For example, in one untitled watercolor from 1918 (fig. 32), which was translated five years later into a lithograph, *Native Laundress* (see fig. 95), the ostensible subject of this work, a figure washing a garment in a rushing stream, was relegated to the far right of the composition. As a result, the primary focus of the scene becomes the rugged streambed, with its clusters of rocks and centrally placed torrent of water that was denoted through a massing of vigorous, linear strokes of paint. Hart's concentration on these natural forms is indicative of his growing interest in viewing the landscape, itself, as a viable subject for his art. During this same period, he executed a series of intensely observed and sensuously painted landscape studies in which the human element has been completely extruded and nature serves as the primary vehicle of artistic expression (see fig. 43; plate 4).

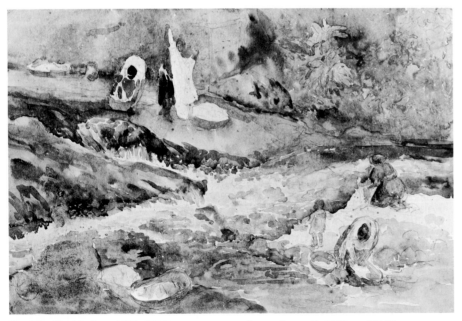

fig. 31 Untitled, c. 1912–1920, crayon, gouache, and pencil, 12¾ × 19¾"

In addition to landscapes, Hart continued to focus on portrait and figure studies during the 1910s, two notable examples being *Two Hindu Priests* of 1917 (fig. 33) and *Girl of the Tropics* (fig. 34), which were executed in the West Indies.[28] In relation to many of Hart's tropical figure studies of the early 1900s, which are little more than spontaneous sketches, *Girl of the Tropics* is a much more fully developed essay in portraiture and reveals his growing awareness of some of the formal considerations of the genre. For example, in this work, instead of the casual, snapshot-like quality of his South Sea portraits, the figure has been arranged in a formal, frontal pose so that it relates effectively to the surrounding compositional frame and background design. Unlike the summary treatment of his earlier figure paintings, the forms in this work were fully modeled and the watercolor has been handled more like gouache with heavily worked, opaque layers of paint and passages of glazing. Hart also displayed a more individual sense of color in this piece, as he did not rely on a simplified impressionist palette of primary hues, but devised a more structured, harmonious color scheme of golden browns and ochres. Despite the stiff, awkward handling of some of the anatomy—a problem that plagued Hart throughout his career—*Girl of the Tropics* is an interesting attempt to combine some of the formal conventions associated with studio portraiture with the *plein air* effects of natural sunlight. It is also with such works as *Girl of the Tropics* that various writers have felt compelled to draw parallels between Hart's tropical figure studies and those of Gauguin.[29] Yet, in comparing this work with a similar subject by the French painter, such as his *Femmes aux Mangos* of 1879, one can see that the two artists' sensibilities were dramatically different, since Gauguin's provocative and symbolic juxtaposition of the lush tropical fruit with the native girl's breasts contrasts sharply with Hart's more innocent vision of native beauty.

Although the subject matter of Hart's work from the 1910s did not vary greatly from that of the previous decade, his treatment of these themes reflects his growing artistic sophistication and technical fluency. For the most part, his South Sea works from the early 1900s were casually executed travel notations, something that is often underscored by the

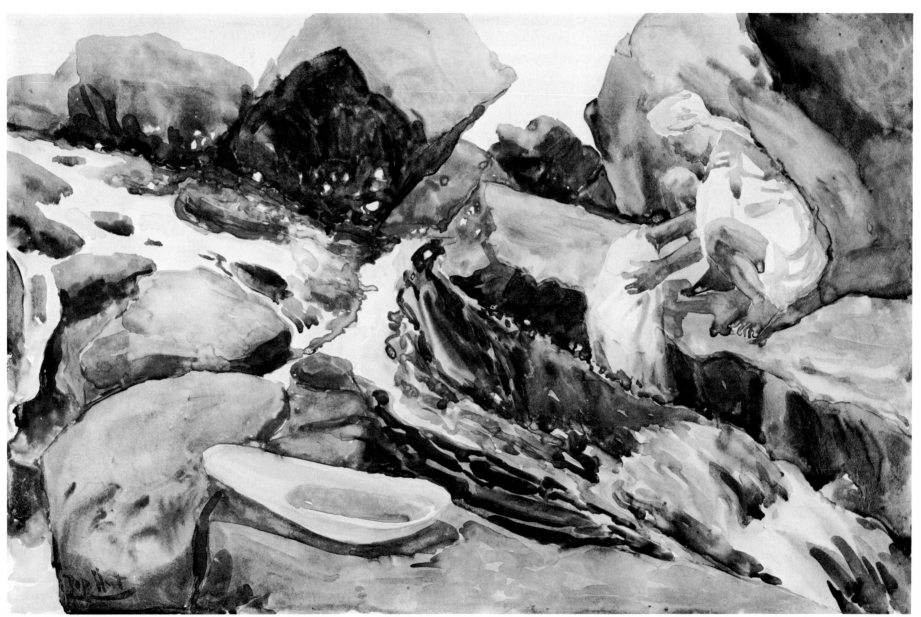

fig. 32 Untitled, 1918, pencil and watercolor, 14 × 22″

depiction of isolated figures and partial landscape views that were placed randomly on paper with little concern for compositional values; however, in many of the works that he produced in the West Indies, Hart began to use larger formats, and created more complex and fully developed compositional schemes.[30] Furthermore, in a large number of his South Sea sketches, figure and landscape elements were divorced from their surroundings, a much less challenging approach than constructing an environmental framework for them. Yet, in his works of the 1910s, Hart began to paint more expansive landscape views in which figures were incorporated into fully articulated and convincing spatial settings.

These advancements in Hart's technical and compositional skills can be seen in two works from 1919 which he painted in Dominica: *A Street in Roseau, Dominica, West Indies* (fig. 35) and *Main Street, Roseau* (plate

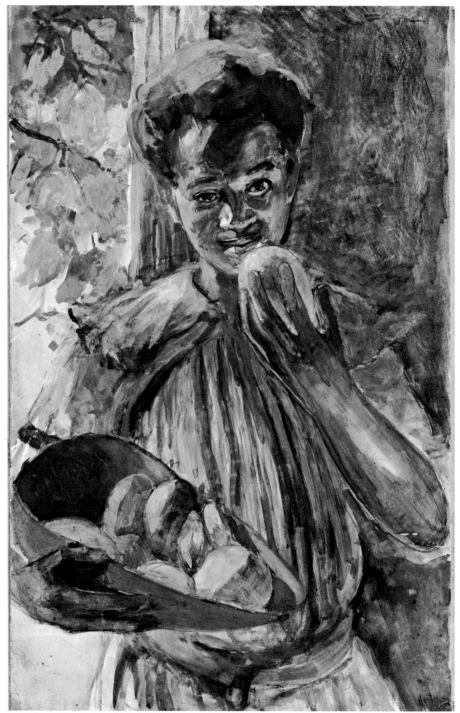

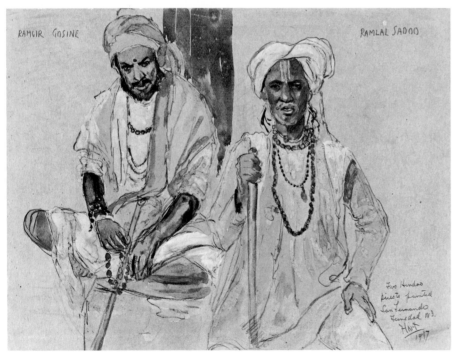

fig. 33 *TWO HINDU PRIESTS*, 1917, gouache, crayon, and pen and ink, 10⅞ × 15″

fig. 34 *GIRL OF THE TROPICS*, c. 1912–1920, gouache, 23⅜ × 14⅝″

6). In *A Street in Roseau,* the scene covers the entire surface of the paper and its structure was carefully conceived within the margins of the support. The landscape details were extended to and balanced against the border of the paper, which successfully imparts to this painted view the proper sense of pictorial closure and self-containment. The work is also punctuated by a series of vertical elements—gate posts, a standing figure, a church steeple, telephone poles—whose height and placement have been varied to create a rhythmic, directional flow throughout the scene that successfully links the various forms together into a compositional entity. Moreover, Hart placed the street in the central register of the composition and painted a figure moving into the background space, a traditional, albeit effective, formula that serves to draw the viewer's attention into the depicted scene. In *Main Street, Roseau,* Hart utilized many of the same devices, but also exploited his impressionistic painting technique to give this work pictorial unity. The swirling brushstroke used to denote such details as cobblestones, masonry, and foliage results in a repetitive formal motif that is echoed throughout the composition, creating a naturalistic all over pattern. Hart's skillful manipulation of the compositional principles described above marks an advancement over his earlier South Sea sketches; in these works, Hart's compositions were formulated by simply massing together landscape forms in a rudimentary fashion, and real pictorial unity was oftentimes achieved only through a consistency in paint handling and surface treatment.

Hart's strengthened technical prowess is also evident in the tropical landscape views that he produced in the West Indies in the 1910s, an excellent example being *Mountain View, Dominica* of 1919 (plate 7). Landscapes had not been a major subject for the artist in the early 1900s. Most of his South Sea landscape studies from that period were incidental notations, often painted on small, pocket-sized pieces of paper. *Mountain View, Dominica,* however, is a larger, more formal presentation and a more mature landscape statement. Because of Hart's fluid draftsmanship and delicate layering of tones, this work is also one of his more facile performances in the watercolor medium. As in the street scenes of Roseau, this piece reflects his more sophisticated approach to landscape composi-

tion. The pictorial weight of the painting is concentrated on the left side, decisively cutting off the view along this edge and leaving the right side open. This type of compositional scheme indicates that the artist has carefully selected his vantage point and has had to compose, perhaps even rearrange, his scene to fit within the strict confines of the format. Like other works noted in this study, *Mountain View* contains certain stylistic features that can be viewed as nascent traits which were to grow more pronounced in some of his later works. For example, the scene is suffused in bright tones of ochre, a color choice that is indicative of a growing subjectivism in his art. In painting this mountainous vista, Hart abandoned strict fidelity to local color, employing an intensified, high-keyed palette in order to stress the lush verdure of Dominica. Furthermore, while the hazy quality of the painted landscape was, no doubt, used to suggest the humid atmosphere of the tropics, there was also a general tendency towards more diffused and indistinct imagery in his works of the 1920s. During this decade, Hart began to de-emphasize the underly-

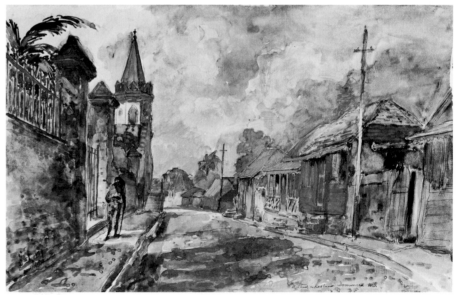

fig. 35 *A STREET IN ROSEAU, DOMINICA, WEST INDIES,* 1919, watercolor, 12½ × 21″

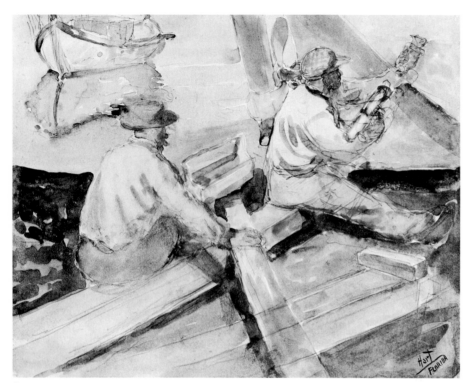

fig. 36 *CAULKING BOAT, TARPON SPRINGS, FLORIDA,* 1910s, pencil and watercolor, 11 × 14″

location for such film studios as World. One of the most important was the extensive range of exotic scenic backdrops that could not be found in the Northeast—jungle settings, virgin forests, wide sandy beaches, and ancient, old-world cities like St. Augustine.[32] While in Florida, Hart produced a large number of watercolor studies, the majority of which depict the activities of the local fishermen, many of whom were probably Cuban émigrés. In several pieces, the fishermen are shown at work (fig. 36) and, in other paintings, they are posed informally at the site of their labors (fig. 37). On other occasions, however, Hart recorded the fishermen

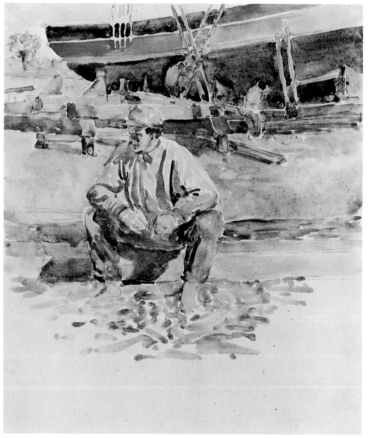

ing architectonic structure of his painted forms, creating pictures that were constructed primarily of amorphous planes of color (see figs. 65, 66).

During the latter part of the 1910s, Hart traveled to various regions in the United States particularly in the South. In 1917, for part of the year, he lived in New Orleans and certain sections of Florida. His visit to Florida was almost certainly due to his affiliation with World Pictures since, in the late 1910s, the film company shot exterior scenes for several of its productions in Palm Beach and St. Augustine, and several of Hart's Florida subjects of the late teens are marked as having been executed in St. Augustine.[31] In addition to the high percentage of sunny days throughout the year, there were several other factors that made Florida a prime

fig. 37 Untitled, c. 1910–1920, watercolor and charcoal, 14⅜ × 11⅜″

engaged in more recreational pursuits, which included playing cards and dining and conversing in cafes or out-of-doors on rustic verandas. One such example is an untitled work that is dated 1918 and shows a group of fishermen seated around a table (fig. 38). Hart executed this figural grouping in charcoal and watercolor, and used a vigorous, wiry line to express the raw, energetic character of these ethnic fishermen. The artist evidently considered this scene to be one of his more successful figural works, as he created a hand colored lithograph in 1922, based upon it (see

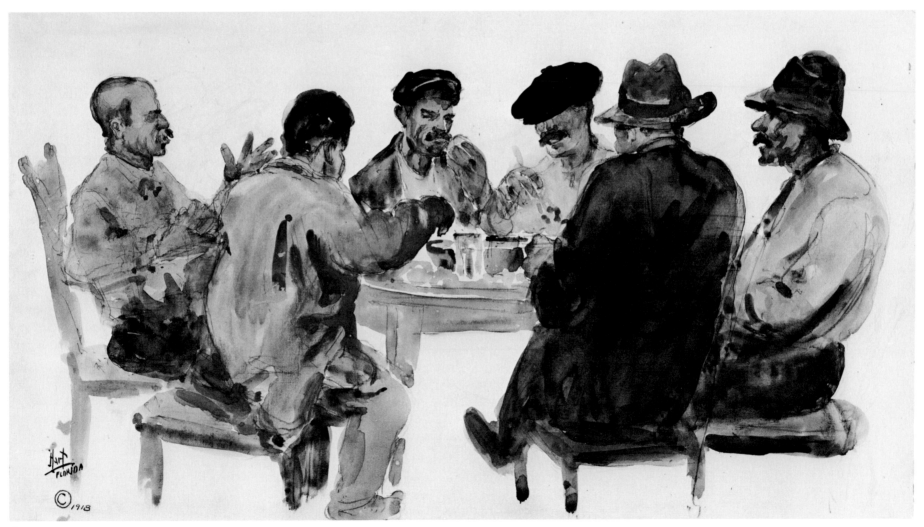

fig. 38 Untitled, 1918, charcoal and watercolor, 12¼ × 22½″

fig. 94). In addition to figural subjects, Hart turned his attention to the Florida landscape, producing an untitled marine scene that is one of his more formally daring works of the 1910s (fig. 39). Although many of the

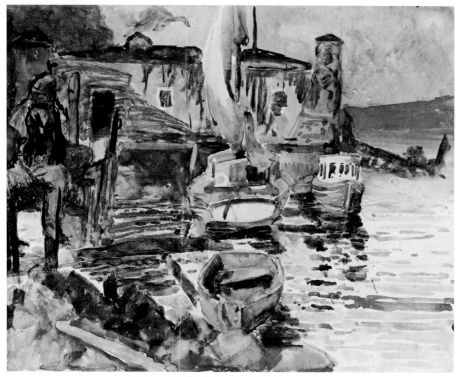

fig. 39 Untitled, late 1910s, gouache and pencil, 14 × 17⅞″

forms in this painting were rendered in a fairly sketchy, representational manner, one can detect traces of fauvist styling, as Hart painted the reflections on the water in vivid, elongated fragments of color that clearly assert themselves as abstract motifs in this impressionistic dock scene. The more radical treatment of the water is reminiscent of certain passages in André Derain's marine views of the early 1900s, but it is also similar to the modified fauvist style that the American artist George Luks employed in some of his watercolors of the late 1910s.[33]

This Florida dock scene, with its combination of impressionistic

realism and abstracted, fauve-like color, is emblematic of Hart's artistic position in the late 1910s. During this period, the majority of his works were rendered in a highly individual, impressionist style. But, simultaneously, he began to explore the stylistic premises of several other modernist vocabularies. Some of the pieces produced in this period represent Hart's relatively bold experimentation with certain aspects of post-Impressionism, Fauvism, and geometric abstraction. In other less radical efforts, he devoted only a portion or an aspect of a composition to more advanced styling.

In 1917, Hart lived for a brief period in New Orleans, where he shared an apartment with the renowned expressionist painter Jules Pascin, whom he apparently had met in New York sometime between 1914 and 1917.[34] Like Kuhn, Pascin was one of the more significant artistic figures with whom Hart enjoyed a close friendship during the latter part of his career. However, in contrast to Kuhn's style, which did not influence Hart directly, Pascin's art exerted a strong influence on the development of Hart's work in the 1920s. Indeed, in many respects, Hart's mature style is indebted to Pascin's expressionistic figural idiom.

Jules Pascin was born Julius Pincas in Bulgaria in 1885.[35] He was trained in Vienna and Munich during the early 1900s and, while in Munich, he worked as a cartoonist and illustrator for the famous satirical journal *Simplicissimus*. He visited Paris in 1905, where he settled soon afterward and gallicized his name. In the summer of 1914, in order to avoid being drafted into the Bulgarian army, he went to London and, in October of that year, he immigrated to the United States. Pascin eventually became an American citizen and remained in this country until 1920, when he returned to France. He later returned to the United States in 1927 for one year in order to retain his citizenship. Subject to bouts of severe depression and melancholia, Pascin committed suicide in Paris in 1930 after a brief period of emotional decline.

By the time Pascin traveled to the United States, his reputation had begun to develop. He had exhibited at the 1911 Berlin Secession and the Independents exhibition in Cologne in 1912. He was also one of the European participants in the Armory Show of 1913, and since he was well

represented in that exhibition, his arrival in New York the following year was greeted with considerable interest by American artists. As Tom L. Freudenheim commented in his 1966 study on the artist:

When American artists were beginning to be aware of new movements in modern art, when they were just emerging from the shock of that most important [Armory] show, one of its European painters arrived in America. Although he was surely not among the most avant-garde artists, Pascin was taken into the group of people who comprised the "scene" in those days, and became acquainted with many prominent American artists and collectors.[36]

Among his closest friends were Louis Bouché, Alexander Brook, Guy Pène du Bois, Max Weber, George Biddle, Walt Kuhn, and Hart.[37] Pascin became particularly well acquainted with artists who were members of the Penguin Club,[38] a professional and social organization for artists that sponsored exhibitions, sketching classes, auctions, and costume balls. In all probability, it was at a Penguin Club function that Hart met Pascin. While in New York, Pascin was associated with several influential critics, among them Henry McBride. The noted collector John Quinn was one of his first American patrons, and the painter also established a close friendship and professional relationship with Edith Gregor Halpert, proprietor of the Downtown Gallery.

During the years 1915 to 1917, Pascin traveled through the southern United States, visiting Texas, Louisiana, South Carolina, and Florida; he also made an excursion to Cuba. While on this extended trip, Pascin devoted his artistic energies to chronicling his travels, executing two sketchbooks and a large number of individual watercolors and drawings, a practice that may have been partly influenced by Hart's example of producing visual records of his sojourns.[39] Moreover, both artists employed similar drawing methods at this time, executing their travel sketches in pen, pencil, or chalk, to which color washes were added. This mixed media technique was well suited to Pascin's and Hart's interest in

capturing fleeting travel experiences and, although it was economical, it also resulted in complete statements that have the spontaneous accuracy of a documentary photograph. As Alfred Werner remarked, Pascin's reportorial travel sketches have a "...definiteness of assertion that permits no correction. Like a camera, Pascin was always ready to snap what his eyes fell on, and he trained himself to transfer his vision to paper with the approximate speed of a camera lens."[40]

As noted previously, Hart and Pascin lived together for a brief period in New Orleans during 1917, sharing an apartment that was located in the Vieux Carré, the city's French Quarter. Although a friendship between the temperamental Pascin and the more affable Hart would not seem likely, the two artists, apparently, were quite close and, as Werner has pointed out, they shared several important interests, namely an "enjoyment of new ventures as well as...[a] passion for drawing."[41] In 1921, Hart executed a lithograph memorializing this period of his life with Pascin.[42] Entitled *Springtime, New Orleans*, this work depicts Pascin shaving in a dilapidated yet picturesque interior, a rooftop view of the Vieux Carré discernible through broken shutters (fig. 40). Hart rendered

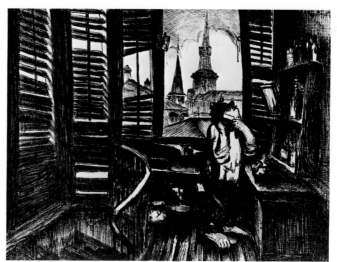

fig. 40 *SPRINGTIME, NEW ORLEANS*, 1925, lithograph, 11½ × 16"

the image of the painter in the expressionistic figural style that he had adopted in the 1920s, using the anatomical distortions of this vocabulary to caricature Pascin's heavy, swarthy features. Since the work was executed in an expressionistic mode that can be linked to Pascin's style, *Springtime, New Orleans* may have been intended, in part, as a humorous artistic tribute to the personal influence of Pascin's art.

While in New Orleans, Hart was primarily concerned with sketching architectural subjects and market scenes like *Courtyard, New Orleans* (fig. 41) and *New Orleans Market Woman* (fig. 42).[43] *Courtyard, New Orleans* is a representative example of Hart's architectural paintings from this period, similar in subject and style to his watercolor *Old Courtyard, New Orleans,* which was acquired by the Metropolitan Museum of Art in 1925. Executed in watercolor in subdued tones of gray and brown, this work—as well as his other New Orleans architectural scenes—was painted in a tighter, more controlled manner than the market views, several of which display an unprecedented degree of technical freedom for 1917. During the mid and late 1910s, Hart sought to develop a more fluid and expressive approach to watercolor, and many of the pieces that date from his stay in New Orleans, such as *Old French Market, New Orleans* (plate 2), were the products of a bold and direct manipulation of the medium. In his earlier watercolors, Hart generally sketched his scenes in pencil and then filled them in with washes of color; however, in *Old French Market, New Orleans,* he did not rely as heavily on preliminary pencil notations, instead describing forms through a more improvisational handling of paint. Much of this scene was painted with a loaded brush, and many of the elements, particularly those on the left, were executed in loose, diaphanous layers of pigment. Hart's growing interest in creating naturalistic, decorative patterns is also evident here, as he rendered the uniform rows and piles of fruit in quick, unmodulated daubs of color.

Hart utilized this abbreviated method of painting in some of his other New Orleans market subjects, such as *Curing Rabbits* (plate 3). This work demonstrates Hart's ability to suggest mass and space relationships in this more economical painting technique. The forms and surface details of the rabbits, for example, were not fully modeled, but only sketched

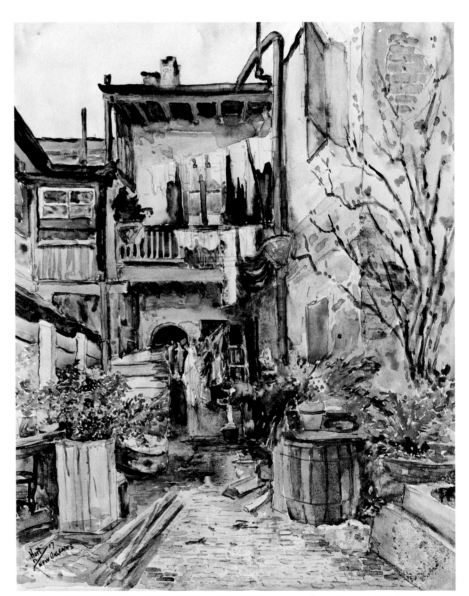

fig. 41 *COURTYARD, NEW ORLEANS,* 1917, watercolor, 19⅜ × 22½"

with flat markings of charcoal and watercolor; however, by placing them against the darker, solidly painted background plane of color, which represents the shadowy recesses of the market stall, the rabbits appear to project forward, creating a convincing sense of three-dimensional relief.

The expressive methods that Hart employed in his watercolors can be linked to the technical and stylistic revolution in American watercolor painting that had been initiated by such artists as Winslow Homer and John Singer Sargent. During the first half of the nineteenth century in America, watercolor was generally viewed as a minor art form, a sketching medium that was used chiefly for rendering colored drawings.[44] However, with the promulgation of the impressionist aesthetic in the last two decades of the 1800s, which placed a high premium on pure color and expedient execution, watercolor began to be used more frequently by professional painters, and even became a favored medium for some, including Whistler and Homer, who played key roles in elevating the stature of watercolor during the late nineteenth century.[45] Although progressive artists such as George Inness and Thomas Eakins sought to develop more bold watercolor techniques in the late 1800s, their works continued to exhibit the traditional, prevailing concern with controlled brushwork and technical finish. In contrast, Homer brought to watercolor a greater degree of technical freedom and painterly expressiveness, rendering his pieces—especially those produced after the early 1880s—in bold, incisive strokes, and using pure, transparent washes to enhance the inherent coloristic brilliance of the medium.[46] In addition to Homer, the impressionist painter John Singer Sargent was a major pioneering figure in watercolor during the late 1880s and early 1900s, who also sought to steer the American watercolor tradition from a tight handling and finish towards a freer, more painterly orientation; however, unlike Homer, Sargent did not rely as heavily on transparent washes to create luminous tones in his watercolors, but was noted more for his use of opaque body color, which allowed him to imitate the chalky effects of pastel.

Several writers have compared Hart's works to those of Homer and Sargent.[47] For example, in their survey *Art in America in Modern Times*, Alfred Barr, Jr. and Holger Cahill wrote that "George Overbury Hart

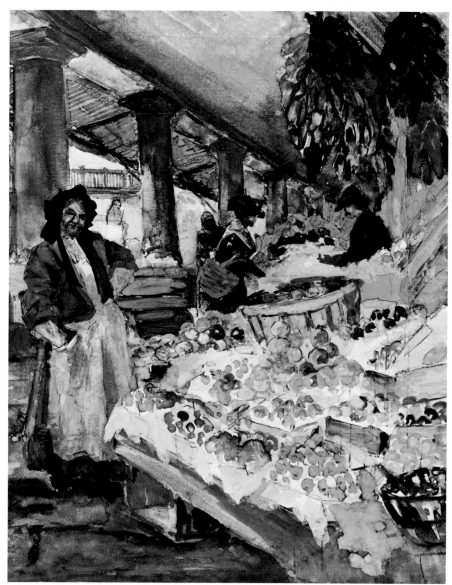

fig. 42 *NEW ORLEANS MARKET WOMAN*, c. 1917, gouache, charcoal, and watercolor, 14½ × 12½"

...in watercolors..., was a kind of contemporary Winslow Homer. He had something of Homer's broad realism and his sturdy American individualism."[48] Hart employed various watercolor techniques—pure, transparent washes and opaque, chalky layerings of pigment—that were strongly tied to the technical legacy of Homer's and Sargent's watercolors. His transition from a tighter handling of the medium in the early 1900s to a more expressive, painterly approach in the 1910s was almost certainly aided by their example.[49]

While Hart's paintings have been placed in the context of the watercolor tradition of Sargent and Homer, he, like other American watercolorists of his day, can be viewed more accurately as an heir to this tradition. His development in the medium reflects his efforts to expand upon the technical and stylistic premises that Homer and Sargent had established in their works. In discussing the watercolors of the latter two artists, writers have generally concentrated on their spontaneous application of the medium and their energetic, almost proto-gestural painting techniques. Hart used similar methods, but employed them with even more daring freedom. In many of his watercolors, especially those produced after 1910, Hart utilized a fairly radical technique of layering on paint in loose, watery strokes, allowing many of his color passages to drip and blend together in an accidental manner. Like Homer and Sargent, Hart devoted a large portion of his career to exploring the unique properties of watercolor, and several scholars have singled him out for his efforts to advance and enrich the technical potentialities of the medium.[50] During his own day, Hart was regarded as a leading figure in American watercolor painting. In an article written by the critic Margaret Breuning in 1926, "Contemporary American Water Color Painters," Hart was included with a group of American artists (e.g., Manhonri Young, Charles Burchfield) whose watercolors exemplified contemporary trends in the medium. According to Breuning, these artists, with their devotion to watercolor and their free, experimental use of the medium, were responsible for elevating it to a more prominent position on the American art scene.[51]

In the late 1910s, Hart executed a series of brook scenes (see fig. 43; plate 4) in watercolor that are reminiscent of some of the *plein air* watercolor sketches that Sargent produced earlier in the decade and of Homer's turn-of-the-century nature studies. During a trip in Europe in the early 1910s, Sargent executed a large number of impressionist watercolor studies of rocky streams. In keeping with his impressionist leanings, Sargent was primarily concerned with depicting the effect of sunlight playing across the surface of the streambeds, using bright stippled touches of paint to depict the sparkling highlights of cascading water and the shiny surfaces of rocks. In his earlier watercolors, such as the series of Adirondack views of 1889 and 1900, Homer, also, was interested in rendering natural light in the landscape, but he was less concerned with the optical effects of natural phenomena. Rather, Homer used watercolor to approximate the material and textural qualities of the landscape, seeking to create a tangible record of his direct contact with the physical realities of nature. Although Sargent and Homer used different methods, their landscapes are similar from the standpoint that the artists did not execute expansive vistas; instead, they painted more restricted and intimate views from a slightly raised perspective which eliminates the surrounding landscape, bringing the viewer into closer contact with the visual delights of nature. In his brook scenes, Hart used a similar formula of a focused, raised viewpoint. In fact, one watercolor, *Rippling Water* (plate 4), is a very detailed view of a small section of a streambed. Since intimate watercolor studies of nature, particularly close-up renderings of water—streams, narrow rivers—were closely associated with Homer's and Sargent's oeuvres, it is possible that Hart was inspired by their examples and used the sensual medium of watercolor to explore similar responses to nature. For, like Homer and Sargent, Hart exploited the bright color and expediency of watercolor painting to capture the luminous tones and fleeting effects of nature. In painting the streambed in *Rippling Water,* he used smooth, transparent washes to describe the hard surface of the rocks, covered with a thin, glistening film of water. Using an approach that is evocative of Homer's concerns, Hart modeled some of the rock forms in broad strokes of solid color, which gives them a fairly strong sense of density. The rushing water that surrounds the rocks was handled

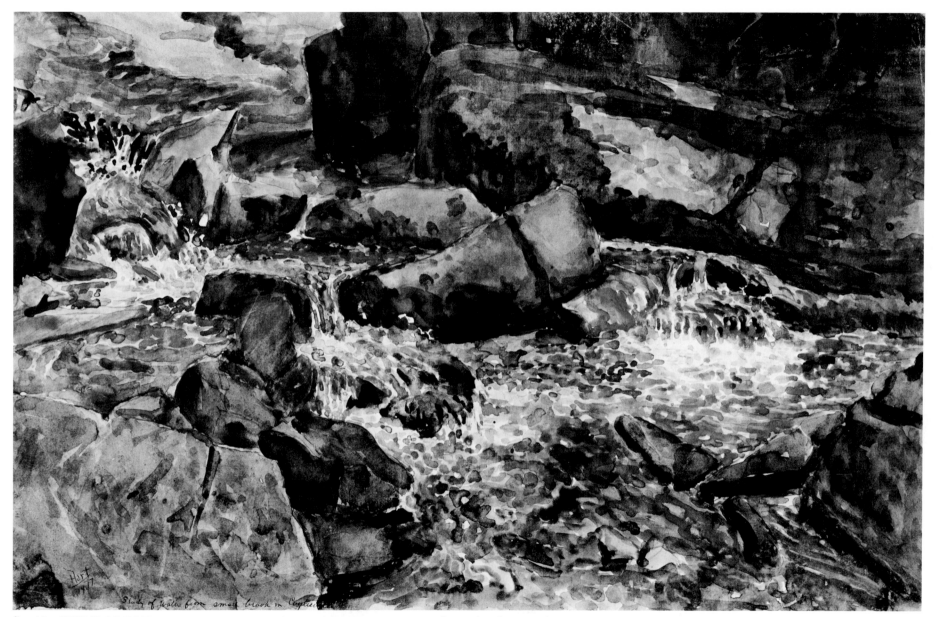

fig. 43 *STUDY OF WATER FROM SMALL BROOK IN COYTESVILLE,* 1918, charcoal and watercolor, 14⅛ × 22½″

in a more impressionistic manner, as the ripples and surface highlights were indicated through sparkling, gestural strokes of paint and exposed areas of paper. The rocks, with their solid, rounded forms and gray tones, were appropriate compositional and coloristic foils for the more brightly colored, fragmented details of the water. In some of his early watercolors (see figs. 7, 14, 15), Hart had used a method of free dripping and blending; however, in his paintings of the 1910s, this technique became more pronounced and appears to have been more consciously employed. It was used in *Rippling Water* to create a unique landscape statement. Although Hart used various impressionistic techniques in executing this work, he does not appear to have been interested in producing a static, impressionistic record of natural phenomena. Rather, the various passages of dripping, melting tones create an illusion of motion, suggesting that Hart was trying to convey through painterly means the constant flux of shifting light and color values in nature. In *Rippling Water,* Hart created a fairly complex composition in which the viewer's eye is led along a weaving, circuitous pattern of angled rocks and swirling currents of water. One reads the scene by starting at the upper left, following the serpentine outline of the rocks and the directional flow of water to the bottom right of the composition. Here, the water eddies in a circular fashion, drawing the viewer's attention to the middle right of the scene. One's eye is then led back to the upper left section of the painting by the strong diagonal lines of the rocks which connect to the undulating elements along the top edge of the composition. This circular scheme allowed Hart to symbolize through artistic design the cyclical flow of primary elements in nature.

In another landscape watercolor that dates from 1917, *Study of Water from Small Brook in Coytesville* (fig. 43), Hart painted a wider view of a rocky stream. The artist appears to have taken a keen delight in rendering the profusion of details in the landscape, as the scene is a veritable survey of light, color, and textural effects. In painting this view of a shaded forest stream, Hart juxtaposed rich, cool primary hues. The velvety gray tone of the rocks glows dully against the more vivid touches of emerald green and blue. Although the forms of the rocks have been modeled and rendered in a more naturalistic fashion, the shimmering reflections on the water's surface have been painted as intense, rounded fragments of color; in relation to the other more representational elements of the scene, the quasi-divisionist highlights stand out as abstract motifs that function as artistic signs expressing Hart's heightened visual response to the landscape. This reliance on a more subjective, abstract approach is indicative of Hart's turn towards various stylistic and conceptual ideas in the late 1910s which can be related to post-impressionist aesthetics.

Hart's move from an impressionist approach in the early 1900s to a more post-impressionist stance in the late 1910s was in keeping with the development of many other American painters in the first decades of the twentieth century. As William Gerdts has pointed out, more progressive post-impressionist modes were not inimical to Impressionism.[52] Indeed, certain formal characteristics of post-impressionist art such as the use of bright color and loose application of unmodeled tones had been based on the stylistic formulas of Impressionism. For many American painters, Impressionism had been a liberating influence from the traditional strictures of academic art, and their involvement with the aesthetic facilitated their experimentation with more radical vocabularies like Expressionism and Fauvism. Prendergast, Marsden Hartley, Arthur Dove, and Joseph Stella were inclined towards more avant-garde styles through Impressionism.

Although post-Impressionism emerged as a distinct tendency in the 1880s, American artists did not actually begin to experiment with its radical formal principles until the first decade of the twentieth century.[53] Like the original European founders of the movement—Cézanne, van Gogh, and Gauguin—American followers of post-Impressionism rejected the strict optical naturalism of impressionist art. Attempting to go beyond mere objective description of natural phenomena, Cézanne, van Gogh, and Gauguin developed various formal strategies for conveying their more subjective, interiorized responses to nature. Although Gauguin's works were studied and appreciated by American artists, Cézanne's and van Gogh's styles proved to be more seminal influences in the development of post-Impressionist trends in the United States. In absorbing Cézanne's pictorial lessons, American painters concentrated on his efforts to distort

the structural and spatial characteristics of a scene to create a more abstract, unified compositional arrangement. They also adopted his modified impressionist technique of rendering forms in small, flat planes of color—an approach that emphasized even more than impressionist art the intrinsic two-dimensional nature of the painted support. As Wanda Corn and John Wilmerding noted in their essay for the exhibition catalogue *Post-Impressionism: Cross Currents in European and American Painting 1880–1906*, the "...American painter...was...as fascinated as his European counterpart with the idea that a painting was *not* a window onto reality, but rather a flat surface covered with paint."[54] This distinction was an important one which made clear that the art object was an autonomous formal creation, giving American artists greater incentive to abstract from nature. Also important to the formation of a post-impressionist movement in the United States was the example of van Gogh's highly expressive brushstroke and Matisse's bold, fauvist liberation of color. Their use of brilliant, saturated hues and agitated brushstrokes had a liberating influence on many American artists, who adopted bolder palettes and a more expressive handling of paint. Although a number of American artists became strict adherents of Cézanne's, van Gogh's, and Matisse's styles, it is also important to stress that the impact of the work of these three led to the development of more general post-impressionist tendencies in American painting of the early 1900s. Many American painters began to restructure their scenes for expressive purposes, eliminating horizon lines and manipulating traditional perspective in order to flatten space. They also injected an element of abstraction into their scenes through the use of asymmetrical compositions and a more arbitrary placement of elements to create a sense of overall design and surface pattern.

Although one can detect specific sources for some of Hart's more experimental, modernist works of the 1910s—most notably the art of Maurice Prendergast—the majority of his pieces can be related to the more general post-impressionist characteristics noted above. In a large number of works, Hart combined his own personal impressionistic approach with various compositional and pictorial devices that were associated with post-impressionist art. Sheldon Cheney detected this quality in Hart's work, writing in his 1941 survey *The Story of Modern Art* that Hart "...carried over something of the vitality of the New York Realists..., while achieving a measure of Cézanne-like formal enrichment."[55] In many post-impressionist works, artists tended to manipulate space by using a raised viewpoint that eliminated the horizon line and tilted the ground plane upward; since normal depth cues are removed, the painted space often becomes flattened, transforming the pictorial elements into more two-dimensional, decorative forms. Hart used a similar approach in several of his works of the late 1910s, most notably in *Rippling Water* (plate 4). In this work, the streambed is viewed from a raised perspective, which results in a slight compression of the pictorial space and a flattening of forms, an effect that is partially modified by a few passages of three-dimensional modeling in some of the rock forms. Hart also painted many of the peripheral elements in flat tones and enhanced the sense of two-dimensionality in the work by rendering the water in thin, planar strips of color, and by inscribing some of the rocks with a heavy outline. Because of this treatment, a representational view like *Rippling Water* can be read on a more purely formal, abstract level as a series of boldly rendered shapes that are deployed across the surface of the paper in a rhythmic, interlocking composition.

This sense of surface pattern was more strongly emphasized in some of his other paintings of the late 1910s, such as *Main Street, Roseau* (plate 6) and *Study of Water from Small Brook in Coytesville*. In these two pieces, Hart overlaid certain sections of his representational depictions with solidly colored daubs of paint. While these elements serve a descriptive function in both works, they can also be perceived as decorative patterns of flat, rounded fragments of color. The bright mosaic of color that represents water in *Study of Water...* appears almost to have been inspired by the loosely stippled surfaces of late neo-impressionist painting.

Hart pushed certain works towards even greater abstraction by eliminating surface details and by exaggerating the shape or the outline of forms to create a decorative compositional arrangement. This approach

can be seen in the untitled West Indies market scene that was discussed earlier (see fig. 29). In this piece, the artist reduced figures and background architectural structures to brightly colored planar emblems. The contours of these flat areas of color were emphasized by a sharp black outline, a pictorial effect that is reminiscent of the cloisonnist paintings of Gauguin. This work also exhibits Hart's adoption of a more personalized painting technique in the late 1910s, in which he rendered flat, local areas of color in a free, painterly manner.

In addition to his use of modernist pictorial devices and a more forceful, autographic manner of painting during this period, Hart also developed a more advanced palette of intense hues. In the watercolor *Fort Lee Boat Docks,* 1921 (plate 8), most of the color scheme revolves around a limited number of vivid blues and greens. Yet, this cooler palette is offset by two trees in the lower center of the scene that were painted in bright tones of yellow and red, approaching a fauve boldness. While their vibrancy (and the intense blue of the water) was surely inspired by the highly saturated tints of expressionist and fauve canvases, they are not rendered in the arbitrary, non-descriptive color of Fauvism, but rather the red and yellow of autumnal foliage. In *Fort Lee Boat Docks,* Hart also employed a post-impressionist color principle that can be related to Cézanne's art, namely the juxtaposition of color to indicate spatial relationships. In this work, Hart utilized a raised viewpoint and broad areas of solid color, resulting in a slight flattening of the pictorial space. Yet, by placing the flat red and yellow forms of the trees against complementary hues of green and blue, a sense of spatial division is established through the advance of warm colors and the recession of cool tones.

Hart could have gleaned knowledge of post-impressionist ideas from a variety of sources. He was exposed to various modernist currents during his sojourn in Paris in 1907. Certain artists with whom he was closely associated during the 1910s, most notably Kuhn and Mager, were experimenting with post-impressionist idioms. Kuhn, for example, had created the post-impressionistic painting *Polo Game* in 1914, which Philip Rhys Adams has termed his first fully developed post-impressionist

work, just prior to Hart's experimentation with the style.[56] Adams noted that again in 1918 Kuhn was involved with the fauve aesthetic.[57] Hart would also have seen many examples of post-impressionistic art at the Armory Show in 1913, which he must have attended, given his close friendship with Kuhn at this time.

Hart's experimentation with post-Impressionism in the 1910s is a logical progression, since many of his impressionistic studies of the early 1900s reflect a predisposition towards subjectivism and personalized execution. Although he developed a more expressive pictorial language through post-Impressionism, his work, like that of most American artists, never reached the high level of abstraction of European post-impressionist art. Corn and Wilmerding have stated that:

> Like the European post-impressionists, the Americans composed and designed pictures with an eye to abstract design, though never were they willing totally to sacrifice three-dimensional structure and form for flat surfaces of shapes and colors. Perhaps the long standing tradition of realism in this country prevented their decomposing or flattening the pictorial structure to the same degree as the French.[58]

In many works, Hart combined a more representational approach, retaining a sense of space and three-dimensional form, with certain characteristics of post-impressionist art, including pictorial distortion, vitalized execution, and vivid color. He seems to have used these devices to convey to the viewer his heightened visual response and creative excitement in observing and recording a scene. Unlike several of the European post-impressionists, such as van Gogh or Gauguin, who often used abstraction to signify transcendent experience and/or a highly introspective psychological state, Hart's less radical approach stresses that his intensified visions were firmly grounded in the concrete structures and actualities of immediate perceptual experience. He was never interested in devoting his art purely to the manipulation of form; some aspect of his daily experience was always the primary issue in his work, even in the

most abstract compositions. Like many of the Americans who experimented with European modernism during the first decades of the twentieth century, Hart appropriated aspects of post-impressionist art and adapted them to his own concerns, which placed a more traditional emphasis on recognizable form and narrative content. In his book *American Painting in the Twentieth Century*, Henry Geldzahler made reference to this trend of synthesizing representational values with abstraction in American art of the teens, twenties, and thirties, and his discussion is particularly apt with regard to Hart's work:

> By this time [the period between the wars] ... there was a less self-conscious attitude toward the modern art of Europe. It was no longer necesary either to reject it totally or to accept it totally. The growing case of its acceptance led to the use of certain of its aspects to reinforce the characteristic American strain of realism and observation. The confrontation with the new was absorbed and greater familiarity with the very art that had once been shocking made it possible to reassert older values in fresh and new color, light and structure. With their insistence on technique, their proficiency, and their familiarity with possibilities of the advanced art of their time, a number of figurative painters of the twenties and thirties created sound and sober works.... These painters kept open the legitimacy of certain conservative approaches in a period when experimentation for its own sake was a distinct danger.... These painters made it clear that it was possible to be eclectic in the choice of modern influences and still maintain both personality and style.[59]

Although much of Hart's more experimental, modernist work of the late 1910s is marked by his efforts to reconcile abstraction with realism, he did produce several pieces during this period in which he utilized a more radical, anti-naturalistic approach. An untitled view of figures in a landscape (fig. 44) and a 1918 watercolor, titled *Market Woman, Santo*

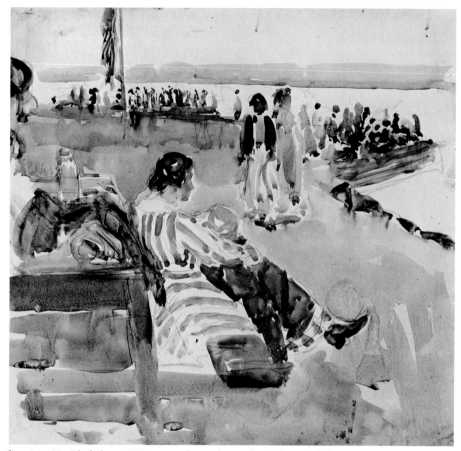

fig. 44 Untitled, late 1910s, gouache and pencil, 14¾ × 13¾″

Domingo (fig. 45), are not only some of Hart's more abstract efforts of the 1910s, but they also reveal his awareness of the work of Maurice Prendergast.

Many art historians have considered Prendergast to be the first true American modernist.[60] He was one of the earliest artists in the United States to fully absorb post-impressionist methods, particularly the divisionist painting techniques employed by the French painter Paul Signac.

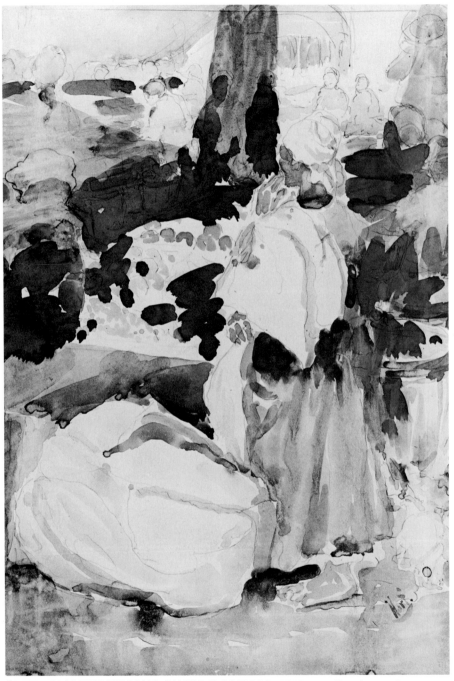

fig. 45 *MARKET WOMAN, SANTO DOMINGO,* 1918, pencil and gouache, 14⅝ × 10″

Prendergast was also influenced by the cloisonnism of Gauguin and his followers; by Cézanne's structural formulas; and by the bright hues of Fauvism. He combined these influences to create a highly personal, decorative vocabulary. In his earlier modern works of the 1890s, Prendergast relied on impressionist light and color and a more naturalistic treatment of space and form. But the surfaces of these paintings were inflected with soft, broken touches of color, an approach that was similar to the one that Hart used in such works as *Main Street, Roseau* (plate 6). In his later works of the 1910s, Prendergast's art followed a more avant-garde, anti-realist course; he began to eliminate horizon lines in order to flatten his compositions, and he transformed figures and landscape elements into rounded, flat units of color. As a result, forms in his paintings literally become fused into an overall mosaic of rhythmic patterns and jewel-like fragments of color.

Hart's untitled watercolor that shows figures picnicking and walking along a waterfront (possibly the Palisades), reveals his debt to Prendergast. Hart used a very high horizon line and tilted the ground plane upward, obscuring any sense of spatial recession. The strong planar effect is strengthened by the lack of atmospheric diminution in the scene, as the foreground and background elements were painted in similar tones. The angled shoreline provides the only significant hint of spatial recession; while it appears to retreat sharply into the painted space, it can also be read simply as a flat line that divides the composition into two planar areas that rest firmly on the picture surface. Likewise, the seated female figure in the foreground is not modeled to convey a sense of plasticity, but is briefly denoted through a pencil outline and flat shapes of color. In depicting the crowds of people in the background, Hart relied on Prendergast's trademark method of transforming figures into ideographic swirls of paint. The majority of Prendergast's works were scenes of crowds at leisure, relaxing in parks or strolling along waterfronts and beaches. Hart's subject of promenading and picnicking figures was, therefore, closely associated with Prendergast's, and his use of delicate, light washes and a casual method of painting allowed him to duplicate the pleasant, holiday atmosphere of Prendergast's scenes. Yet Hart's abstracted forms

are not as highly reductive as those of Prendergast. For example, although the figure of the seated woman has been simplified, her form is still fairly representational, and the stripes on her garment are curved slightly to suggest that the cloth covers a corporeal structure—a concession to realism that Prendergast eschewed.

In *Market Woman, Santo Domingo,* Hart utilized similar painting methods, but applied them to one of his own travel subjects. As in the previous example, Hart accentuated the picture plane by painting the elements of the scene in flat, silhouetted shapes. He also rendered the forms of produce in vigorous splotches of paint that are so highly abstract that they almost lose their representational function, standing out as independent decorative motifs. Prendergast had several followers in North America including Alice Schille, David Milne, and Edward Middleton Manigault.[61] Hart's emphasis on surface pattern, the bold flattening of forms, and negation of three-dimensional space in the two works just discussed place him among the artists commonly recognized as being responsive to Prendergast's solutions.[62]

Hart could have gained a fairly direct knowledge of Prendergast's art from several sources. For example, it is quite possible that he was familiar with Prendergast's work through Walt Kuhn, who was well acquainted with Prendergast, having visited him in his home in Boston in 1912 to acquire works for the Armory Show. Kuhn, in fact, began to employ a decorative post-impressionist style in 1914 that was partly influenced by Prendergast.[63] Later, in 1915, the Montross Gallery sponsored an exhibition of mural decorations by Kuhn, Davies, and Prendergast, and the three artists completed their projects in Kuhn's studio in Fort Lee, where Hart surely saw them.[64] Furthermore, Hart participated in several exhibitions in which Prendergast's work was also included, such as a 1914 Daniel Gallery show and several exhibitions in the late 1910s which were sponsored by the Society of Independent Artists, an organization of which both artists were members.[65]

In addition to his experimentation with various post-impressionist methods in the late 1910s, Hart made a brief, and sometimes caricatural, foray into geometric abstraction, exemplified by the three works re-

produced here. The location of two of these pieces is unknown. One, depicting a group of figures in a bowling alley, is undoubtedly the oil painting *Bowling Alley* (fig. 46) of c. 1915 that was part of the collection of John Quinn.[66] The other, also apparently an oil painting, shows figures

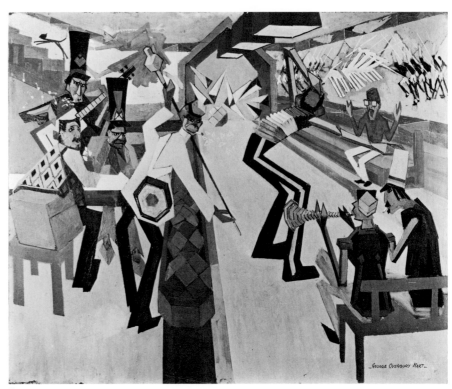

fig. 46 *BOWLING ALLEY,* c. 1915, location unknown

capering on ice and is most probably the cubist scene *Ice Cutting on the Hudson* (fig. 47) to which Frederick James Gregg referred in a 1918 article.[67] These are satirical renditions of cubist styling. The angular vocabulary that Hart employed is also reminiscent of the highly simplified, geometric style that many humorous illustrators used, in 1913, to characterize and lampoon cubist and futurist works in the Armory Show. With *Ice Cutting on the Hudson,* Hart was obviously poking fun at what

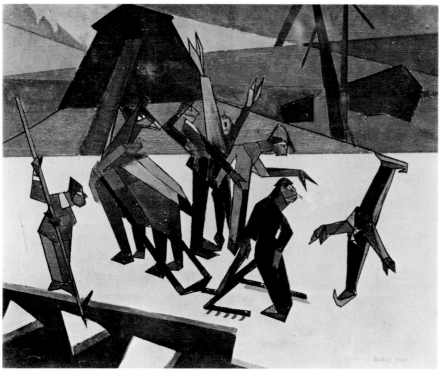

fig. 47 *ICE CUTTING ON THE HUDSON*, c. late 1910s, location unknown

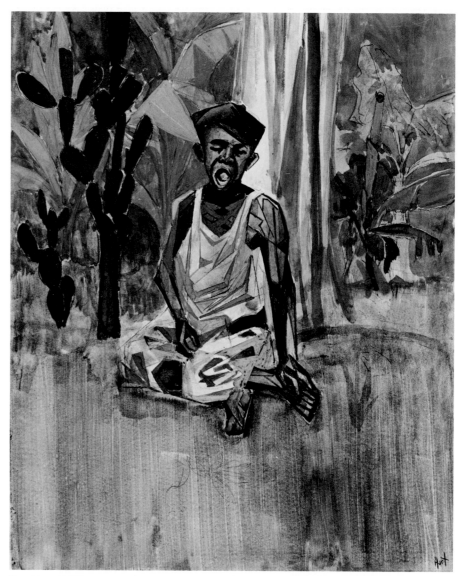

fig. 48 *CRYING BOY*, late 1910s, watercolor, 14¼ × 11¼″

he felt to be the formal pretentions of Cubism, since one of the major features of the idiom's stylistic program, the use of transparent, faceted forms, is an intrinsic part of the subject of this work—cut ice. Another work from the 1910s, however, titled *Crying Boy* (fig. 48) is a more serious attempt at geometric abstraction, both in terms of formal application and content. In this piece, Hart painted the small, wailing figure of a native boy sitting alone in a jungle setting. Both the background details of the landscape and the face of the boy have been handled in a representational style, but his body and clothing were rendered in an angular manner and overlaid with a pattern of faceted elements. This approach is almost identical to the one that Arthur B. Davies used in several of his cubist inspired pieces, such as *Dancers* of 1913, in which he literally grafted onto fairly representational figural forms a decorative overlay of brightly colored cubist faceting. Like Davies' work, *Crying Boy* was not an attempt at the analytical dissection and reintegration of forms that was characteristic of French Cubism. Yet, Hart's use of a cubist vernacular can

56

be related to a particular tendency in American modernism. While several American artists like Max Weber and Alfred Maurer comprehended the theoretical premises of Cubism and attempted to apply them in a manner emulous of Picasso or Braque, other artists who worked in more representational styles simply appropriated aspects of Cubism in order to strengthen their designs or to articulate more fully the emotional content of their images.[68] One of the more noted examples of this practice is the series of realistic clown portraits that Walt Kuhn executed in the 1920s. In these works, Kuhn used the spatial compression of cubist art to flatten out the clowns' bodies, pulling their faces to the fore of the picture plane in order to place full pictorial emphasis on the expression of the figures. In taking this approach, Kuhn was able to utilize the spatial principles associated with Cubism to intensify the emotional thrust of his representational depictions.[69] In *Crying Boy,* Hart used an aspect of cubist art for a similar purpose, as the sharp facets of the boy's body create a visual tension that reinforces the sense of emotional dissonance in the scene.

While much of Hart's work of the 1910s was related to several major stylistic movements, his subject matter can also be connected to various thematic currents in early twentieth-century American art. One of these is the tradition of the artist-traveler represented by Rockwell Kent, Boardman Robinson, and George Biddle, each of whom focused on exotic foreign subjects; Hart's New Orleans works also have been related to a collective interest in Southern genre scenes, a theme that appealed to such artists as Ann Goldthwaite and Jules Pascin.[70] Further, because of his portrayal of life in various regions of the United States during the 1910s and the 1920s, Hart has been linked to the American Scene movement.

In discussing the progressive nature of Hart's work, it is also important to consider his choice of subjects, since artistic radicalism in the 1910s was not restricted solely to formal innovation. As Joshua Taylor remarked in his study, *Fine Arts in America,* "…in the years before and after World War I, modernity in the United States was not characterized in any way. Abstractness was no more modern than was a candid look at contemporary life."[71] Taylor was referring to a thematic revolution in American art that had been initiated in the early 1900s by the artists who were associated with the New York Realist movement. During this period, American art was dominated by the traditional tastes of the art academies including the National Academy of Design and the Pennsylvania Academy of the Fine Arts. The New York Realists renounced the genteel subject matter favored by the art academies—allegory, mythological themes, idealized history painting, and polite genre—in an attempt to develop an art that they felt was more reflective of contemporary American experience. Many of the Realists focused on scenes of common street life, which critics and academic painters generally felt to be vulgar, unsuitable subject matter for art. With his strong interest in picaresque regionalist subjects and exotic themes, Hart also has been regarded as a figure who was instrumental in challenging the strictures of contemporary academicism.[72]

Like many of the figures associated with the New York Realist movement, Hart maintained strong non-academic views, which he had developed during his student days at the School of the Art Institute of Chicago and the Académie Julian. This stance was reflected in his membership in the Society of Independent Artists.[73] In the early 1900s, artists who were experimenting with new formal developments, or novel, unfashionable subject matter, often had difficulty showing their work, particularly in the exhibitions sponsored by the art academies. In an attempt to combat the conservative forces of the academies and to provide themselves and other artists with more opportunities to show their work, a number of progressive artists banded together to form their own independent exhibitions. One of the first of these protest shows was the 1908 exhibition at the Macbeth Gallery that brought about the formation of The Eight, a group of non-academic artists that included Robert Henri, William Glackens, Everett Shinn, George Luks, John Sloan, Maurice Prendergast, Ernest Lawson, and Arthur B. Davies. Similar efforts were organized in 1910 with the "Exhibition of Independent Artists" and, in 1913, with the Armory Show. While these exhibitions were instrumental in eroding conservative artistic values in the United States, the Society of Independent Artists was formed in 1916 in order to provide a more continuous forum for the display of advanced art, and the group held

annual exhibitions from 1917 until its dissolution in 1944. Hart participated in almost every one of these exhibitions from 1917 until 1929.[74] Much of the art in the SIA annuals did not reflect a single aesthetic doctrine; rather, the homogeneity of academic art was challenged by shows that displayed a pluralistic range of subjects and styles.

One of the most important currents, in conjunction with which Hart's themes have been discussed, is the New York Realist movement. The painter Robert Henri was the central figure of the movement and he also headed The Eight. Henri met many of the artists who later made up The Eight while teaching at the Pennsylvania Academy in Philadelphia in the 1890s and later, in 1904, he opened his own school in New York City, where he steered such artists as George Bellows and Glenn O. Coleman towards a realist orientation. Through his teaching and writing (Henri's artistic principles were codified in his 1923 book *The Art Spirit*), Henri exhorted his pupils and other artists to leave the confines of their studios and seek out their subjects in daily life. Many responded by studying and recording the activities of the working class, and some of the Realists like Shinn, Luks, and Sloan gained a certain amount of notoriety for their then radical depictions of slum life in New York. Although Henri's style—and that of several other New York Realists—was based on impressionistic painting techniques and the tonal color schemes of Hals and Velazquez, he did not promote a particular style of painting. Yet, he was opposed to many of the recent modernist developments and the philosophy of art for art's sake. Rather than stress a particular stylistic program, Henri encouraged his students to develop a more intuitive approach to art making, letting the style of their works emerge naturally from their individual reactions to a subject.[75] Henri was not overly concerned with formal values in art, his primary dictum being that artists should learn to convey with the most telling force their emotional response to life, noting in *The Art Spirit* that "…It isn't the subject that counts but what you feel about it."[76] For Henri, the artist's creative impulse was triggered by his personal response to a subject, which should be captured in a rapid, spontaneous technique that would strike the viewer as a direct apprehension of real life.[77]

A number of writers, including John I. H. Baur, E.P. Richardson, Alfred H. Barr, Theodore Stebbins, Peyton Boswell, and William Gerdts have linked Hart's works to the New York Realist movement, both in terms of subject matter and technique.[78] Under Henri's guidance, various members of The Eight such as Sloan, Luks, and Shinn had rejected the naturalistic hues and high-keyed palette of Impressionism, adopting instead the dark tonalities found in the work of Rembrandt, Hals, Velazquez, and early Manet. During the 1920s, Hart began to combine watercolor with a large amount of charcoal, creating darker tonal mixtures that Baur, Richardson, and Stebbins have related to the somber palette favored by the members of the New York Realist circle.

There are strong parallels between Hart's thematic concerns and artistic methods and those of the New York Realists. For example, although Hart's work of the 1910s reflects his increased awareness of and interest in avant-garde stylistic tendencies, narrative content and realist concerns usually took precedence over formal values. Like the New York Realists, Hart was also concerned with focusing on daily experience as the primary subject matter for his art. As one writer reported on Hart, "He would, he declared, find the seclusion of and the security of a studio intolerable. He did not believe that his art could have developed except through rapidly changing experience and vigorous, even violent encounters."[79] Several of The Eight, namely Luks, Shinn, and Glackens, had been trained as journalistic illustrators, and with the additional influence of Henri's theories of spontaneous execution, they developed an energetic, notational style of drawing and painting that allowed them to capture fleeting action. Similarly, Hart developed a rapid, reportorial style in which he transcribed the momentary events that he encountered during his travels. Like Henri and several other of the New York Realists, Hart attempted to convey with a sense of artistic immediacy his emotional response to a particular situation or human subject. Hart's attitudes toward style and technique were analogous to those of Henri, as he was less concerned with pictorial effects than with using a particular stylistic approach that was best suited to conveying the essence of a subject and his reaction to it. In the catalogue for the 1935 Newark Museum exhibition

of his work, Harry Wickey observed that "…this artist transcends his medium and presents us with realities that are in no way derivative either in vision or technique…. Obvious aesthetic approaches are not to be found here, but life presenting itself through the sensitive medium of Hart."[80]

Although many of the Realists sought to produce works that reflected their direct contact with daily life, a few of their pieces appear to be somewhat contrived, almost as if they had been staged to give the effect of candid observation. Indeed, their scenes of urban life were generally studio productions that were based on sketches or written observations. For example, in his series of prints, titled *City Life,* of 1905–06, John Sloan created intimate vignettes of working class life in which it is clear that he was not a participant in the scene. In fact, in one work from this series, *Turning Out the Light,* an intimate view that depicts a couple preparing for bed, Sloan even assumes the identity of an omniscient visual narrator. Sam Hunter has noted of Sloan that he "…viewed and recorded foibles with a certain amused detachment. He scarcely mingled with the common people or identified with their despair…."[81] Hart, on the other hand, was committed to the act of drawing and painting his scenes on the spot and he was usually immersed in the environment of his subjects. In several of his works, he created a sense of immediacy and observed realism that almost surpasses that of The Eight. For example, in one untitled drawing that depicts a back view of people in an outdoor theater (fig. 49), Hart shows a young woman who has turned around and caught him in the act of sketching. By using this device, the artist confirms his presence in the reality he has depicted.

While a number of scholars have related Hart to The Eight, none have noted that he knew several other artists who were associated with the New York Realists. For example, Hart was a friend of the urban realist Jerome Myers, who was also involved with The Eight. In fact, Myers was so closely affiliated with these artists (he was a friend of Henri's) and his works were so similar to theirs that several writers have speculated as to why he was not included in the 1908 Macbeth Gallery show that launched The Eight.[82] In his autobiography *Artist in Manhattan,* Myers wrote a

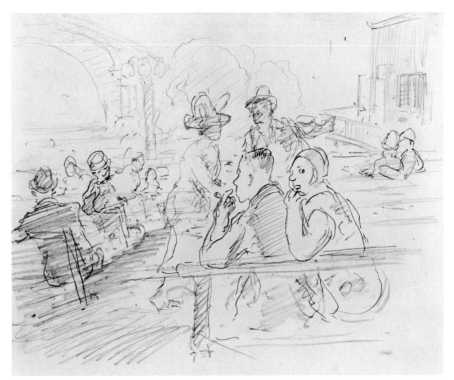

fig. 49 Untitled, c. 1920–1933, pencil, 8 × 10″

short account of his friendship with Hart.[83] In addition, Walt Kuhn and Rudolph Dirks were both friends of John Sloan, and Gus Mager was acquainted with Henri, Sloan, George Bellows, Ernest Lawson, and William Glackens.[84] Thus, Hart could have become familiar with the ideology and the work of the New York Realists through any combination of such figures. Also, the Whitney Studio Club, an organization with which Hart was affiliated, exhibited the work of The Eight in the early twenties, exposing a younger generation of artists to the realist concerns of this group.

It is quite possible that Hart's work of the 1910s (and even his vernacular themes of the 1920s) was influenced by the art of some of the New York Realists. In several of his pieces that appear to date from the

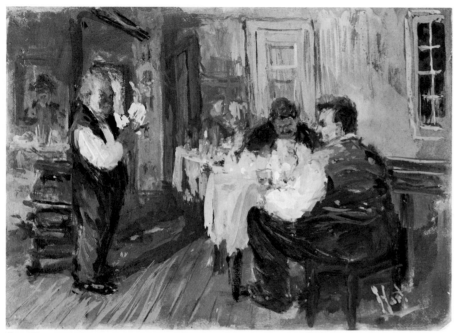

fig. 50 *THREE MEN IN DINING ROOM*, c. 1910–1920, gouache, 13½ × 19¾"

executed in the United States during the 1910s and the early 1920s recall similar depictions by his friend Jerome Myers.

Although Hart was undoubtedly aware of the artistic achievements of the New York Realists, his exposure to their work would not have dramatically altered the direction of his art, for many of the thematic and stylistic concerns of the New York Realists were quite close to Hart's own personal artistic interests. He had long been devoted to a realist subject matter that was based on his daily experience; this is evident beginning with his early childhood experiments in sketching and his extemporaneous studies of native life in the South Seas. While he had received formal training in art, Hart never became drawn to the slavish, highly finished methods of academic art, developing instead a more incisive, notational style which paralleled that of the New York Realists. The importance of the New York Realist tendency to Hart's work is that it probably reinforced his own natural artistic inclinations; he, undoubtedly, looked upon the movement's aims as being sympathetic with his own, and its success might have encouraged him to remain true to his realist convictions. If Hart had been aware of and responsive to Henri's ideas, they might have provided him with a more disciplined framework for developing some of his own concerns that were analogous to those of Henri. The art of certain New York Realists could have exposed Hart to a broader range of subject matter, but even these themes followed his general course of interest. In relating Hart to the New York Realist movement, it is perhaps best to consider him a figure like Eugene Higgins, Glenn O. Coleman, Jerome Myers, or George Bellows, each of whom extended the tradition of the Ashcan School into the 1910s and 1920s. By 1910, The Eight was no longer a collective force and many of its members had drifted to other artistic pursuits. Yet, their realist revolt had developed into a more general tendency that had attracted a number of adherents. The devotion of such artists as Hart, Bellows, Higgins, and Coleman to the figural and narrative interests of the New York Realists was instrumental in bringing about a revival of these concerns in the 1930s.

early 1910s, including his gouache study *Three Men in Dining Room* (fig. 50), Hart used a simplified figural style and a sketchy manner of painting that is highly reminiscent of George Luks' work. Hart also focused on various subjects that were prominent in the art of several of the New York Realists. For example, his views of figures in a beach setting, such as *Bathers, Sunday Afternoon* (fig. 51), is a subject often portrayed by William Glackens, and later a favorite theme of the realist artist Reginald Marsh. Hart's 1917 watercolor *Fort Lee Dock* (plate 5), which depicts children playing and swimming around a dock, combines the sparkling color and broken brushstrokes of Prendergast with a subject that is closely associated with George Bellows' oeuvre. The more modernist approach that Hart used in the last two works is similar to Sloan's efforts in the 1910s to synthesize aspects of advanced art with the realist subject matter of The Eight. Further, many of the street and park scenes that Hart

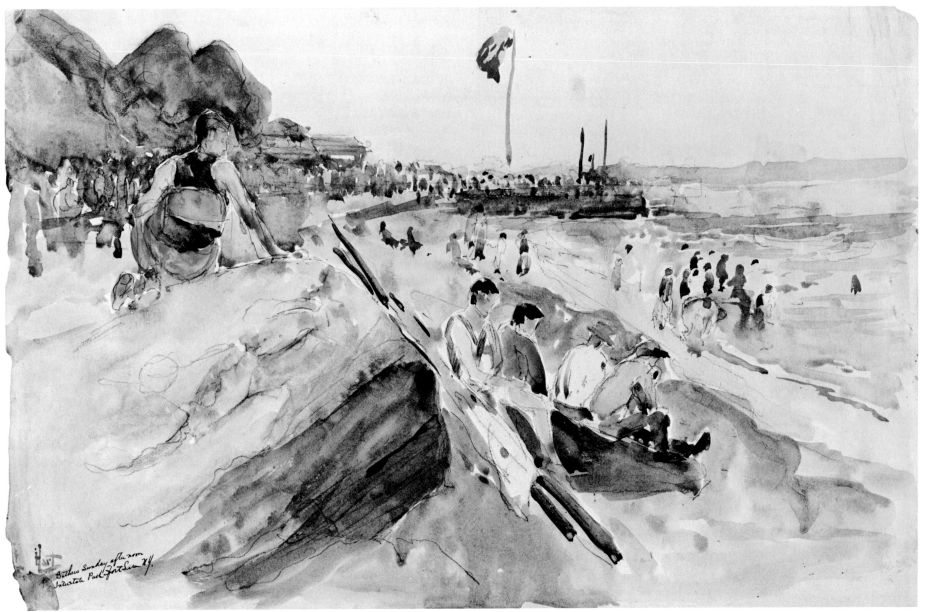

fig. 51 *BATHERS, SUNDAY AFTERNOON,* late 1910s, watercolor and pencil, 14⅝ × 23¼″

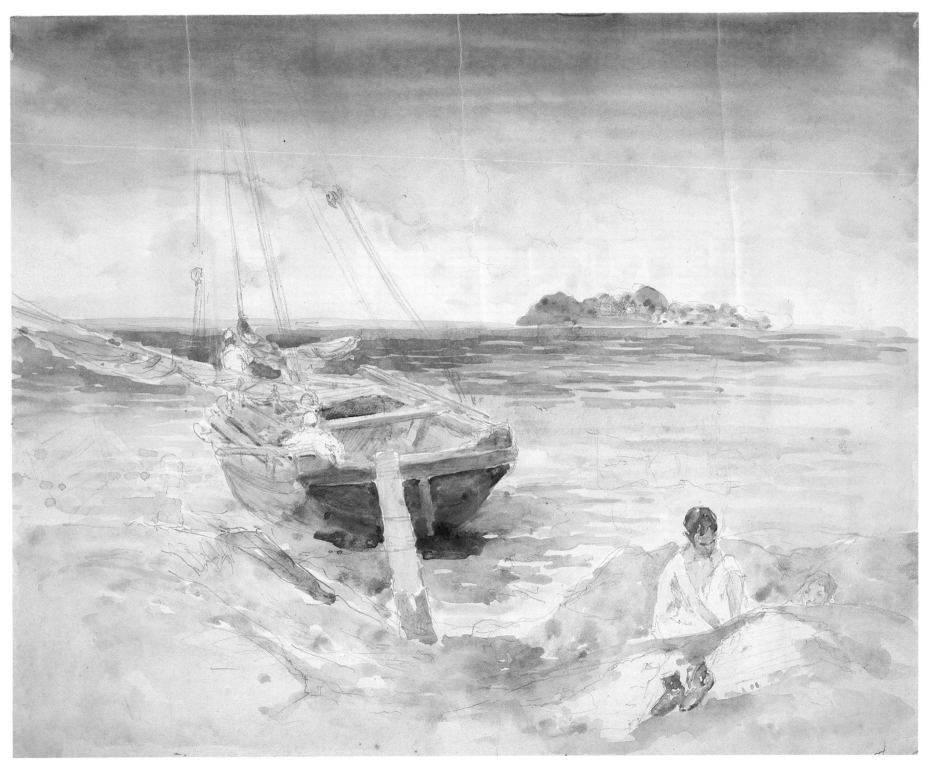

plate 1 Untitled, c.1903–1904, pencil and watercolor, 11¼ x 14¼"

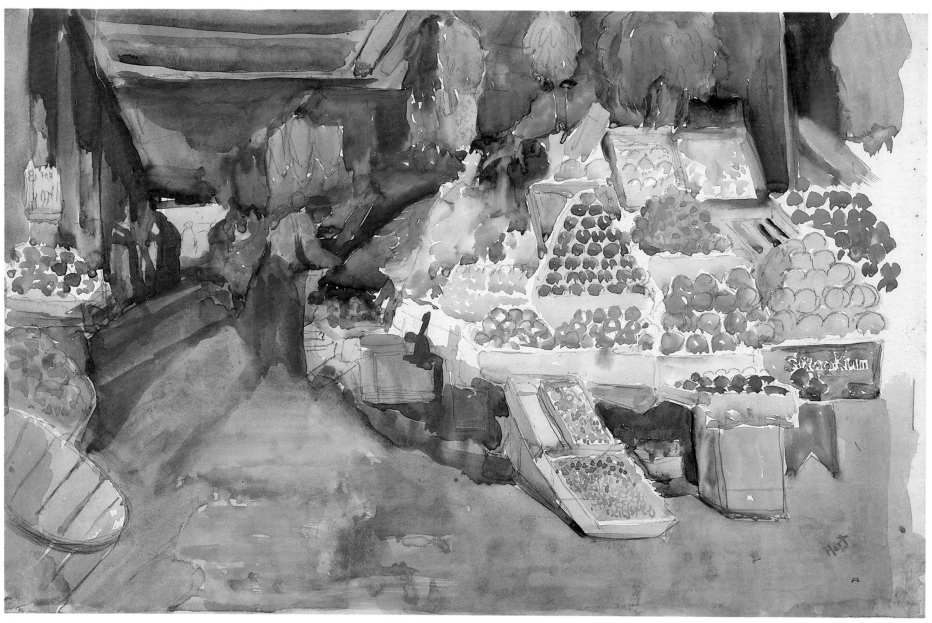

plate 2 OLD FRENCH MARKET, NEW ORLEANS, *c.1917, watercolor and pencil,*
14⅝ x 23¼"

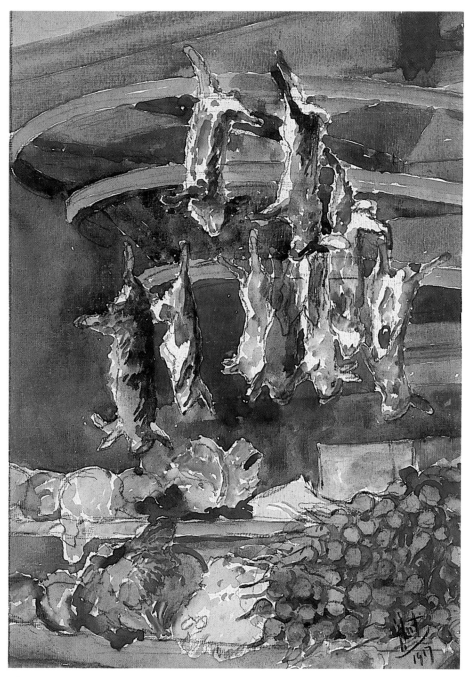

plate 3 CURING RABBITS, *1917, charcoal and gouache, 11⅝ x 8″*

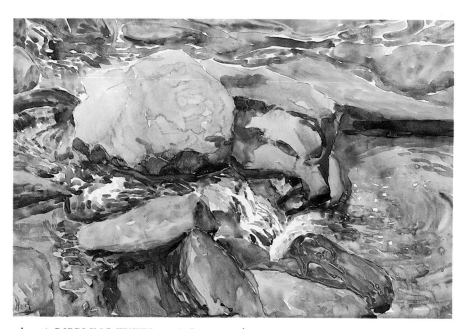

plate 4 RIPPLING WATER, *c.1917, watercolor, 14¼ x 22½″*

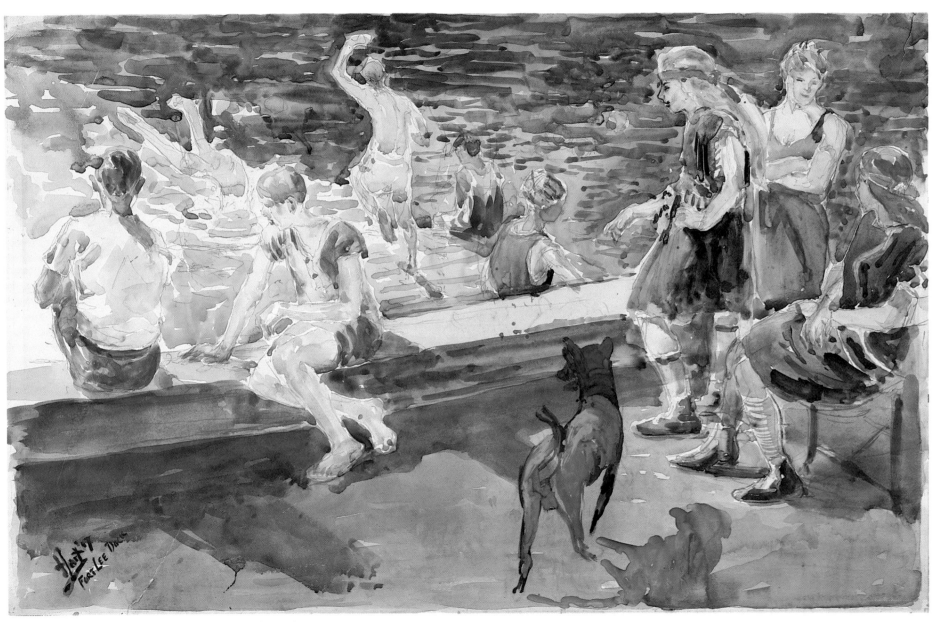

plate 5 FORT LEE DOCK, *1917, watercolor and pencil, 14⅝ x 23¼"*

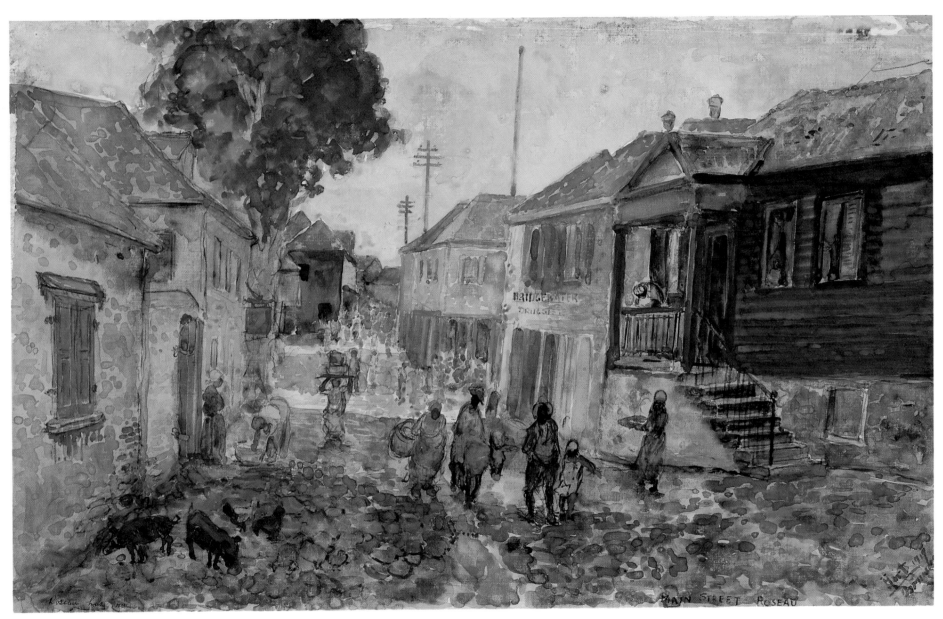

plate 6 MAIN STREET, ROSEAU, 1919, pencil and gouache, 12³⁄₈ x 20¹⁄₄"

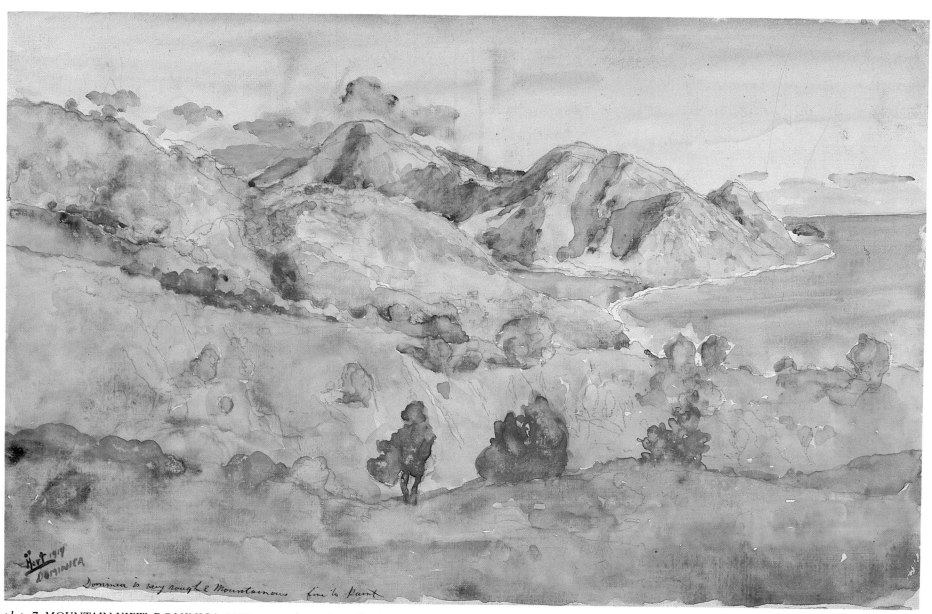

Dominica is very rough & Mountainous fine to paint

plate 7 MOUNTAIN VIEW, DOMINICA, *1919, watercolor and pencil,* 12½ x 20¼"

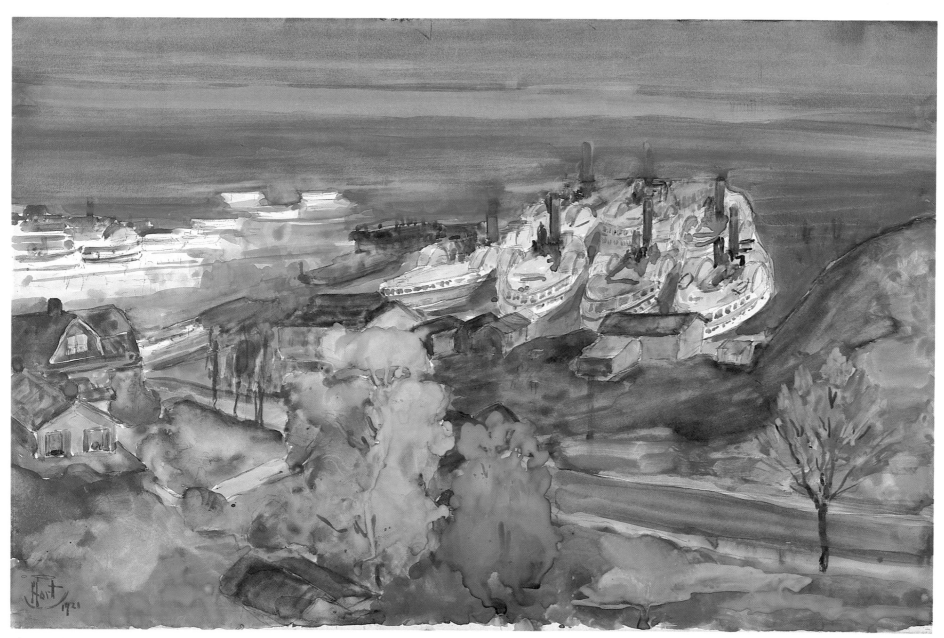

plate 8 *FORT LEE BOAT DOCKS, 1921, charcoal, gouache, and watercolor, 14⅜ x 22¾"*

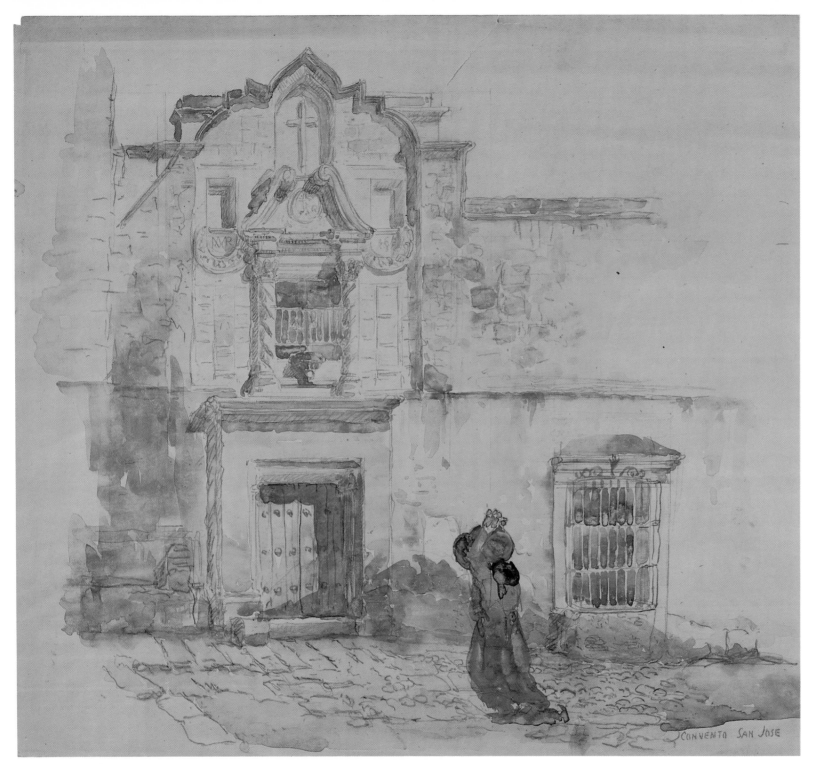

plate 9 CONVENTO SAN JOSE, c.1920s, pencil and watercolor, 18½ x 20¼"

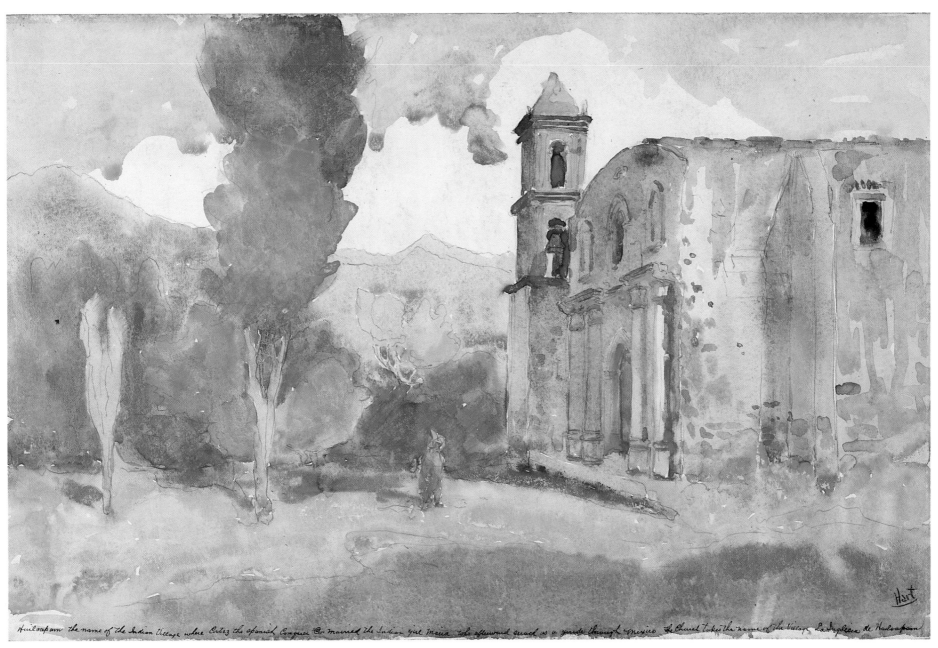

Huiloapam the name of the Indian Village where Cortez the Spanish Conqueror married the Indian girl Maria who afterward served as a guide through Mexico. The Church takes the name of the Village La Iglesia de Huiloapam

plate 10 LA IGLESIA DE HUILOPAN, *c.1920s, gouache, watercolor, pencil, 13⅛ x 20⅜″.*

plate 11 TAHITI WASHWOMEN, *1925, color etching and sandpaper, 9½ x 13½"*

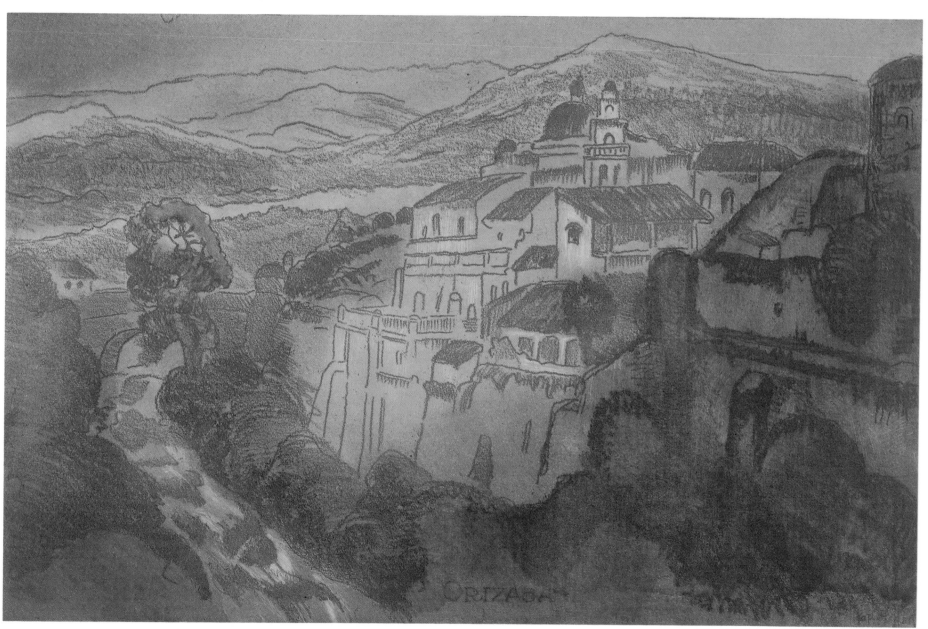

plate 12 ORIZABA, MEXICO, 1925, softground in color, 10⅝ x 15¼"

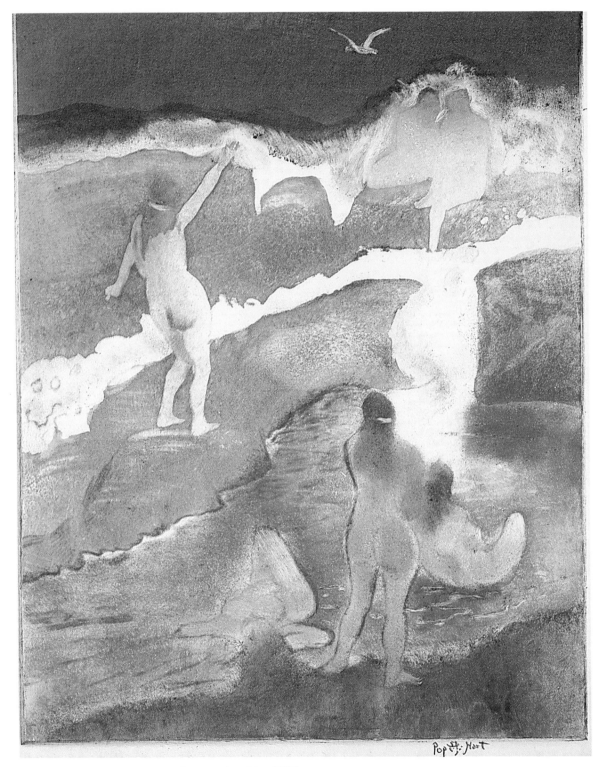

plate 13 SEA WAVES, 1926, color aquatint, 14 x 10½"

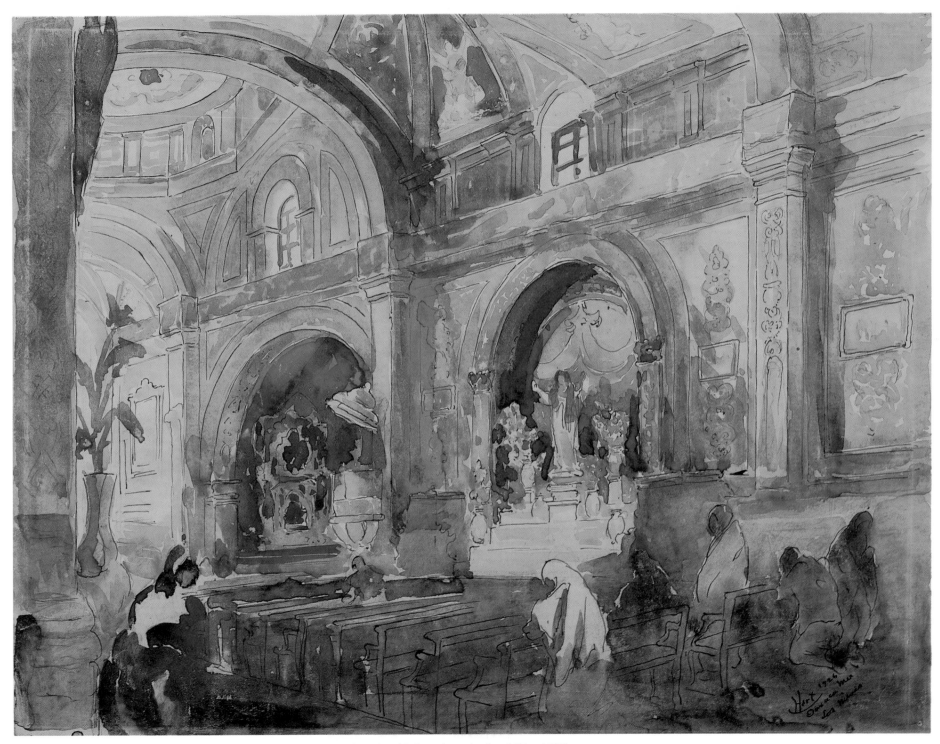

plate 14 MERCED CATHEDRAL, OAXACA, MEX., 1926, *pencil, pen and ink, and watercolor,* 14⅛ x 18⅜"

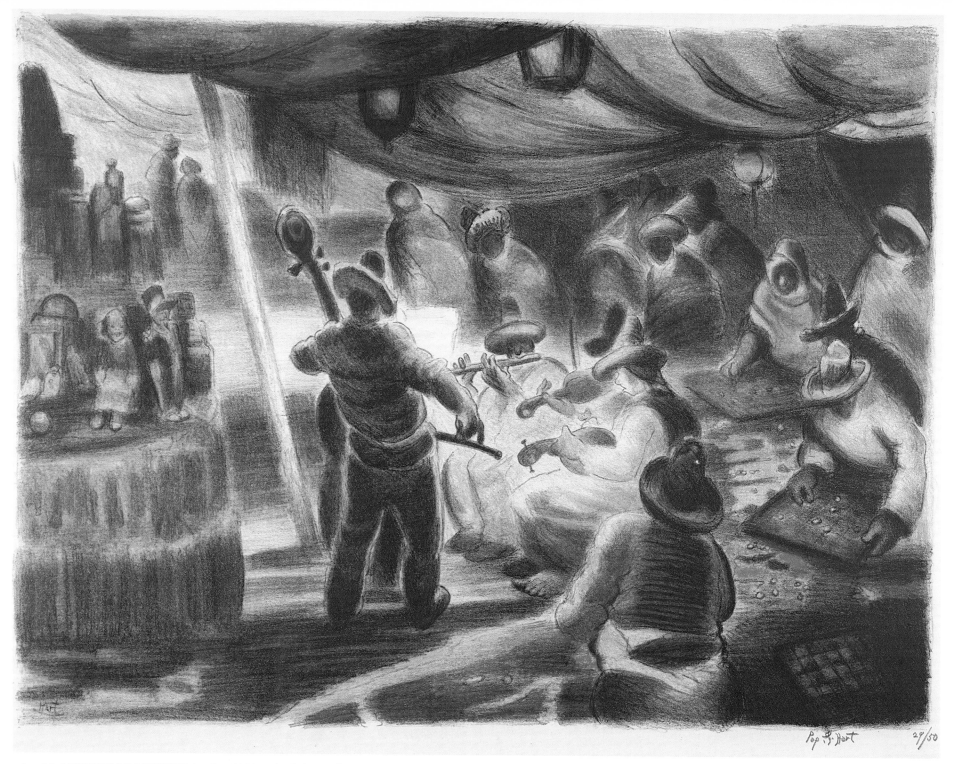

plate 15 MEXICAN ORCHESTRA, *after 1928, color lithograph, 22 x 28¾"*

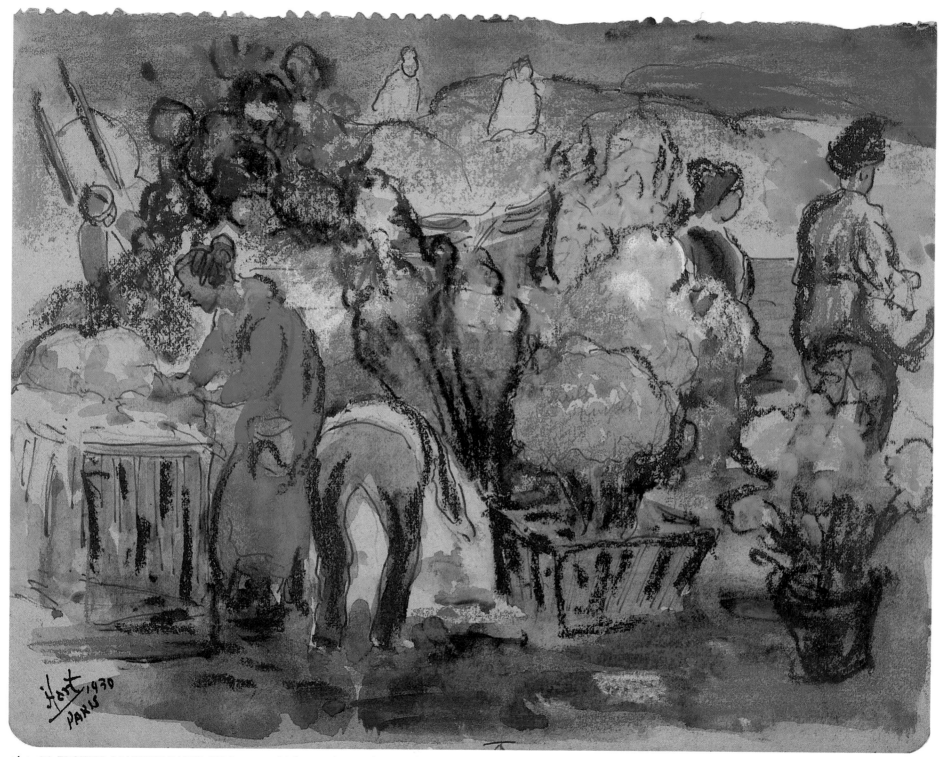

plate 16 FLOWER MARKET, PARIS, 1930, pen and ink, pencil, gouache, pastel, 8½ x 11″

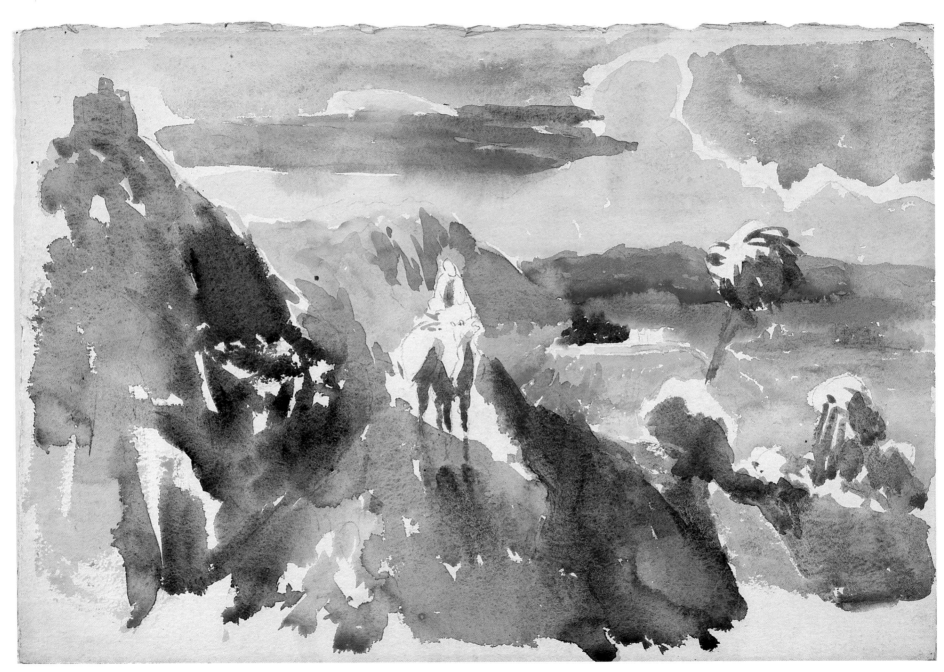

plate 17 Untitled, c.1930, watercolor and charcoal, 15³⁄₈ x 22⁷⁄₈"

FOUR

1920–1933

ONE OF THE MORE important aspects of Hart's career in the late 1910s and in the 1920s was his involvement with various artists' organizations and societies. In 1911, Hart joined the Palisades Yacht Club, a social group for artists in which members did not actually own yachts, but held festive "indoor regattas," where they displayed painted images of their imaginary vessels.[1] Later, sometime between 1916 and 1919, he joined the Penguin Club, which Walt Kuhn had founded in 1916.[2] Like earlier artist fraternities such as the Kit Kat Klub and Salmagundi Club, the Penguin Club was primarily a social organization, but it did sponsor exhibitions of works by both members and non-members (one of the most important exhibitions was a showing of vorticist art in January 1917 which was organized by John Quinn). Located at East 15th Street, the club occupied a single floor of an old brownstone, and its headquarters consisted of a large front room, reserved for exhibitions, and a back room that was used for a weekly sketch class. The club's roster was exclusively male, but it did acquire a group of female adherents known as the Penguinettes who assisted with the group's social functions. Its membership was made up of many artists who were centered around Kuhn, including such well-known figures as Edward Hopper, Alexander Brook, Guy Pène du Bois, Max Weber, Joseph Stella, and Alexander Calder. One of the highlights of the group's social agenda was an annual Penguin Ball, the proceeds from which financed the club's yearly expenses. These balls were usually elaborate affairs organized around a particular theme (e.g., Mexican Ball, Prohibition Ball), and the artists dressed in costumes and performed

vaudeville skits that had been created and directed by Kuhn. In 1919, the Penguin Club held one of its summer gatherings at Hart's home in Coytesville. Billed as a "Summer Outing," the event was an informal party that featured a barbecue and a jazz band (Gus Mager played the banjo).

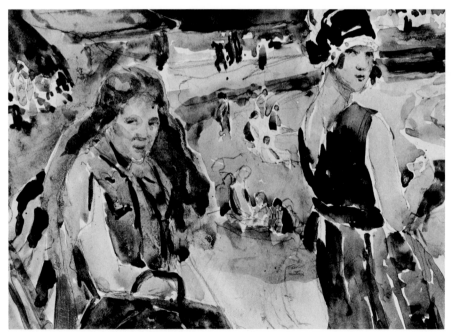

fig. 52 Untitled, c. late 1910s–1920, pencil and gouache, 6 × 8¾″

The club was also known for staging comical, nonsensical events at its gatherings, including a mock wedding at one of its annual Strawberry Festivals. In it Hart played the role of minister; Wood Gaylor, a painter friend of Hart's, was the groom; and the bride was a male Penguin Club member "in drag," named Bob Ament.[3]

Hart was also involved with the activities of a more important artists' organization, the Whitney Studio Club.[4] In 1907, six years prior to the Armory Show, Gertrude Vanderbilt Whitney, already an established sculptor, had taken a studio in Macdougal Alley in Greenwich Village. Whitney was closely associated with several of the artists of The Eight, including Henri and Davies, and was interested in many of the progressive developments that were occurring in American art during the early 1900s. In an effort to help support the cause for an advanced art in America, Whitney began to hold informal exhibitions in her studio of works by fellow artists and, in 1914, she opened an informal gallery called the Whitney Studio, where she organized regular exhibitions of works by progressive and young artists. She was assisted by Juliana Force, a dynamic figure and skilled administrator who later became the first director of the Whitney Museum.[5] In 1915, Whitney, with the aid of Force, formed the Friends of the Young Artists, which held shows in the Whitney Studio. This organization was formed to promote the work of younger artists, who often had little opportunity to exhibit their work. The Friends of the Young Artists was the germ for the Whitney Studio Club, which was launched in 1918 with Juliana Force as director. The club was an egalitarian organization that admitted any artist with demonstrated ability, or any serious artist who was introduced by a member. Among the earliest members were most of The Eight and other independent artists such as Edward Hopper, Glenn O. Coleman, Guy Pène du Bois, and Stuart Davis. Within a short time, the membership grew to several hundred. Like the Society of Independent Artists, which had also been formed to advance the work of liberal, non-academic artists, the Whitney Studio Club did not attempt to promote a particular aesthetic creed. Its members' works represented a wide range of artistic sensibilities and formal approaches. Besides its emphasis on professional activities, the Whitney Studio Club was an important social center for many artists outside the academic establishment, who often gathered in its headquarters on West Fourth Street; its membership had grown so extensive by 1924 that it opened a new club house next door to the Whitney Studio on

fig. 53 Peggy Bacon, *FRENZIED EFFORT (THE WHITNEY STUDIO CLUB)*, 1925, drypoint, Yale University Art Gallery. The John P. Axelrod, B.A. 1968, Collection of American Art. Photo credit: Yale University Art Gallery

West Eighth Street. The club also held evening sketch classes to which members were invited for a fee of twenty cents which covered the cost of hiring models. Hart attended these classes and he appears in a 1925 drypoint by Peggy Bacon, titled *Frenzied Effort (The Whitney Studio Club)* (fig. 53), which depicts one of the sketching sessions at the club.[6] Hart is fifth from the left, in the top row of figures. Bacon and Mabel Dwight are also pictured in the group. One of the major features of the club's activities was its sponsorship of both one-man shows and large annual exhibitions of members' works. Hart participated in two of the club's annual exhibitions in 1923 and 1925.

As the most active center for independent art in the United States, the Whitney Studio Club was extremely successful in exposing the public to progressive trends and shaping a more liberal, supportive attitude towards advanced American art. Yet, Whitney began to feel the need to establish a more official and prestigious center for displaying modern American art (at this time, there was no museum devoted exclusively to twentieth-century American art) and she founded the Whitney Museum of American Art in 1930. Hart, evidently, had become well acquainted with Juliana Force, the first director of the Whitney Museum, as she sent him a letter in May of 1933, inviting him to submit two of his watercolors to the institution's first Biennial Exhibition. In his reply to Force, Hart accepted the invitation, but also indicated that the museum should consider holding a one-man exhibition of his work:

> Have just passed my 65th birthday. And am beginning to think it might be nice to have a one man show while I am very much alive though getting on in years. Have many etchings doing all the printing myself. The plates I have presented to Newark Museum where they have incorporated in their permanent collection of Graphic Art....A hundred watercolors and seventy five etchings and lithos would be enough for a one man show.[7]

Hart was also a member of the Salons of America which, like the Society of Independent Artists and the Whitney Studio Club, was an artists' organization that sponsored exhibitions, and was presided over by his friend Wood Gaylor.[8] Hart also became involved with a number of groups that promoted a specialized interest in a particular medium. He was a member of such organizations as the American Watercolor Society and the New York Watercolor Club, the Brooklyn Society of Etchers (serving as president of the organization in 1925 and 1926), the Chicago Society of Etchers, the Philadelphia Society of Etchers, and the American Print Makers.[9] In contrast to oil painting, watercolor and printmaking were viewed as minor art forms during the late 1880s and early 1900s, and artists who specialized in these media often had fewer opportunities to exhibit their work. Furthermore, few commercial galleries at this time handled artists' prints. In an effort to give more prominence to watercolor and printmaking, a number of clubs and societies, devoted to the study of these media, were formed. While these groups were active centers for the exchange of ideas and often provided instruction in the more specialized techniques of watercolor and printmaking, they also sponsored exhibitions, giving their members a much needed forum for displaying their work to the public.

Hart's involvement with various art groups contradicts a particular view of the artist that developed during the latter years of his life—a view which has influenced subsequent assessments of his career. In discussing Hart in the 1920s, many writers stressed his reclusive nature and his disdain for the professional art world, particularly its requisite social activities.[10] One writer referred to Hart's Coytesville home as a "hermit's cabin."[11] Arthur F. Egner once remarked of Hart that "While he was fond of people, he would permit nothing to interfere with his work. Few, therefore, were invited to Coytesville, and his visits to others, though cordial, were brief."[12] Hart was partly responsible for promoting this view of himself, as on several occasions he declared, "If your [sic] going to paint a picture worth painting or etch an etching worth etching, you've got to go off in a corner by yourself and suffer....You can't do it wearing a white collar and holding a tea-cup in your dukes and sitting around on plush chairs talking art...."[13] "These artists talking art with a big 'A' with a hunk of cake in their hand get my goat."[14] Throughout his career, Hart was noted for his independence and his unconventional behavior and, undoubtedly, he reveled in this image. It is true that he was not as professionally aggressive or as gregarious as some of the other artists with whom he was associated, such as Kuhn, but he was not quite the contentious, solitary figure that has been portrayed in much of the literature. Indeed, the record of his membership in eleven artists' groups and his two-year tenure as president of the Brooklyn Society of Etchers indicate that he was much more actively involved in the New York artistic community than has been previously recognized or acknowledged. The

view of Hart as a reclusive, peripheral figure has led a number of scholars to assert that he was independent from many of the major currents in early American modernism, and has, in turn, limited the scope of inquiry into the tendencies that may have been influential in shaping his art. Hart's affiliation with these artists' groups provided exposure to a variety of developments and individual styles that would have had a strong impact on the formation of his aesthetic outlook during the 1910s and 1920s.

Due to his association with various artists and organizations, Hart's circle of friends and acquaintances within the New York artistic community was quite extensive by the 1920s. In addition to his earlier circle of friends that included Kuhn, Mager, Dirks, Pascin, and Myers, Hart became closely acquainted with such notable figures as Wayman Adams, George Biddle, Arthur B. Davies, Ernest Fiene, Emil Ganso, Edward Hopper, Jose Clemente Orozco, Robert Laurent, Max Weber, and William Zorach. He also became familiar with various art critics including Peyton Boswell, Henry McBride, and Margaret Breuning, and in the early twenties, after he began working in printmaking, he established a friendship with the noted print specialist Frank Weitenkampf.[15]

Matthew Baigell has written that Hart was "a painter cut from the archetypal mold of the wandering bohemian and anti-intellectual," noting that the artists "Frederick Remington, Thomas Hart Benton and Jackson Pollack have all had aspects of the latter quality in their characters."[16] Hart, who was strongly anti-intellectual in his artistic views and somewhat self-effacing about his achievements, left few statements about his art.[17] Yet, it is perhaps possible to interpret some of his artistic intentions by discussing the concerns of the faction with which he was most closely associated, namely the less-radical members of the American avant-garde like Kuhn, Davies, Sloan, and Mager. Discussing this circle of artists, the historian Judith Zilczer asserted that it was "...an intellectual circle comparable to those of Alfred Stieglitz and Walter Arensberg in this country and to that of Gertrude Stein in Paris."[18] Despite Zilczer's assessment, the artists that were clustered around Kuhn and Davies did not really follow the aesthetic dictums of a single figure like those artists

associated with Stieglitz, nor did they adhere to a particular conceptual program like the American Dadaists who comprised the Arensberg circle. Nevertheless, they were bound together by various commonalities that can be detected in their works. For example, many of the interests of such figures as Kuhn, Davies, or Sloan were rooted in the more traditional concerns of late nineteenth- and early twentieth-century American art. Their vital contact with people and lived experience became the sustaining impulse of their art and, as part of the legacy of turn-of-the-century American realism, their painted statements tend to reflect a preoccupation with narrative content and a somewhat ingenuous exploration of the human psyche. While they were not interested in devoting their art exclusively to the precepts of formalist abstraction, these artists were familiar with many of the developments in European modernism and attempted to incorporate aspects of these tendencies into their works (some of the conservative modern painters such as Kuhn did experiment for a brief period with complete abstraction). Many of these artists were also committed to the notion of individuality in their work, and the modernist emphasis on personalized expression and vitalized execution was used to convey their subjective response to life and to intensify the emotional force of their realist observations. Joshua Taylor discussed these concerns, noting:

> Although most of the artists had spent time abroad and were abreast of the various theories and movements, they showed little interest in emulating the more austere formal tendencies but wished to draw vitality for their art from local sources. They were concerned less with the detached purity provided by abstraction than with a sense of human togetherness. Many of them were obsessed with people—their fellow artists, the people in the street....In many cases they were the continuers of the "Eight" but with a greater awareness of the open possibilities of art. Cézanne was no stranger to them, nor were their French and German contemporaries....Their belief was in the creative spirit as expounded by Henri....Theirs was not an

art of forms but an art of artists, a convivial art that depended much on an artists' community.[19]

Furthermore, artists such as Kuhn and Davies remained committed to the figure as an essential vehicle of artistic expression, and while this more traditional concern was filtered through a variety of modernist strategies, the human characteristics of the figure were rarely sacrificed in favor of purely formal considerations. Virtually all of these concerns and commitments could be applied in an analysis of Hart's artistic motivations, since his works reflect a similar devotion to daily experience and to figural and narrative issues. Hart also experimented with a variety of

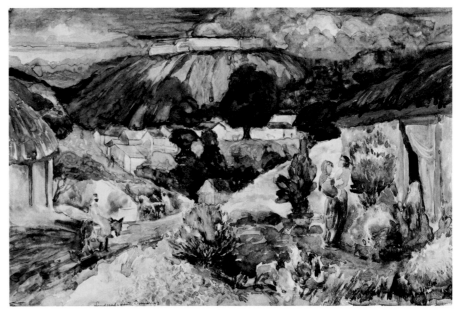

fig. 55 *LANDSCAPE, SANTO DOMINGO,* c. 1920–1922, watercolor, 14¼ × 22½"

progressive idioms, but adapted various modernist conventions to his own realist objectives. His shared interests with Kuhn, Davies, and Mager undoubtedly helped to draw him into their circle, and his active involvement with them most likely strengthened his orientation towards a mode of artistic expression that synthesized realist and abstract values.

During the early twenties, Hart continued to travel to the West Indies, primarily to Trinidad, Santo Domingo, and Dominica. Many of his artistic concerns of the late 1910s, such as his interest in naturalistic decorative pattern, extended into the early 1920s, and can be seen in the works *Hindus Resting by Wayside,* 1921 (fig. 54), *Landscape, Santo Domingo* (fig. 55), and *Wash Day, Trinidad* (fig. 56). In *Hindus Resting* the artist rendered the vibrant designs of the native costumes in expressive, Prendergast-like splotches of tone. In *Landscape, Santo Domingo* and *Wash Day, Trinidad,* he simplified the structure of the figures and surrounding landscape details, transforming them into rounded, formalized elements. In 1925, Hart created a print in softground and

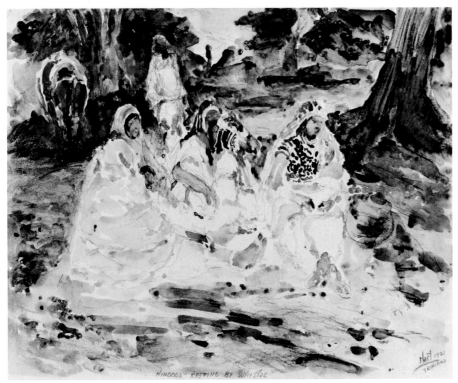

fig. 54 *HINDUS RESTING BY WAYSIDE,* 1921, pencil, gouache, and charcoal, 11¼ × 14¼"

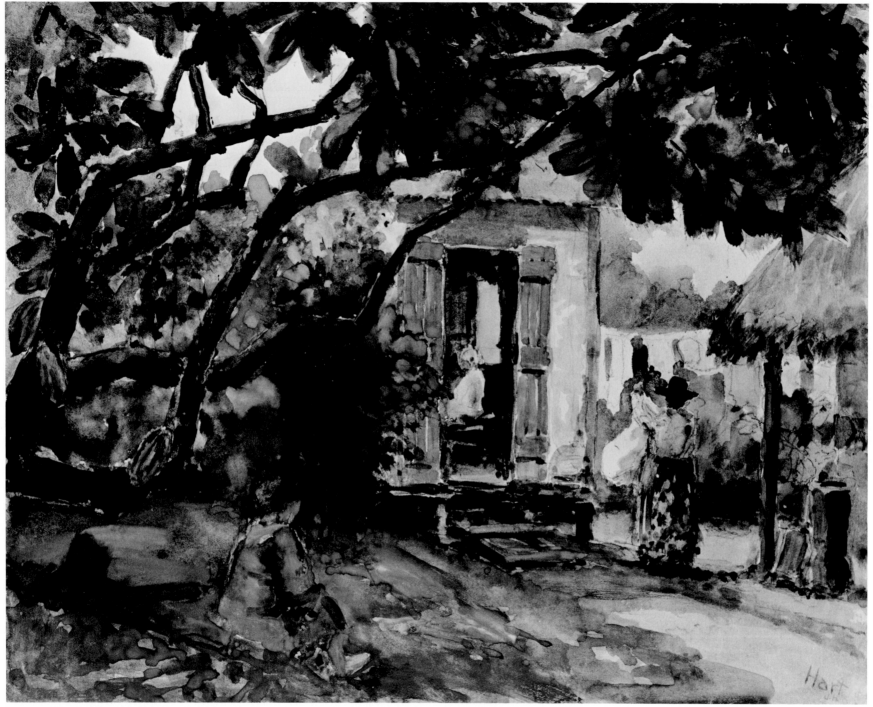

fig. 56 *WASH DAY, TRINIDAD,* c. 1916–1920, gouache, watercolor, and pencil, 11½ × 14¾"

68

drypoint (fig. 57), based on *Landscape, Santo Domingo*. In adapting his painted design to printmaking, he translated the heavily inscribed strokes of gouache into a deeply etched, rich network of lines in order to retain a sense of blunt, primitivized expression.

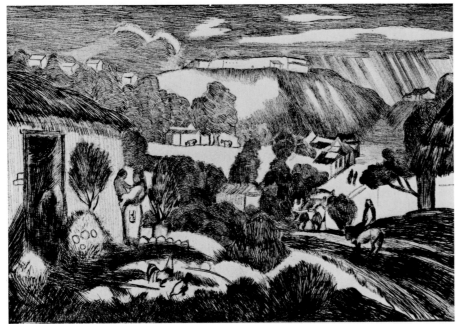

fig. 57 *LANDSCAPE, SANTO DOMINGO*, 1925, softground and drypoint, 9 × 12″

In the early 1900s, Hart had made a brief visit to Mexico, and returned often in the twenties, beginning in 1923. His travels through Mexico were extensive and included such places as Jalapa and Orizaba in the early 1920s and, in the middle and latter parts of the decade, Oaxaca, Tehuantepec, Guadalupe, Patzcuaro, and Xochimilco.[20] In 1929, Hart made his last trip, visiting Urapan. He had been drawn to Mexico for several reasons, including the desire to find an unspoiled location that reminded him of the primitive, non-Westernized environment of the South Seas. He felt that in Mexico he had discovered such a region. Hart once

described his attitude, remarking that:

> I'm tired of tourist places. You hear of a charming old town, buried somewhere and you go there, thinking that you will find the primitive. But when you get there, after treking [sic] all over the map, you find that the tourist had been there before you with Kodaks and things. The place is spoiled. They've ruined Tahiti and Samoa....I was in Tahiti in Gauguin's time and the islands were paradise then. But now its all gone. Tin cans all over the place and development companies exploiting every-thing....So I thought I'd try Old Mexico again. I had been there before and enjoyed it...I thought if I looked long enough I'd be able to find a place that was untouched....[21]

By the early twenties, Hart was beginning to support himself through his artwork, primarily his graphics; his income was small, but the low cost of living in Mexico allowed him to reside there comfortably. During the mid-twenties, he spent a considerable amount of time in

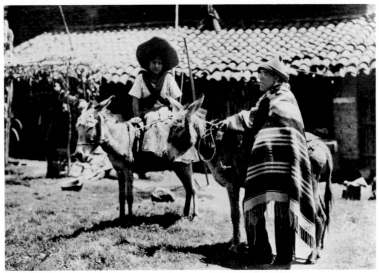

fig. 58 George Hart and Juanita in Mexico, c. mid-1920s

69

Hart's thematic concerns while in Mexico were, at times, quite similar to those displayed in his travel images of the early 1900s and 1910s.[23] Like his studies of native life in the South Seas and the West Indies, his travel subjects of the twenties were often devoted to market scenes (see figs. 92, 108; plate 16) and to the quaint domestic activities of

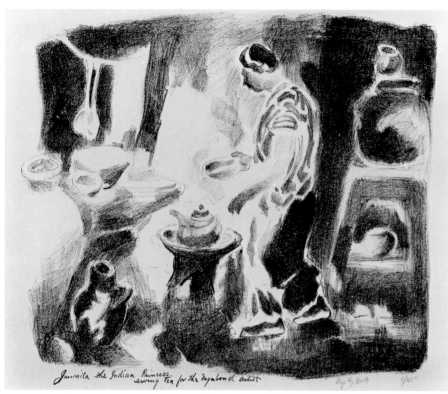

fig. 59 *JUANITA, THE INDIAN PRINCESS, SERVING TEA FOR THE VAGABOND ARTIST,* after 1928, lithograph, 16 × 22⅞"

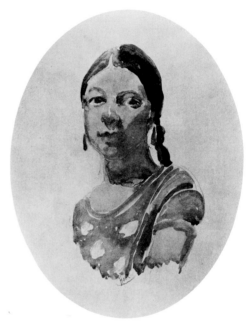

fig. 60 *JUANITA, MY INDIAN PRINCESS,* 1927, collotype, 21¼ × 15⅝"

Oaxaca, which was noted for its fine examples of sixteenth-century art and architecture and picturesque market places. While living there from 1926 to 1927, Hart, apparently, became romantically involved with a young Mexican girl named Juanita, whom he had hired as his cook and housekeeper (fig. 58).[22] Juanita appears in several works, most notably a lithograph from the late twenties titled *Juanita, the Indian Princess Serving Tea for the Vagabond Artist* (fig. 59), and the 1927 collotype *Juanita, My Indian Princess* (fig. 60), a romantic, cameo-like portrait that had been rendered in softly modeled pale washes, imparting the nostalgic tone of a vintage photograph.

the Mexicans (figs. 61, 62). Other themes that were unique to the culture of Mexico, such as rustic farmyards and cockfights, emerged as primary interests for Hart during this period. Many of the pieces produced in Mexico reflect his fascination with the impressive old-world architectural structures of historic cities like Orizaba and Oaxaca (earlier, in the late 1910s, Hart had demonstrated a similar interest in studying examples of vernacular architecture in New Orleans). In a pen and ink rendering of a cathedral interior titled *Merced Cathedral, Oaxaca, Mex.* that dates from 1925 (plate 14), Hart defined the structure in rapid, incisive strokes.

fig. 61 Untitled, c. 1923–1929, charcoal, 13¾ × 17⅞″

Although the details of the vaulted interior are highly summarized in this impressionistic sketch, Hart used luminous touches of color wash to convey the sumptuous quality of the religious decoration. In *Convento San Jose* (plate 9), the artist also used a simplified, linear style, but rendered the ornamentation of the facade in more delicate tracings of pencil overlaid with watercolor, and painted the scene on tan paper to suggest the sun-baked patina of stucco. This work and Hart's other depictions of Mexican townscapes are reminiscent of the picturesque architectural vignettes produced by such artists as James Whistler, Frank Duveneck, Joseph Pennell, and John Marin during their tours of old-world European centers at the turn of the century. While much of Hart's subject matter can be related to various thematic tendencies in early twentieth-century American art, his extensive production of Mexican scenes also places him at the forefront of an American artistic tradition exemplified by Henry Glitenkamp, George Biddle, John Groth, and Raymond Creekmore, all of whom traveled to Mexico in the early 1900s to study and portray the exotic sights of the region.[24] This trend was

fig. 63 Untitled, c. 1923–1929, pen and ink, charcoal, and pencil, 10⅛ × 17⅞″

paralleled by the early twentieth-century phenomenon of American painters who sojourned in Taos and Santa Fe, New Mexico for the similar purpose of transcribing the scenery and customs of the Indian inhabitants.[25]

fig. 62 Untitled, c. 1923–1929, pencil and gouache, 15¾ × 20¾″

fig. 64 Untitled, c. 1923–1929, pencil, gouache, charcoal, 12¾ × 19¾″

Although Hart's Mexican studies reflect his ongoing interest in regional genre themes, many of his works from the 1920s reveal a new inclination toward a much freer, more abstract manner of painting. In several of his more stylistically advanced works of the late 1910s, such as *Market Woman, Santo Domingo*, 1918 (see fig. 45), one detects a tendency to let painterly washes, formerly restricted to the description of tone and texture of objects, become independent of the structural elements of the scene. During the twenties, Hart began to rely more frequently on this approach. For example, in *Hindus Resting by Wayside* (see fig. 54) and an untitled Mexican courtyard scene (fig. 64), both the figures and their settings were delineated in loose, sketchy strokes; however, the washes of paint that cover these elements do not strictly adhere to the linear armature of the forms, but often overlap and extend

fig. 66 *THE GORGE, ORIZABA*, 1927, watercolor, 13⅜ × 21½"

fig. 65 *ARAB SHEPHERDS LUNCHING*, 1929, charcoal and gouache, 13½ × 20½"

across the surface of the paper to create expressive patterns of pure color. In some other works of the 1920s, Hart dispensed with descriptive line altogether and based his pictures on expressive, improvisational layerings of paint.

In the late 1910s, Hart had attempted to utilize an abbreviated style of painting while retaining a fairly clear sense of three-dimensional form and spatial division. Yet, in the twenties he began to sacrifice this traditional concern for firm plastic structure in order to develop more expressive, economical painting techniques. In such works as his 1919 watercolor *Arab Shepherds Lunching* (fig. 65) and a view of a Mexican church titled *La Iglesia de Huilopan* (plate 10), the landscape elements were denoted through flat areas of freely layered wash, and only light, gestural markings of pencil were used to indicate the contour of forms and to suggest spatial separation. This method was more boldy applied in the 1927 work *The Gorge, Orizaba* (fig. 66) in which details of the romantic

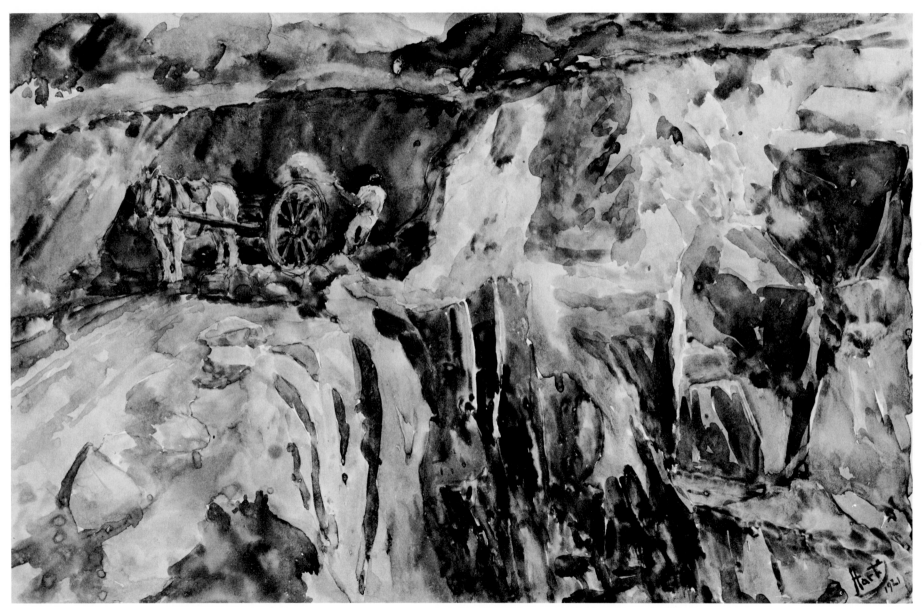

fig. 67 Untitled, 1921, charcoal and watercolor, 13⅞ × 22″

fig. 68 Untitled, late 1910s, gouache, 8 × 10⅝″

landscape vista, executed in broad, watery strokes, lack any real sense of inner structure, and the entire scene appears to be on the verge of dissolving into dripping passages of tone.

In addition to these advancements, Hart began to handle watercolor with a greater degree of painterly freedom, developing a more simplified, abstract style. For example, in an untitled work from 1921 (fig. 67) that depicts a figure with a horse and wagon in what appears to be a quarry setting, the rugged landscape was contructed of vigorously brushed patches of color. In fact, if one focuses on the rocky bluff that fills the right-hand section of the scene, Hart appears to have been less concerned with the mimetic function of his strokes than with the sensual manipulation of pigment. The densely massed, fluid strokes of paint were handled with such freedom that this portion of the work almost presages the development of gestural abstraction. In an untitled work of the same period, Hart experimented with an even more advanced form of abstraction that borders on non-objective painting (fig. 68). With its blurred, dribbled splotches of paint, this work anticipates a surrealist decalcomania or the blotted image of a Rorschach test. At first glance, this

curious excursion into extreme painterly abstraction appears to be merely a random smearing of pigment, but one can detect certain shapes that resemble human figures and a deer (see lower right section of the image). It is as though the expressive painting methods of the quarry scene were given full rein in this piece. Although Hart had developed a more abstract manner of painting by the 1920s, this piece remains an anomaly in his extant oeuvre, and is reproduced here only as an indication of his willingness to experiment with a more radical mode of non-objective expression; however, this work must not be dismissed as an isolated incident of technical play, since a similar sense of gestural freedom informed some of his more representational depictions from the twenties. For example, in the watercolor *In Market, Tehuantepec, Mexico*, 1926 (fig. 69), the artist painted the scene in fluid, cursive strokes, transforming the figures and the forms of the landscape into flat, translucent patches of wash.

Hart's use of more expressive painting methods in the 1920s culminated in one of the more abstract statements of his career, an untitled African landscape in watercolor that was most likely done in

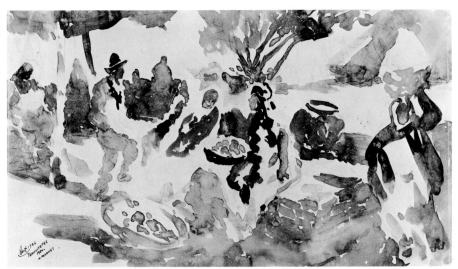

fig. 69 *IN MARKET, TEHUANTEPEC, MEXICO*, 1926, charcoal and gouache, 10⅜ × 18⅜″

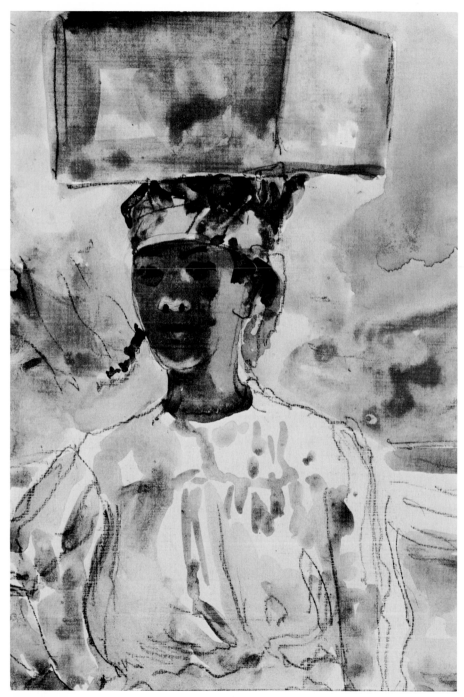

either 1929 or 1930 (plate 17). While in keeping with the freer handling of his works from the 1920s, the style of this watercolor was clearly inspired by the lyrical nature abstractions of John Marin. Like Marin, Hart used vivid hues and brisk, incisive washes to convey his intense subjective response to nature. The imagery of this view also resembles that of Marin's modernist landscapes, as Hart transposed the exotic elements of the scene—a figure on a camel, distant mountains, a palm tree—into highly abstract pictorial signs. Given Hart's devotion to watercolor and the more progressive nature of his works in the 1920s, it is not surprising that he would have looked to Marin, acknowledged at this time as a modern master of watercolor, for solutions in a more radical handling of the medium. Furthermore, Marin's ecstatic language of nature painting would have appealed, undoubtedly, to Hart, since many of Hart's landscapes, particularly those executed in the late 1910s, also reflect an intensified visual response and excitement in observing nature.

fig. 70 Untitled, early 1920s, pen and ink, gouache, and charcoal, 8 × 9⅞″

fig. 71 Untitled, c. 1920–1933, pen and ink and charcoal, 8 × 10″

fig. 72 Untitled, c. 1920–1933, pen and ink and ink wash, 8¾ × 11¼″

fig. 73 *THE GALLERY, FRENCH OPERA HOUSE, NEW ORLEANS*, 1924, lithograph, 9 × 12¾″

Hart also appropriated caricatural conventions in formulating a more expressionistic, figural style during the 1920s. It is not known exactly when he first developed this idiom, but it was early in the decade, and he continued to produce many works in this style until his death in the early thirties. He had begun to simplify the facial features and the anatomical structure of figures in the late teens. This may be seen in an untitled sketch of a native girl, done during this period (fig. 70). *Hindus Resting by Wayside*, 1921, displays a similarly generalized treatment of anatomy and facial features. This simplification of forms can be viewed as a transitional phase that led to the more bold anatomical distortions of his expressionist vocabulary. The shift to this style was accompanied by a greater reliance on pure line, as many works were executed in pen and ink with little or no use of washes. Some of the more notable examples from this expressionistic/caricatural phase are a vigorously drawn cockfight scene (fig.

fig. 74 *VIRGINIA REEL, AMUSEMENT PARK*, 1926, etching and aquatint, 8⅛ × 11¼″

71), a study of heads, apparently combining various ethnic types in one grouping (fig. 72), and a pen and ink drawing, titled *American Artists Croquet Club, Luxembourg Gardens, Paris* (see fig. 110). This approach appears also in a large number of prints, particularly lithographs, since the fluid, linear distortions of the style were well suited to this process. Examples include *Cockfight, Santo Domingo*, 1923 (see fig. 77), *The Gamblers*, 1924 (see fig. 78), *Mr. American in France* (see fig. 111), and *Juanita, the Indian Princess Serving Tea for the Vagabond Artist* (see fig. 59). In many of these expressionist works, Hart's approach recalls the more refined expressionism of Pascin; however, in other pieces, such as his 1924 lithograph *The Gallery, French Opera House, New Orleans* (fig. 73), Hart's style more closely resembles pure caricature, and in some works from this period, such as the print *Virginia Reel, Amusement Park* of the same year (fig. 74), it even assumes the reductive character of a cartoon. Indeed, in *Dance of Centaurs* (see fig. 88) the rounded heads and dot-like eyes of the figures are quite reminiscent of the cartoon style of the humorous illustrator John Held, who was active during the twenties. Hart's experimentation with this cartoon-like style might have stemmed from the fact that many of the figures in his circle—Rudolph and Gus Dirks, Mager, Kuhn, and Tom Powers—worked as cartoonists and humorous illustrators of the popular press.[26]

Hart's adoption of this free, expressive approach can be traced to several sources, most notably the art of Pascin and the graphic caricatures of Daumier. Several writers, including Emily Genauer and E.M. Benson, have related Hart's works to those of Pascin.[27] Yet, there has never been a discussion linking the work of these two artists that takes into account their close personal association. As discussed earlier, Hart and Pascin were well acquainted in the later 1910s and their friendship was renewed in the late twenties, providing the context for this cross-fertilization. Pascin's influence is readily apparent in such works as *Dance of Centaurs, Juanita, the Indian Princess Serving Tea for the Vagabond Artist*, and *Tea Garden, Fez* (see figs. 88, 59, 101), all of which contain lyrical manipulations of form coupled with soft tonal passages. In addition to Hart, a number of other American artists including Walt Kuhn, Emil Ganso, Alexander

Brook, and Yasuo Kuniyoshi began to emulate Pascin's work during the early twenties.[28] As H.H. Arnason remarked of this development, "...Pascin ... held considerable interest for younger American artists trying to find a new direction. Since his actual style did not represent a radical departure from their own experiments, ... (his interest in watercolor was a bond) his influence on these American painters was substantial."[29] Besides the direct influence of Pascin's style, there was also a more general tendency towards figural expressionism in American art of the 1920s, as such artists as Peggy Bacon and Mabel Dwight included humorous anatomical distortions and a caricature-like treatment of physiognomy in many of their works.[30]

Another source for Hart's expressionistic figural style and caricatural imagery is the work of the French nineteenth-century painter and caricaturist Honoré Daumier, whose gutsy depictions had been popular among several members of The Eight.[31] A number of writers have discussed the relation of Hart's works to Daumier's and it is known that Hart owned a book on Daumier's art.[32] In Hart's *The Gallery, French Opera House,* the doughy features of the figures, the energetic, assured line, and the rich modulations in tone were clearly inspired by Daumier's style. This view of figures in a loggia is also quite similar to Daumier's depictions of French nineteenth-century theater scenes, which often focus on the humorous antics of the gallery audience. Hart's pen and ink sketch *Connoisseurs,* c. 1920–1933 (fig. 76), depicting a group of collectors huddled in a covetous circle around a print folio, was undoubtedly taken from Daumier, since the latter produced a notable series of works in the late 1850s and early 1860s that include the watercolors *Quatre Amateurs d'estampes* and *Trois Amateurs devant la revue nocturne de Raffet,* which show figures engaged in the study of prints.

Although Hart's interest in expressionism and caricature is linked to Daumier and Pascin, it should be noted that he was not merely emulating their styles, nor was he simply following the more general trend of figural expressionism in American art of the twenties. Rather, Hart actively sought out these influences, for the formal conventions of Pascin's style and the more general principles of caricature that he borrowed from

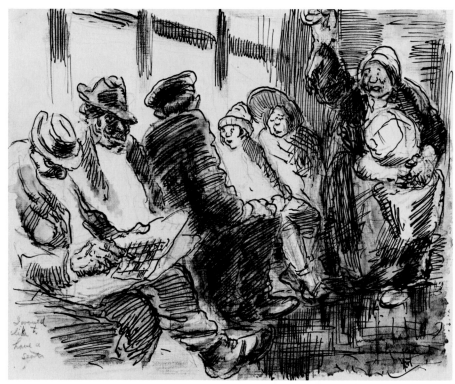

fig. 75 *I WOULD LIKE TO HAVE A SEAT,* c. 1920–1933, pen and ink, pencil, and ink wash, 7⅞ × 9⅞"

Daumier were perfectly suited to his own aesthetic aims of the 1920s. Throughout most of his career, Hart utilized an impressionistic representational style and, in the 1910s, it grew even more loose and simplified. While this type of approach allowed Hart to capture the activity of a market place, or *plein air* atmospheric effects, it presented certain problems with figural subjects. Aside from his interest in expedient methods, Hart was devoted to figural narrative and portrait studies. But the sketchy, notational style that he preferred did not allow much psychological penetration, since the facial expression of his figures often became generalized in his impressionistic renderings. Hart must have sensed this problem and sought expressionistic and caricatural solutions.

In the case of both of these approaches, an artist seizes upon a particular facial or anatomical feature of a subject and distorts it in order either to provide insight into, or to mock, some aspect of his character (in expressionist art, figural distortion is also employed to reflect the artist's emotional response to his subject). Furthermore, these anatomical stylizations are usually based on an incisive, linear mode of drawing and painting. By relying on these two major stylistic and conceptual formulas of expressionist art and caricature, Hart was able to combine in his figural works an interest both in expedient execution and psychological content. Indeed, Hart once commented that his humorous morphological distortions granted him access into the psyche of his subjects.[33]

During the 1910s, Hart attempted to adapt various modernist approaches to his realist and figural interests. While other artists such as Davies and Kuhn also experimented with various modernist idioms that

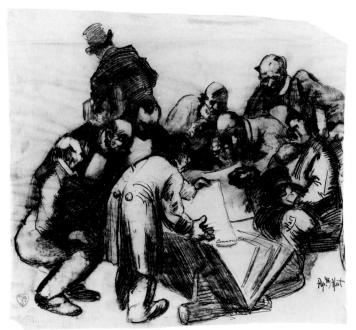

fig. 76 *CONNOISSEURS*, c. 1920–1933, charcoal and ink, 16½ × 17¾″

were applied to figural themes, they occasionally used more geometric abstract styles that were inimical to many of the realist and emotional values associated with the figure. Hart's adoption of an expressionist figural idiom, however, allowed him to employ a style that was both sufficiently progressive and one that was in accordance with his realist and figural concerns. The caricatural style that he developed can be related to the practice of several other American realist artists including George Bellows and Reginald Marsh, who also appropriated aspects of popular illustration to enhance the emotional and humorous content of some of their images.[34]

Hart's expressionistic scenes have been related to Thomas Rowlandson, and it is quite possible that he was inspired by the English caricaturist's satirical depictions of cockfights.[35] Hart's use of a caricatural mode was perhaps most prevalent in his various drawings and prints of cockfight scenes, such as the lithographs *Cockfight, Santo Domingo*, 1923 (fig. 77), *The Gamblers*, 1924 (fig. 78), and his 1927 collotype *The Jury* (see fig. 105). In these pieces, Hart utilized comical, elastic exaggerations of anatomy to amplify the brutal gestures and the coarse nature of these picaresque characters.

One of the most important aspects of Hart's career in the 1920s was his involvement with printmaking, which began in 1921. His art historical importance has been based largely on his innovative efforts in printmaking, and it was primarily through his graphics that Hart began to gain critical recognition for his work in the twenties. According to Hart, several of his artist friends, upon discovering his large output of drawings, suggested in the early 1920s that he translate these works into prints (see figs. 32 and 95; 55 and 57; 66 and plate 12).[36] Hart did not indicate who these figures were, but Kuhn, Davies, or Jerome Myers are likely candidates, since all three were actively involved with the graphic arts at this time. It is not surprising that Hart moved into this arena, since his art had always been firmly rooted in a graphic sensibility; it is, however, notable that he initiated in his work at this fairly late stage of his career such a high degree of technical and formal experimentation. As Hart recalled in the late twenties, "I was over fifty years old. Pretty near time I

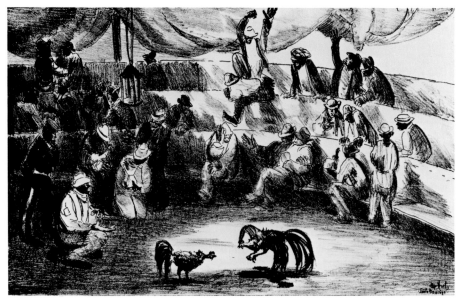

fig. 77 *COCKFIGHT, SANTO DOMINGO,* 1923, lithograph, 12¾ × 17″

settled down to my life work."[37] In adapting his earlier subjects to printmaking, Hart was concerned with translating many of the significant formal qualities to the print medium. Yet, unlike other American painter/printmakers such as Grant Wood or Thomas Hart Benton, whose translations of their paintings were often overly literal and unreflective of a strong graphic sensibility, Hart viewed his transpositions as a fresh opportunity for exploring new stylistic and technical effects; his prints generally reflect his sensitivity to the unique formal and textural properties of the various graphic processes that he employed. By the early twenties, when Hart adopted printmaking, he had achieved in his watercolors a high degree of technical facility and painterly expressiveness; however, for his first prints, such as *The Toilers,* 1921 (fig. 79), and *Jack and Jill,* 1921 (fig. 80), Hart based his efforts on paintings that date from the early 1910s, and in translating these images he returned to the fairly stiff drawing style that was characteristic of his work from this period. This can be attributed partly to the assumption that an artist's

first efforts in a medium usually reflect a certain amount of technical hesitancy. But his prints of the mid-twenties quickly begin to display the more progressive, vitalized qualities apparent in current paintings. One of the important aspects of Hart's work in printmaking is that unlike many of his drawings and watercolors, all of his prints are dated, thus making it possible to trace with greater accuracy his technical and stylistic evolution in this medium.

Hart was noted for his radical combinations of different intaglio processes in order to obtain more painterly effects and a greater tonal variance in his prints.[38] He often mixed different grounds with various media to create an unusual variety in texture, line, and tone on a single plate.[39] He was also able to create unique textural effects by employing roulette and sanding methods. Through his experimental mixed media techniques, Hart challenged the traditional purity of etching and other intaglio methods. His interest in mixed media approaches may have been stimulated by the example of Arthur B. Davies' intaglio works of the late 1910s and early 1920s, which often combine several methods.[40] Although Hart has been noted for his innovative efforts in printmaking, he was,

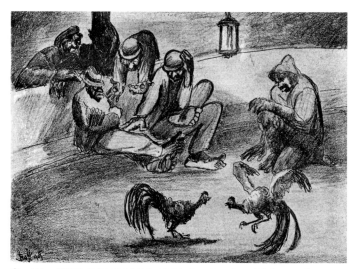

fig. 78 *THE GAMBLERS,* 1924, hand-colored lithograph, 10 × 13½″

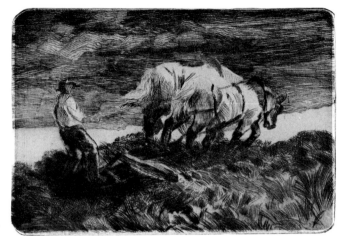

fig. 79 *THE TOILERS,* 1921, drypoint, 8⅜ × 10½″

perhaps, even more devoted to experimentation and variety in his works than has previously been recognized. He investigated not only the artistic potential of blending various grounds and processes, but he experimented with altering the tonal value of his images by using both chine collé and different combinations of ink and paper.[41] While most of Hart's methods are unconventional and many of his intaglio works appear to be the products of an untutored, spontaneous technique, he actually was more sophisticated and methodical in his approach than is perhaps apparent when viewing his prints. For example, Hart often made careful preparatory drawings which he transferred to plates. The compositional and tonal schemes of a number of his intaglio works were developed through

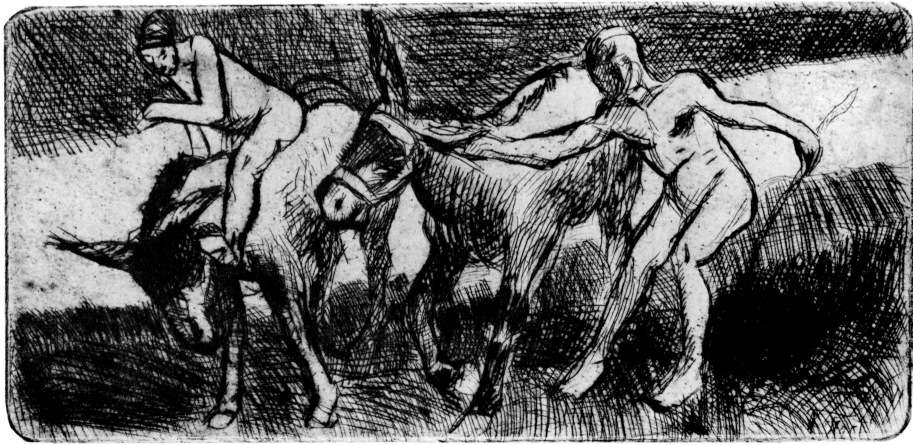

fig. 80 *JACK AND JILL,* 1921, drypoint, 5⅛ × 9¾″

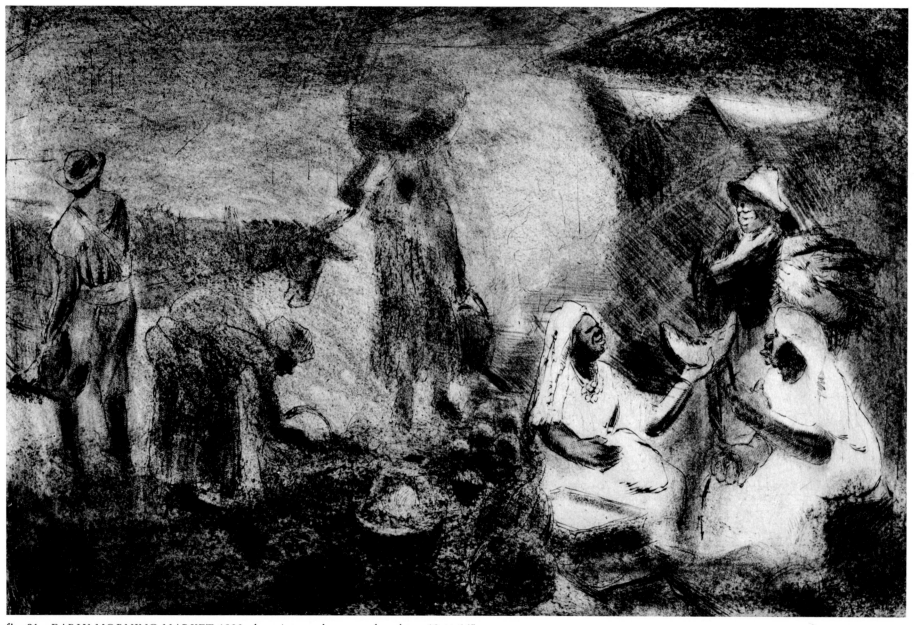

fig. 81 *EARLY MORNING MARKET*, 1923, drypoint, sandpaper, and roulette, 10 × 14″

as many as five or six states.[42] He also created different versions of some of his favorite designs either by transposing the image to a different format or by translating it into another print medium. In the case of *Landscape, Santo Domingo* (see fig. 57), drypoint and softground, he executed a larger version in softground only. *Dias de Fiesta* (see fig. 90), softground and aquatint, was reworked as a larger composition in the same media. The intaglio prints *Early Morning Market* (fig. 81) and *The Corral (Pack Animals and Indians Resting)* (fig. 83) were later reinterpreted in lithography (figs. 82, 84). In addition to his mixed media techniques in intaglio, Hart has also been regarded as a pioneering figure in American lithography and he experimented actively in other innovative areas including monotype, color printmaking, and photographic printing methods.

When Hart first decided to undertake printmaking, he was unfamiliar with the craft, and a lithographer friend suggested he begin by experimenting with drypoint.[43] Since drypoint requires neither the use of a ground nor acid immersion, it is easily attempted by artists with little or no printmaking experience. Preparing a drypoint is similar to sketching,

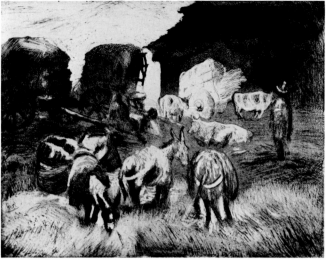

fig. 83 *THE CORRAL*
(PACK ANIMALS AND INDIANS RESTING),
1928, aquatint and softground, 10⅞ × 12½"

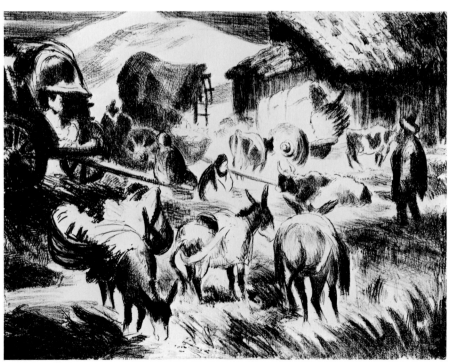

fig. 84 *MEXICAN INDIANS AND ANIMALS RESTING (THE CORRAL)*,
1928, lithograph, 17 × 20¼"

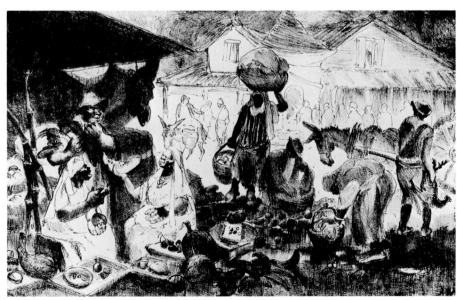

fig. 82 *HAITI MARKET*, 1924, lithograph, 12¾ × 16"

except that the image is drawn directly onto a metal plate with a pointed needle. Hart's first prints, *The Toilers* and *Jack and Jill,* were drypoints on zinc. Drypoint must have appealed strongly to Hart's sensibility as a draftsman, since it is a very active, physical process. One of the notable aspects of Hart's drypoints is that most of the line work done in this medium traditionally has a soft, velvety quality; Hart's marks, however, were so sharply incised into the plate that his drypoint impressions have more of the intense, expressive quality of a deeply bitten etching.

Hart's first four prints were executed solely in drypoint line, but he gradually introduced more tonal values. In fact, even in *The Toilers* and *Jack and Jill,* he attempted to create tonal effects through areas of dense hatching and by lightly wiping his plates to leave an overall tone. With the 1923 prints *Chicken Vendor, Trinidad* (fig. 85) and *Early Morning Market,* Hart continued to use drypoint, but treated the surface of the plates with a fine grained sandpaper, producing a subtle range of tones that resembles the textural character of an aquatint. Hart commented on his use of this unconventional sanding method:

> I wanted to get a more painterlike quality, to get tones like those of water colors and paintings. Then I tried making a sandpaper ground on the zinc plate. This gave me interesting tones. "Chicken Vendor" and "Boats and Natives"...look as if they had an etched ground, but they were done with sandpaper and drypoint....They created quite an interest in the graphic world. No one knew just how they had been done. Many of my friends thought I had done them with aquatint.[44]

In addition to the tones created with sandpaper in *Chicken Vendor, Trinidad* and *Early Morning Market,* Hart used roulette to embellish and enrich some of the textural passages in these works. Using roulette (an implement with a revolving toothed wheel that leaves a track of lines or dots on the plate), Hart wielded the tool in a forceful, energetic manner, creating a rough, pitted surface on the plate, which when printed, simulated the sketchy, textural effects of a charcoal drawing.

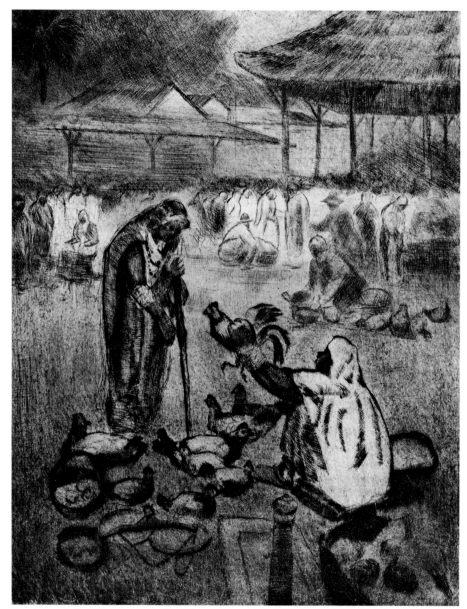

fig. 85 *CHICKEN VENDOR, TRINIDAD,* 1923, drypoint, sandpaper, and roulette, 13 × 10″

fig. 86 *MARKET STAND, SANTO DOMINGO*, 1924, softground etching and sandpaper, 11⅝ × 15¼"

Hart continued to work with drypoint, sandpaper, and roulette techniques until 1924 when, through his growing interest in tonal and textural values and his discussions with other printmakers, he decided to experiment with more challenging intaglio methods that required the use of acid.[45] Hart studied various technical manuals on intaglio printmaking in the print division of the New York Public Library, which at that time was run by the noted print specialist Frank Weitenkampf. Hart established a friendship with Weitenkampf through his visits to the library and, under his guidance, Hart received expert technical instruction in a variety of graphic processes.[46] The first etching method that Hart utilized was softground, which he employed in his 1924 print *Market Stand, Santo Domingo* (fig. 86). With softground, a ground containing a soft wax is used on the plate and a textured material, usually paper that has a heavy tooth, is laid over the plate. In drawing the image, pressure is then applied

with a pencil or crayon so that the wax is transferred to the back of the paper, exposing an area of the plate that, when bitten by acid, will produce a line with the corresponding texture of the paper. A softground line is lighter and grainier than a traditional etched line, and in *Market Stand* which also contains drypoint, Hart exploited this effect to achieve a softly modulated range of painterly tones, a quality that was enhanced when he printed a color version of this image in pastel tinted inks.

In an effort to create a more extensive range of tonalities in his prints, Hart next experimented with aquatint. In preparing an aquatint print, a plate is treated with a porous ground of rosin, which leaves a distribution of tones where the acid has bitten between the grains of rosin. In his first effort in aquatint, a lyrical nocturne titled *Native Baptism, Trinidad* of 1924 (fig. 87), Hart used a fine dusting of rosin in certain sections of the plate and, in other areas, the ground was more loosely applied, resulting

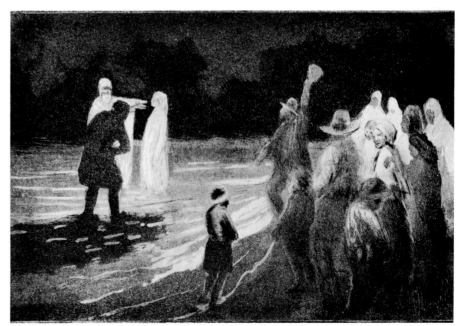

fig. 87 *NATIVE BAPTISM, TRINIDAD*, 1924, aquatint, 9⅛ × 12½"

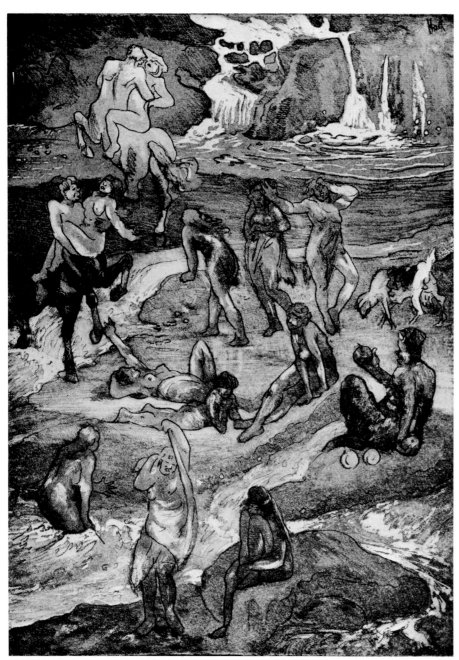

fig. 88 *DANCE OF CENTAURS*, 1926, aquatint and softground, 15 × 11⅞″

in a fairly wide variation of tones that range from the dense black of the nighttime sky to the light gray of the figures that are illuminated by a mysterious hidden light source. Aquatint was perfectly suited to Hart's interest in producing painterly effects, as the subtle value changes possible with the process can be used to emulate delicate watercolor washes. In fact, Hart's 1926 aquatint and softground print *Dance of Centaurs* (fig. 88) was based on his 1921 watercolor *Centaurs and Nymphs*, which is in the collection of the Hirshhorn Museum. In this print, Hart used grainy softground contours to mimic the penciled outline of the figures in the original painting, and the translucent layers of watercolor were translated into broad areas of lightly stippled aquatint.

Hart created a wide variance in tone through the use of pure aquatint and the combination of aquatint and softground, producing effects that ranged from the more traditional, evenly modeled values of *Native*

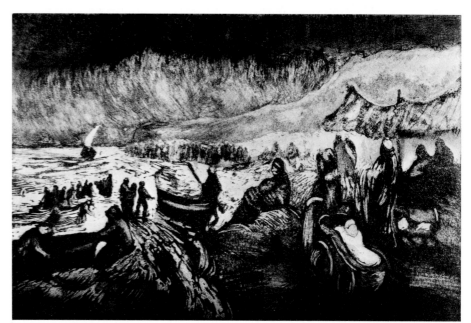

fig. 89 *BATHING BEACH, COYTESVILLE ON HUDSON*, 1925, softground and aquatint, 11⅝ × 15¾″

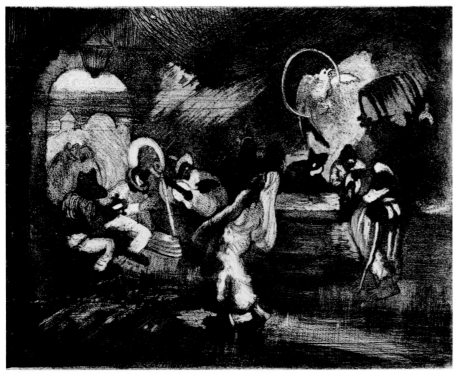

fig. 90 *DIAS DE FIESTA*, 1926, softground and aquatint, 8⅜ × 10⅝″

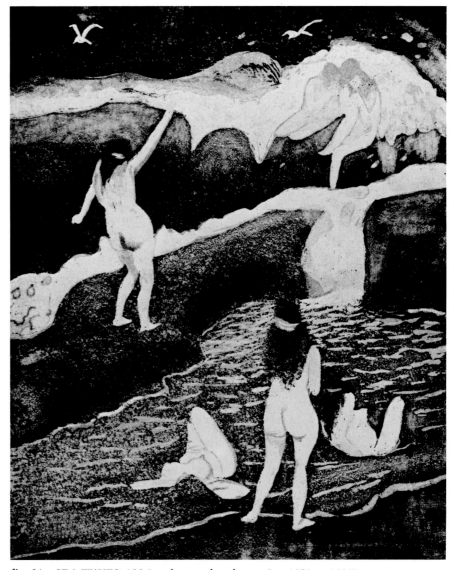

fig. 91 *SEA WAVES*, 1926, softground and aquatint, 12⅞ × 10¾″

Baptism to such novel solutions as the expressive textures of *Bathing Beach, Coytesville on Hudson* (fig. 89) that resemble the coarse, splintered markings of a modernist woodcut. Due to his interest in introducing more tonal qualities into his graphics, Hart began to rely less on line to describe forms and, in some of his more advanced intaglio works like *Dias de Fiesta, Sea Waves,* and *Pig Market, Mexico* (figs. 90, 91, 92), his pictorial elements are primarily constructed out of broad applications of tone, an approach that fulfilled his aim "to get a more painterlike quality...."[47]

Hart's desire to achieve more painterly effects in printmaking led to his experimentation with monotype, a method that actually involves

painting an image directly on a non-absorbent matrix like glass or metal and, while the design is still wet, it is transferred to paper either through the pressure of the hand or a printing press. One of Hart's more notable efforts in monotype is *The Hostess* (fig. 93), a print from 1924 that combines both monotype and drypoint. It is also possible that Hart was drawn to monotype because it is a rather simple process that does not require a great deal of technical knowledge or skill; the year that he adopted monotype, 1924, was the same year that he started to investigate more complex intaglio methods. During the modern era, monotype was extremely popular among several late nineteenth-century French artists, such as Degas, Pissarro, and Gauguin, but it did not become a focus for artistic interest in the United States until the 1880s, when several American artists, including Frank Duveneck, William Merritt Chase, and Maurice Prendergast, began to experiment with the technique.[48] Later, in the early 1900s, the process gained many adherents among the members of The Eight, and Sloan, Henri, Davies, Glackens, Luks, and Shinn all

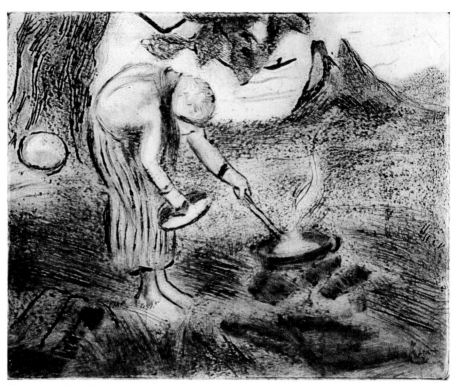

fig. 93 *THE HOSTESS*, 1924, drypoint and monotype, 9¼ × 11½″

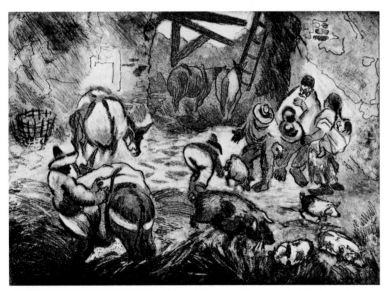

fig. 92 *PIG MARKET, MEXICO*, 1926, aquatint and softground, 12⅛ × 15⅞″

experimented with monotype.[49] Other American artists who are noted for their work in this process in the early 1900s are Albert Sterner, Eugene Higgins, and Abraham Walkowitz. Hart, generally, has been cited along with this group as being one of the more important figures who explored the artistic potential of monotype during the first part of the twentieth century.[50]

In keeping with his interest in mixed media techniques, Hart employed both monotype and drypoint in *The Hostess*, delineating the basic structural outline of the bent figure and the landscape forms in drypoint while using monotype to add tonal passages and effects of modeling. This blending of methods resulted in an image that combines

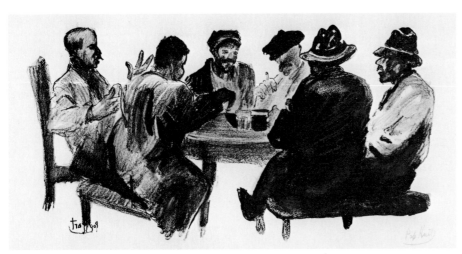

fig. 94 *LUNCH HOUR,* 1922, hand-colored lithograph, 10 × 13⅞″

ward efforts in the medium which feature isolated images drawn in a fairly dry, controlled manner; however, Hart soon began to develop more ambitious and complex compositional and tonal schemes, as can be seen in *Native Laundress* of 1923 (fig. 95). This print was based on an untitled

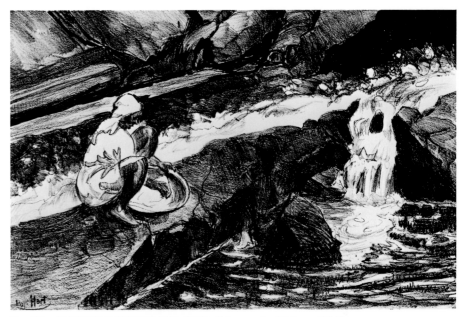

fig. 95 *NATIVE LAUNDRESS,* 1923, lithograph, 12½ × 17¾″

the rich, painterly qualities of a monotype with the greater graphic clarity of an intaglio impression. The various impressions of *The Hostess* actually constitute an *edition variée,* as each printed image is altered slightly through variations in the monotype work and in the use of different inks. Hart experimented with a pure application of the technique in a monoprint version of his 1925 print *The Poultry Man* (not illustrated) and, in several of his color intaglio pieces, he manipulated the etching and inking methods in order to mimic the more diffused tonal effects of monotype printing. It is possible that Hart was introduced to monotype through Weitenkampf, who wrote on the process in the early twenties.[51] But Prendergast's monotypes and those by The Eight might also have been an important stimulus in his decision to employ the technique.

Another major area of Hart's printmaking activity was lithography, and his preference for a swift, spontaneous stroke made it a logical medium for him to adopt.[52] Hart became involved with lithography in 1922, shortly after he had started to produce works in drypoint, and his progression in lithography closely parallels his technical and stylistic development in intaglio printmaking. Hart's first lithographs, *Cabin Boy* (not illustrated) and *Lunch Hour* of 1922 (fig. 94), are simple, straightfor-

watercolor from 1918 (see fig. 32) and Hart used broad strokes of the lithographic crayon in several sections to suggest the fluent color washes of the original work. Yet, this print is also an important graphic statement in its own right, as the variegated tones of the rocks appear to have been sketched with a soft crayon, resulting in a richly textured surface of energetic hatchings that contrasts with areas of bold, white unprinted paper. Many of Hart's earlier lithographs, such as *Voodoo Dance* of 1924 (fig. 96), are rendered in a sketchy, linear style. But, as he had done with intaglio, Hart began to base his lithographic designs on broad areas of printed tone. For example, in *Moonlight in Jungle* of 1924 (fig. 97), the

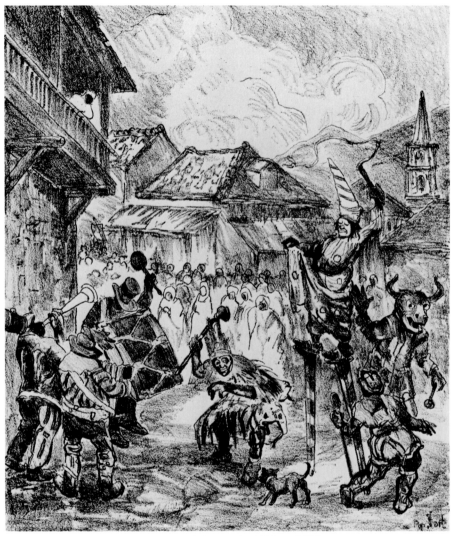

fig. 96 *VOODOO DANCE*, 1924, lithograph, 12¾ × 11½″

And the shadows of the trees that extend across the jungle floor were indicated through smoothly textured layerings of ink, creating an abstract pattern of sinuous light and dark shapes in the bottom register of the composition.

In several other lithographs that date from 1924, including *The Rainbow* (fig. 98) and *Atlantic City* (fig. 99), Hart utilized a delicate, tonal style in which the forms and the atmospheric qualities of the scene were printed in grainy, diffused tones. In *The Rainbow,* the various pictorial elements in the background were denoted through a rich skein of interlaced strokes, a technique that can be viewed as the lithographic counterpart to the intricate, wiry hatchings found in many of his intaglio works. During the same year that Hart had produced these tonal prints, he painted a watercolor titled *Carnival, New Orleans* (fig. 100) which was also executed in a lyrical, tonalist style. In the early 1900s, he had flirted with Tonalism in one of his South Sea landscapes (see fig. 16) and these works indicate that some twenty years later he experimented again, briefly, with the vocabulary. Hart's interest in emphasizing tonal values in his lithographs reached its most advanced level of expression in the print *Tea Garden, Fez* (fig. 101), which was executed sometime after 1928. In this work, one of the last prints of his career, Hart used an expressive application of liquid tusche to create fluid, painterly effects, rendering the highly summarized garden setting and the garments of the figures in a brushy, lightly textured film of tone. During the late twenties, Hart began to focus most of his printmaking efforts on lithography. This might have been due to the fact that the painterly values he wanted to create were easier to achieve through planographic means, since comparable tonal effects in intaglio techniques would have required more time-consuming and complex manipulations of the matrix. Intaglio methods require various steps of drawing, toning, redrawing, and retoning; but a single drawing on one stone (or in the case of many of Hart's lithographs, a zinc plate) was sufficient to produce a lithograph.

In producing his intaglio pieces, Hart had pulled his own impressions.[53] But, since printing a lithograph is a much more complex technical process, like many artists, Hart relied on the skill and assistance of

details of this tropical landscape were reformulated into dark, flattened areas of tone that were arranged in a kind of compressed cubist space.

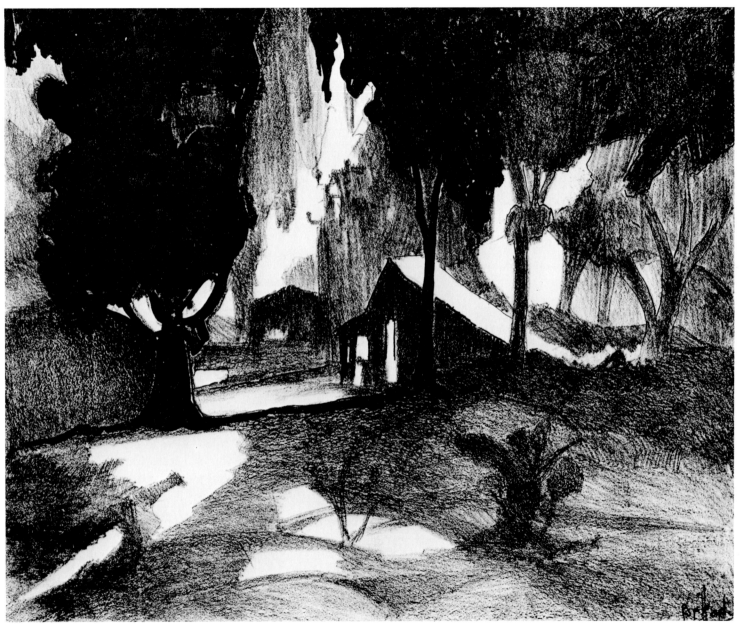

fig. 97 *MOONLIGHT IN JUNGLE*, 1924, lithograph, 11⅞ × 12⅞″

trained printers, including George Miller and J.E. Rosenthal.[54] Along with Bolton Brown, George Miller was one of the premier lithographic printers in the United States during the first decades of the twentieth century, and a number of significant artists including Arthur B. Davies, Jules Pascin, Joseph Pennell, George Grosz, Walt Kuhn, Rockwell Kent, and Childe Hassam relied on his services. Hart was probably drawn to Miller's shop because of his reputation for producing high quality editions and his dedicated efforts in trying to reproduce an artist's tonal values with extreme fidelity. It is also possible that Hart was directed to Miller's shop by Edith Gregor Halpert, proprietor of the Downtown Gallery; Halpert, who was Hart's primary dealer in the twenties, often encouraged the artists she represented to have their lithographs printed by Miller.[55] While J.E. Rosenthal was less well known than Miller, he assisted several notable

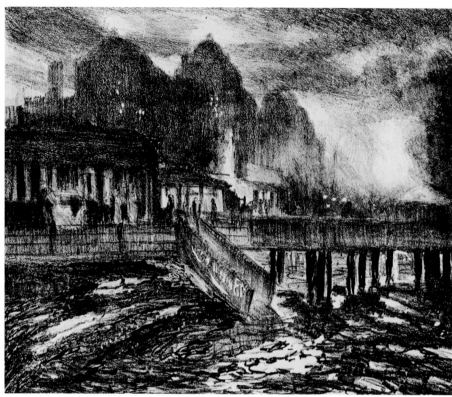

fig. 99 *ATLANTIC CITY*, 1924, lithograph, 11½ × 12⅞″

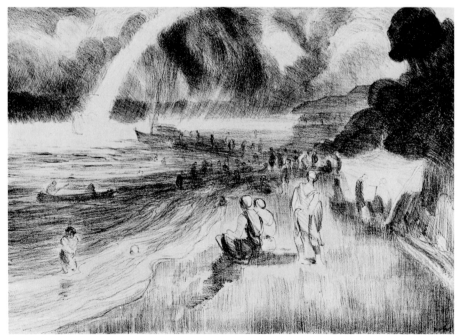

fig. 98 *THE RAINBOW*, 1924, lithograph, 11 × 15⅝″

artists with their lithographic printings, such as Max Weber and Walt Kuhn.[56] As with Miller, Hart was probably advised to collaborate with Rosenthal by Halpert, since his studio also printed a large number of works by artists affiliated with the Downtown Gallery. Hart's lithographic work on zinc plates was most likely done by Rosenthal, since his studio was known for its specialized service in zincography.[57] Because of the increased expense and rarity of lithographic stones, the use of zinc plates for lithographic printing became more common in the early 1900s.[58]

One of the more innovative aspects of Hart's graphics was his experimentation with various color printmaking techniques. A large number of Hart's efforts in color printing involved hand tinting his black and white lithographic images with watercolor washes, two examples of which are his 1922 print *Lunch Hour* (see fig. 94) and *The Gamblers* of 1924 (see fig. 78). He also executed hand colored versions of the lithographs *Juanita, the Indian Princess Serving Tea for the Vagabond Artist, The Corral, Tzararacua Falls–Urapan* and *Tahiti Woman* (not illustrated). Yet, Hart also attempted more complex experiments with color intaglio printing, in which his prime objective was to integrate color more thoroughly with the graphic impression, rather than simply overlay an existing black and white design with a tinted wash. Several notable examples of his work in color are reproduced here, including *Tahiti*

Washwomen of 1925 (plate 11), which was executed in etching, sandpaper, and roulette; a softground print titled *Orizaba, Mexico,* also of 1925 (plate 12); and *Sea Waves,* a print in aquatint and softground which dates from 1926 (plate 13). In executing these works, Hart used an *à la poupée* method, meaning that all of the different colors that are used for printing an image are applied to a single plate. This type of approach is much less complex than some of the more elaborate color methods in intaglio that involve cut or multiple plate techniques; in employing these techniques, separate plates or parts of plates are reserved for each color, and printing the image requires the use of very exacting registration methods. In studying Hart's graphic oeuvre, it appears that he preferred to base the technical complexity of his prints on experimental combinations of different grounds and processes, rather than on more intricate printing

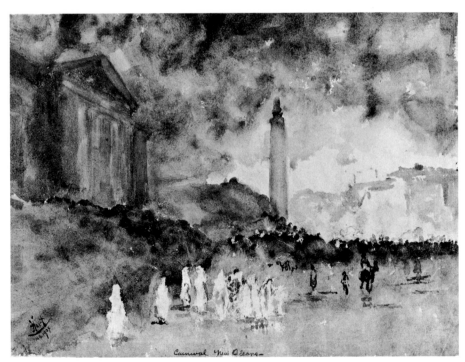

fig. 100 *CARNIVAL, NEW ORLEANS,* 1924, watercolor, 10¼ × 14¼″

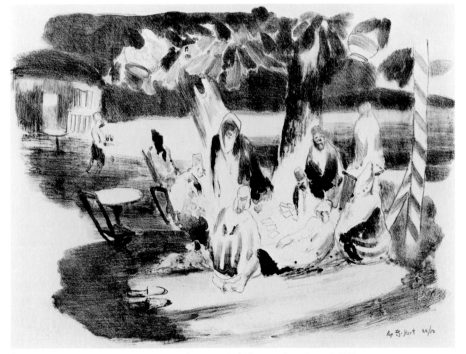

fig. 101 *TEA GARDEN, FEZ,* after 1928, lithograph, 15 × 21¾″

and inking techniques. In *Tahiti Washwomen, Orizaba, Mexico,* and *Sea Waves,* Hart used the different tonal methods of sanding, softground, and aquatint to produce a grainy surface texture on his plates which, when coupled with loosely applied colored inks, created delicate, painterly effects that have been likened to those of a monoprint.[59]

Hart's use of color was perfectly suited to such subjects as *Sea Waves* and *Tahiti Washwomen.* In these pastoral, almost visionary depictions, the use of delicately colored inks served to enhance the dream-like character of these images. For example, a black and white version of *Tahiti Washwomen* (fig. 103) has the appearance of an incisive, reportorial pen and ink travel sketch. Yet, printing the work in color dramatically alters one's perception of the subject, as Hart's use of glowing, diaphanous tints allowed him to transform a rather matter-of-fact travel vignette into a more idyllic, timeless vision. *Sea Waves,* with its ethereal nudes and idealized setting, was almost certainly inspired by the symbolist iconography of Arthur B. Davies' works, which often feature mythical landscapes populated with nudes, classically draped figures, and fantastic creatures such as unicorns; however, like Hart, Davies also transformed more mundane depictions into pastoral, imaginary scenes by employing a subjective palette of non-naturalistic, delicate tonalities. During the first decades of the twentieth century, several American artists besides Davies, including Manierre Dawson, Rockwell Kent, and Edward M. Manigault, produced symbolist works that depict nudes and romantic figures in visionary landscapes.[60] Although Hart's interest in some of the thematic conventions of American Symbolism were most likely derived from the art of an intermediary figure like Davies, several of his works such as *Sea Waves, Tahiti Washwomen,* and the watercolor *The Brook* (not illustrated) can be linked to this introspective, nineteenth-century strain in early American modernism. Moreover, Hart's symbolist graphics can be related to a less well known practice among several of the New York Realists including Robert Henri and John Sloan, who reserved printmaking for their more fanciful artistic statements, executing pastoral, neo-pagan themes in monotype in the early 1900s.[61] It is possible that Hart, Henri, and Sloan viewed printmaking, with its intimate qualities and emphasis

on a personalized aesthetic, as one of the more appropriate vehicles for developing such subjective, imaginary depictions.

One of Hart's more sophisticated and accomplished essays in color printmaking was his lithograph *Mexican Orchestra* (plate 15), which was produced sometime after 1928. This piece—executed in a large, ambitious format—can be viewed as a masterful culmination of several of Hart's major concerns in printmaking, as his interests in tonal effects and integrated color were synthesized here in a single work. Many of the forms in *Mexican Orchestra* were printed in broad, wash-like areas of tone, overlaid with a sketchy web of dark lines that simulate the textured markings of charcoal. The formal effects of *Mexican Orchestra* are quite

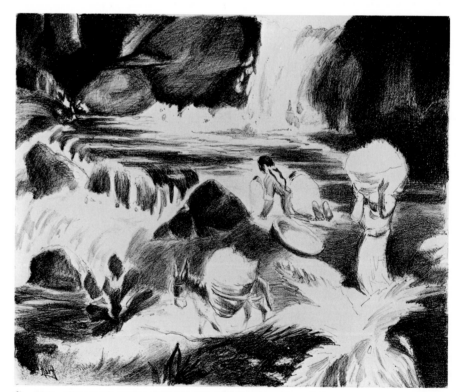

fig. 102 *TZARARACUA FALLS–URAPAN,* after 1928, lithograph, 16⅛ × 20⅜"

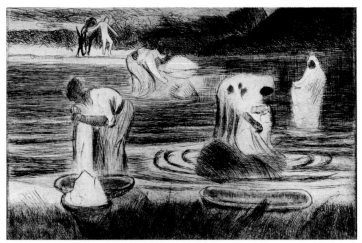

fig. 103 *TAHITI WASHWOMEN,* 1925, etching, sandpaper,
and roulette, 10 × 14″

similar to many of Hart's mixed media works from the twenties, in which
he combined expressive mixtures of watercolor and charcoal.

Hart's interest in color printmaking and his attempts to incorporate
coloristic effects into his works were actually quite radical for the 1920s,
as the American printmaking tradition was still firmly oriented towards
an aesthetic of black and white.[62] Official taste in fine art printmaking
was particularly opposed to color, owing to its negative, low art con-
notations, since color was used widely in a number of commercial
reproductive methods. This entrenched prejudice towards the use of color
in printmaking was not overturned until the 1930s, when the many
experiments in color lithography, serigraphy, and other methods that were
conducted under the auspices of the Federal Arts Program helped to
stimulate a wider interest among American artists in color graphics. As
Riva Castleman stated in her recent study, *American Impressions: Prints
Since Pollock,* very few prints were executed in color in the United States
before the FAP's innovative graphic arts programs.[63] In the early twenties,
Davies had experimented with color lithography and during this same
period Max Weber employed color in a large number of his modernist
relief prints.[64] Hart, actually, was part of a select group of American

printmakers in the 1920s who were seriously committed to exploring the
aesthetic possibilities of color in the graphic arts. Hart's *Mexican
Orchestra,* with its large scale, multiple color scheme, and intricate
layering of tones, was a particularly ambitious undertaking for the late
twenties, before color lithography was widely practiced in the United
States.

The innovative nature of Hart's printmaking can be more fully
understood when placed within the context of American printmaking in
the early 1900s and in light of some of the radical graphic tendencies that
emerged at this time. During the late nineteenth century, American
printmaking was largely dominated by the European tradition of the
peintre-graveur (the artist as printmaker), which had been initiated in the
mid-1800s by several artists of the "Barbizon School" including Theodore
Rousseau and Jean-Francois Millet, and developed further by such figures
as Charles Meryon, Seymour Haden, and the American expatriate artist
James A.M. Whistler. The *peintre-gravure* tradition in both Europe and
the United States in the late 1800s was primarily centered around the
revival of etching, a medium that was prized for its ability to accommo-
date spontaneous effects and personalized draftsmanship. Basing many of
their technical practices on seventeenth-century Dutch printmaking
(Rembrandt's etchings were particularly seminal), the artists of the
etching revival experimented with tonal values by varying the inking and
wiping of their plates. Another hallmark of the art of *peintre-gravure* was
the painstaking development of an intaglio image through a complex
process of stopping out, redrawing, and repeated acid baths—some artists
created as many as a dozen states of a single image in which there is often
only a slight variation in the line work. Many of the prints produced
during the period of the etching revival were the result of a very sensitive
handling of the medium and contain delicate modulations in line and ink
tone. The subject matter of these works was largely drawn from a
circumscribed range of turn-of-the-century themes that focused on pic-
turesque old-world views and pastoral landscapes.

The etching revival survived into the first decades of the twentieth
century in the United States, but it was basically a conservative con-

tinuation of the tradition; in the hands of second-generation printmakers, the rarefied aesthetics and experimental methods of Whistler and Haden degenerated into a kind of formulaic graphic mode. The print historian James Watrous discussed this development in *A Century of American Printmaking,* writing that:

> The stimulating ventures of the late-nineteenth century American artist-etchers and encouragements of their efforts slackened as the new century began. Printmakers became less innovative and sponsors' enthusiasms for American printmaking diminished. Many of the second generation etchers continued for years to emulate the prints of the French and Whistler and Haden....they became latter-day heirs and, in some degree, victims of a dominating heritage handed down by the European artist-etchers who had nurtured the revival of the art in the nineteenth century....a time had come for new conceptions by American printmakers who were impelled to such different artistic goals and to temper the proliferation of prints from an aging tradition that could no longer foster fresh conceptions and progressive change.[65]

During the 1910s and 1920s, a younger generation of artists that included such figures as John Sloan, Edward Hopper, Arthur B. Davies, Max Weber, and John Marin rejected the moribund practices of the etching revival and sought to forge a more progressive approach to printmaking. Many of their works reflect a bolder manipulation and a more individualistic handling of various intaglio methods. They were generally less concerned with mastering intricate technical effects than with formulating a more expressive, personalized graphic language. Not only did these artists eschew many long-established technical and stylistic traditions in the graphic arts, but they also broke away from the more genteel thematic conventions of the painter-etchers. Rather than focusing on quaint architectural vignettes and romantic landscape views, many of these younger, more radical printmakers took a keen interest in contemporary

American life and produced a large number of works that were devoted to urban subjects and prosaic regional themes. In much the same manner that progressive artists had challenged the conservative standards of academic art in the early 1900s by encouraging a more pluralistic approach to subject matter and style, radical printmakers in the 1920s and 1930s countered conservatism in the graphic arts by producing works that displayed a greater diversity in media, thematic content, and style.

In many articles that were written during the 1920s extolling the innovative advances in modern American printmaking, Hart was invariably cited as being one of the more significant figures whose works had been influential in revolutionizing and revitalizing graphic practices in the United States.[66]

For instance, the noted print specialist Carl Zigrosser, who was one of the leading champions of progressive developments in American graphics during the 1920s and 1930s, often included Hart's works in his articles discussing new trends.[67] In an artistic climate that encouraged greater experimentation and radical change in the graphic arts, Hart's bold and somewhat untutored approach to intaglio printmaking was, no doubt, viewed as being a perfect antidote to the overly refined methods of the painter-etchers. Moreover, during the late 1880s and early 1900s, most of the printmakers associated with the etching revival in the United States followed very strict and complex technical methods that were outlined in such celebrated manuals as Maxime Lalanne's *A Treatise on Etching.* Hart's unconventional mixed media approaches and his seeming disregard for established methods were, no doubt, perceived as being a daring break from the outmoded technical formulas of the etching revival.

Hart's efforts in lithography were, perhaps, equally innovative in the intaglio media, considering that before the late 1910s in the United States lithography was viewed and utilized more as a commercial medium than as an artistic form. Prior to this time, the laborious task of printing lithographs and the lack of artistic ateliers had discouraged printmakers in the United States from using lithography. This situation changed in the late 1910s, when the printers Bolton Brown and George Miller opened shops where they assisted artists in printing their works. In the early

1900s and in the 1910s such artists as Albert Sterner, Joseph Pennell, and George Bellows began to experiment with lithography as an artistic medium, and it was largely through their work and the collaborative efforts of Brown and Miller that lithography became established as a fine art medium by the 1920s. During this decade, other innovative artists including Adolph Dehn, Louis Lozowick, Yasuo Kuniyoshi, and Stuart Davis were attracted to lithography and made important contributions to its artistic and technical advancement. By the 1910s, artistic etching was an established tradition in the United States and, as a result, many practitioners of the craft resisted the progressive solutions that were being formulated by younger, more avant-garde printmakers; however, lithography had no such fine art ancestry in this country and many artists working in the medium enjoyed a greater freedom in experimenting with its aesthetic possibilities without breaching sanctioned codes of craft. Through his concentrated efforts in lithography and his experimental use of color and various textural and tonal effects, Hart was recognized both during his own day and by later print scholars as being a significant figure

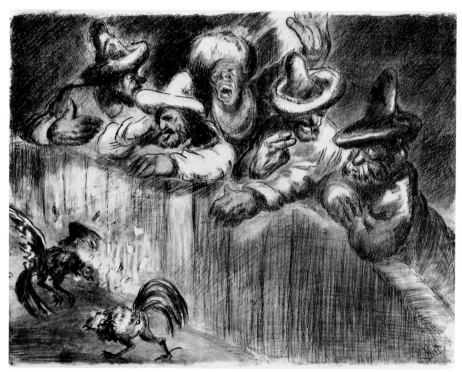

fig. 105 *THE JURY*, 1927, collotype, 16 × 21″

who expanded upon the technical and artistic potentialities of the medium.[68]

During the late 1920s, Hart experimented briefly with collotype (also known as heliotype and photogelatin printing), a high-quality reproduction process related to lithography in which a gelatin-coated glass plate is used to fix the image. In the late 1920s and early 1930s, a number of American printmakers experimented with collotype as a means of producing a large volume of fine prints at a reduced cost.[69] Hart executed five works in 1927 using the collotype method, *Juanita, My Indian Princess* (see fig. 60), *Contentment* (fig. 104), *The Jury* (fig. 105), *Matching and Weighing the Birds*, and *The Hero, Champion High Diver of Guadalupe* (not illustrated). It is possible that after working in some of the more rigorous and expensive intaglio and planographic processes,

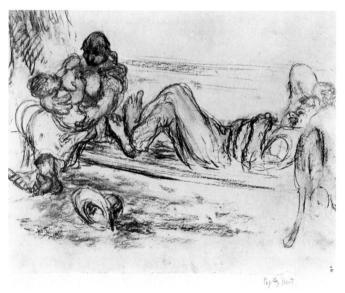

fig. 104 *CONTENTMENT*, 1927, collotype, 13⅝ × 18¾″

Hart turned to collotype in order to execute fairly high-quality graphic impressions in a more expedient, less costly manner.

Hart began to receive a great deal of critical recognition for his achievements in printmaking only a few short years after he began to work in the medium, and his ascendancy within the print world was surprisingly swift. In 1923, he began to exhibit his works in the annual exhibitions sponsored by the Brooklyn Society of Etchers, an organization that was founded in 1915 with the express purpose of advancing the work of American etchers and encouraging progressive developments in the medium.[70] In 1925, Hart was elected president of the Society and he was nominated for a second term the following year (his appointment followed the presidency of John Taylor Arms, a conservative, albeit highly respected, printmaker who was sympathetic to more avant-garde tendencies in the graphic arts). During the twenties and early thirties, Hart's works were featured in many important publications on the graphic arts, such as Frank Weitenkampf's survey history *American Graphic Art,* James Laver's study *A History of British and American Etching,* and Ralph Flint's *Contemporary American Etching.*[71] Hart was also singled out as being a major figure in American printmaking by Alfred H. Barr, Jr. and Holger Cahill in their *Art in America: A Complete Survey.*[72] Hart was awarded several prestigious prizes for his prints in the twenties and, in the early part of the decade, his graphics began to be acquired by a number of museums including the Brooklyn Museum, the Metropolitan Museum of Art, the New York Public Library, the Smithsonian Institution, the British Museum, the Victoria and Albert Museum, and the Art Institute of Chicago. His prints, also, were successful commercially and it was because of the high sale of his graphics during the twenties that Hart was able to abandon his commercial work and devote himself exclusively to his fine art.

Hart's graphic achievements were honored by the Prints and Photographs Division of the Library of Congress, which purchased his 1925 intaglio print *Happy Days, Self-Portrait* (fig. 106). This work was acquired in the 1930s for the Joseph and Elizabeth Pennell Collection and Fund which had been established in 1926 for the purpose of collecting

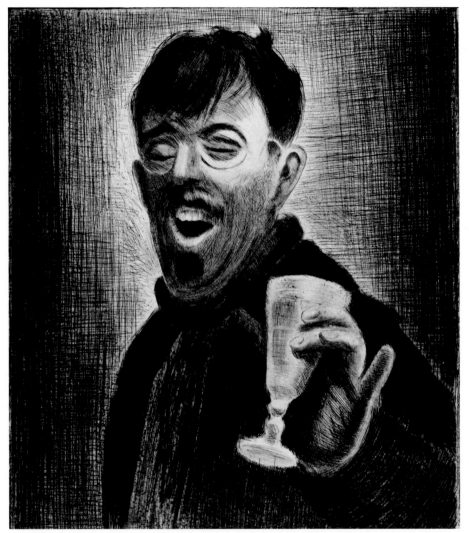

fig. 106 *HAPPY DAYS, SELF-PORTRAIT* 1925, etching, 15⅞ × 12″

"original prints by modern artists of any nationality living or who have produced work within the last one-hundred years, the prints so purchased to be of the greatest excellence only."[73] This print, which shows the artist heartily lifting a wine glass, was based on a self-portrait in oil that Hart

had painted in Paris in 1907. But, as the print version was executed during the era of prohibition, this scene of drunken merriment was, no doubt, intended to be a humorous flouting of the legal and social mores of the day.

Although Hart often combined various artistic materials in his works during the 1910s, his experimentation with mixed media techniques in printmaking might have prompted him to develop more original and elaborate combinations of media in many of his drawings and watercolors of the late 1920s. During this period, Hart began to produce works in which one can often detect a complex mixing of such divergent materials as watercolor, gouache, charcoal, and pen and ink. One of Hart's more successful efforts using this method is his 1930 work *Flower Market, Paris* (plate 16). In this view, the market stands and the figures were executed in incisive pen and ink strokes, while the garments and the clusters of flowers were described through freely applied washes of paint and energetically scribbled areas of pastel and charcoal. While Hart has been noted for his innovative mixed media techniques in printmaking, he has also been noted for his experimental efforts to enrich and expand upon the formal character of watercolor by investing the medium with a greater range of textural values.[74] In many of his watercolors from the 1910s and the early 1920s, Hart was not interested solely in coloristic optical effects, but attempted to convey some of the textural and material qualities of his pictorial elements by using a broken, stippled brushstroke or solidly painted areas of tone; however, by blending transparent washes of watercolor and semi-opaque layerings of gouache with charcoal and pastel, Hart was able to create luminously colored forms that also have a strong sense of plasticity and material structure. Hart's involvement with printmaking might also have stimulated his interest in producing works that were based purely on graphic line as, in the 1920s, he executed a large number of drawings in charcoal. Two excellent works in this medium are an untitled sketch of wild horses (fig. 107), and a grim view of a butcher shop interior (fig. 108), a subject that is reminiscent of similar depictions by Daumier. These works are two of the most forceful and expressive renderings of Hart's career, as the powerful musculature of the horses and the vigorous, tearing action of the butcher were denoted through dense clusters of rough, agitated strokes of charcoal.

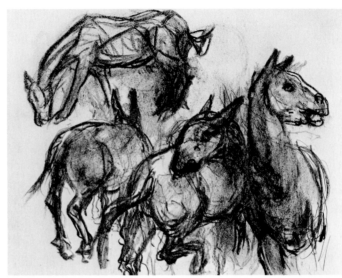

fig. 107 Untitled, c. 1920–1933, charcoal and pencil, 8 × 9¾″

fig. 108 Untitled, c. 1920–1933, charcoal, 15 × 20″

fig. 109 Jules Pascin, *POP HART AND FRIEND*, c. 1929, frottage, 17¾ × 27¼″, private collection. As reproduced in *The Edith G. Halpert Collection of American Paintings*, Sotheby Parke Bernet, 1973

In 1929, Hart made his last trip to Mexico, visiting Urapan, and embarked on an extensive tour abroad which included France, Spain, and North Africa. In 1927 or 1928, Hart had been reunited with Jules Pascin in the United States through their mutual association with the artist George Biddle.[75] Pascin had returned to the United States for one year in 1927 to retain his American citizenship. During Hart's trip to France in 1929, he remained in Paris for the entire summer, spending time with Pascin and a circle of artists that included Emil Ganso, Ernest Fiene, Stuart Davis, and the gallery dealer Edith Gregor Halpert.[76] At this time, Pascin executed a sketch in frottage that depicts Hart with a young woman draped across his lap, one of his hands thrown languorously across her breasts (fig. 109). This provocative and uncharacteristic portrayal of Hart as a playful, lecherous figure contains a tone of humorous eroticism that is one of the major hallmarks of Pascin's art. Among the works Hart executed during his stay in Paris are *American Artists Croquet Club, Luxembourg Gardens, Paris* (fig. 110) and *Flower Market, Paris*. Hart also did an ink sketch in Paris that he later translated into a lithograph, titled *Mr. American in France* (fig. 111), in which he

fig. 110 *AMERICAN ARTISTS' CROQUET CLUB, LUXEMBOURG GARDENS, PARIS*, c. 1929, pen and ink, watercolor, and charcoal, 15⅜ × 20⅝″

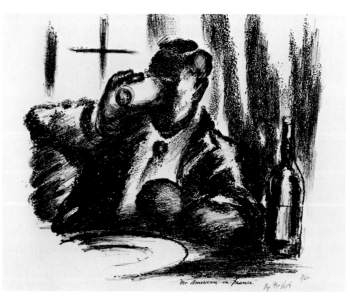

fig. 111 *MR. AMERICAN IN FRANCE*, after 1928, lithograph, 16⅛ × 21⅜″

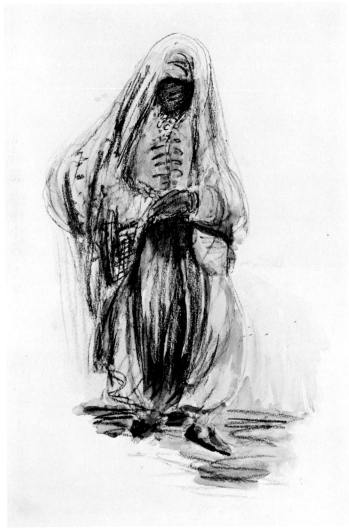

fig. 112 Untitled, c. 1930, crayon and watercolor, 18 × 12"

subjects. For example, a work that is typical of his art from this period is an untitled drawing of an exotically costumed Arab woman, which was rendered in fluid, sketchy strokes to suggest the rapid movement of the figure (fig. 112). Hart also remained interested in landscape subjects during the late twenties and, while visiting Palma, he executed several marine views, such as the scene reproduced here (fig. 113), in which he

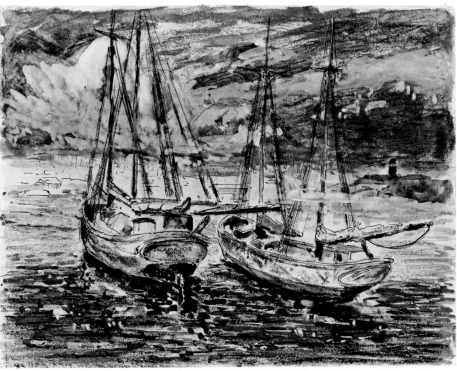

fig. 113 *THE CALAMAJOR, PALMA*, c. 1929–1930, gouache, pastel, and pen and ink, 14½ × 19⅜"

created a unique graphic effect by using quick jottings of tusche to mimic the spattered markings of an ink and brush drawing.

While in North Africa, Hart journeyed through Morocco and Algeria, and many of the works that he produced during these travels reflect his active, ongoing interest in market scenes and exotic figural

employed his experimental mixed media technique. The late twenties and early thirties was an eclectic period for Hart, as he produced works that ranged from the broad caricature of *American Artists, Croquet Club* ... to more delicately rendered representational essays such as an untitled portrait study of a young Arab woman which was done in Algiers in 1930

(fig. 114). It is possible that during the latter part of his career, Hart felt that he had fully developed his artistic powers and desired to test his facility by returning to a more traditional and, perhaps more technically demanding, representational mode.

In the twenties and early thirties, Hart also produced works that can be related to the American Scene movement. During this period, a large number of artists rejected elitist European modern art and theory and embraced more representational styles. The formation of the movement actually arose from a complex of influences, but one of the most important was the growing interest in regional cultural values in the United States in the 1920s. The onset of the Depression and its attendant social problems also focused greater attention on American life during this period. One of the most ardent supporters of the American Scene movement was the critic Thomas Craven, who advocated the development of a movement that was based on American themes and indigenous, realist styles. The American Scene movement was actually comprised of two distinct currents—Regionalism and Social Realism. The major figures associated with Regionalism were the painters John Stuart Curry, Grant Wood, and Thomas Hart Benton, whose works often reflect a nostalgic view of rural American life (in particular small-town life in the Middle West) and a reverence for its cultural values and activities. Unlike the Regionalists, the Social Realist artists, including such figures as Ben Shahn and Philip Evergood, were not as supportive of nationalistic, rural values (their art dealt generally with urban themes), and usually criticized social conditions in the United States, particularly the social and economic inequities stemming from industrial capitalism. The formation of the Social Realist movement was actually prompted by the onset of the Depression and most works associated with it focus on the social and economic hardships of the era. A large number of Social Realists worked in an expressionist figural mode based on an amalgam of styles that ranged from the expressionism of Pascin to the German *Neue Sachlichkeit* and Mexican proletarian art. Several of the Regionalist painters had also formulated an expressionistic approach to the figure.

While the proponents of the Regionalist and Social Realist move-

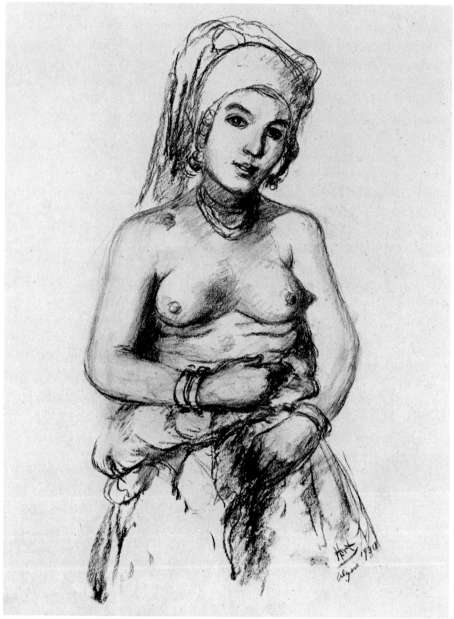

fig. 114 Untitled, 1930, charcoal and pencil, 25 × 18⅝″

ments maintained divergent ideologies, members of both factions were generally opposed to American capitalist society and the tenets of European formalist abstraction. In addition, both Social Realists and Regionalists believed that artists should create works that reflect their immediate environmental experience, and the primary purpose of art was to serve a communicative function, thus explaining their adherence to more accessible, realist styles.

Hart has often been related to the American Scene movement and a number of his works from the 1920s and early 1930s do reflect certain stylistic and thematic interests that are associated with the current. For example, although Hart did experiment with a variety of modernist vocabularies, he remained committed to realist and figural concerns, and his art reflects a regionalist preoccupation with observing and recording the cultural practices and activities of the various locales that he visited. These aspects of Hart's work were admired by the major proponent of the American Scene, Thomas Craven, who wrote:

> This extraordinary figure shunned the dreary art atmosphere of New York, and the cliquish painters dominated by Stieglitz—he was an independent adventurer in art and life. Undisciplined, … he was saved from capricious estheticism by his intense love and appreciation of the world and its inhabitants, his rambling, insatiable curiosity in the types, faces, habits and amusements of the lower orders of society.[77]

While he often created romantic depictions of the different cultures that he studied, he did not promote and mythologize aspects of regional life in the manner of Benton, Wood, and Curry. As Patricia Eckert Boyer has noted, "…Hart's personal form of regionalism depends not on one geographic locale, but on the sensitive, humorous depiction of the people and activities of the many regions that he visited."[78] Hart did produce one work in 1933, *Depression* (fig. 115), that clearly can be related to Social Realist art, as he depicted a group of unemployed men loitering and dozing in a train station; one figure has even assumed a despondent

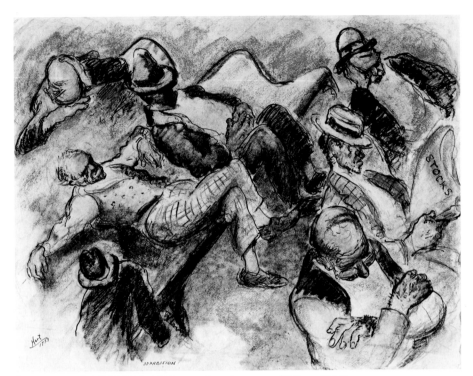

fig. 115 *DEPRESSION*, 1933, pastel and crayon, 17½ × 23½"

posture, burying his face in one hand. *Depression* is similar to Ben Shahn's *Scott's Run, West Virginia*, which also shows unemployed men, standing aimlessly by a railroad track, each wearing an expression of numb inertia. In 1933, Hart's etching *Working People* (fig. 116), which depicts a group of weary commuters trudging through the rain across a train platform, was shown at the John Reed Club of New York in an exhibit of Social Realist art titled "The Social Viewpoint in Art."[79] Although Hart had made *Working People* in 1925, the organizers of the exhibit evidently felt that the somber tones and dejected posture of the figures conveyed the cultural malaise of the Depression era.

It is important to note that during his career, with the exception of his original experiments in the graphic arts, Hart was largely a follower of

fig. 116 *WORKING PEOPLE*, 1925, drypoint, 9½ × 13"

various established tendencies. Yet, with his ongoing interest in regional subjects and development of an expressionist figural idiom in the early twenties, Hart can be said to have anticipated two of the major currents in American art of the late 1920s and the 1930s. His career extended into a period when several artistic concerns that were equivalent to his own personal aesthetic interests gained a wide, collective following. If Hart had lived into the 1930s, and continued to work in this manner, he might have become recognized as a major figure associated with the American Scene movement.

During the twenties, but most particularly towards the middle and latter part of the decade, Hart's work began to attract increasing critical, scholarly, and commercial attention. During this period his work was included in numerous exhibitions, and museums began to acquire his prints and watercolors. Aside from many commercial gallery shows, Hart had several prestigious one-man exhibitions. For example, in 1926, the Art Institute of Chicago organized an exhibit of his watercolors, drawings, and prints and, in 1927, the Los Angeles Museum included his work

in a large two-man show. In 1929, several of his pieces were exhibited in an important exhibition at the Museum of Modern Art entitled "Paintings by Nineteen Living Americans" which also featured works by Pascin, Feininger, Kuniyoshi, Demuth, Hopper, and John Marin. In 1927, he began to be represented by the Downtown Gallery, which was run by Edith Gregor Halpert.[80] The Downtown Gallery was extremely important in the 1920s, as it was one of the first galleries to promote the work of American modernists. In the late twenties, Halpert acquired Abby Aldrich Rockefeller as a client, who, in addition to being one of the more active collectors of modern American art and among the founders of the Museum of Modern Art, became one of the early leading collectors of Hart's work. In fact, in 1928, she officially revealed herself to be a collector of modern American art by sponsoring an exhibit of her collection of Hart's work at the Top Side Gallery.[81]

In the 1920s and 1930s, there was an increasing interest in American art among collectors, and Hart benefited from this trend. Arthur Egner, president of the Newark Museum, and Preston Harrison, an important collector of American art, began actively to acquire his work. In 1928, the Downtown Gallery published a hardcover monograph on Hart written by Holger Cahill, which helped to further establish Hart's reputation. The fact that many notable and lesser-known artists chose Hart as a subject for their portrait studies indicates the respect and admiration of his peers, and Hart's prominence within the New York artistic community. Among the more significant of these works were two busts from 1932 (figs. 117, 118) done by Reuben Nakian as part of a series of artists' portraits (Peggy Bacon, Alexander Brook, and Raphael Soyer were also in the series) and a large oil portrait done in the same year by Wayman Adams which was awarded a second prize at the National Academy of Design (fig. 119).[82] The renowned modernist William Zorach executed a pen and ink drawing of Hart in 1930 that was also part of a series of artists' portraits (fig. 120).

Although Hart enjoyed a great deal of success and recognition during the late 1920s and early 1930s, his last years were marked by failing health and financial problems that centered on a tax dispute over his property in Coytesville. While Hart had intended to visit India and

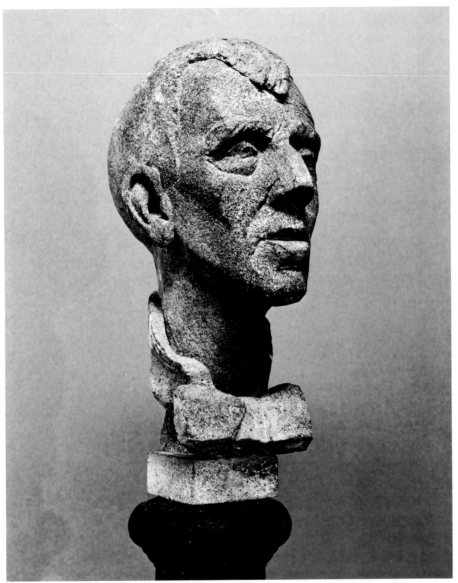

fig. 117 Reuben Nakian, *"POP" HART*, 1932, tinted plaster, 17″, Collection, The Museum of Modern Art, New York. Gift of Abby Aldrich Rockefeller. Photo credit: Museum of Modern Art

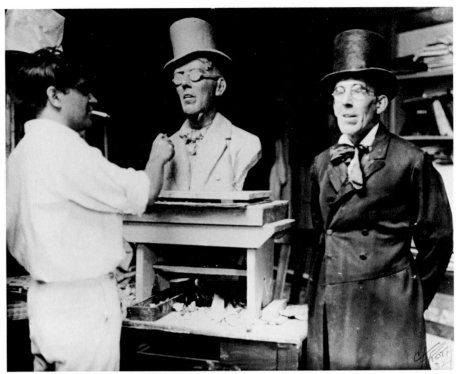

fig. 118 Reuben Nakian sculpting bust of Hart, 1932

Japan in the early 1930s, his travels were confined to shorter excursions to Cuba and Florida, undoubtedly due to his poor health. During the mid-teens he had become re-acquainted with his brother William, who had taken over the family printing business, opening a factory in Kew Gardens, New York; and over the years, he had grown quite close to his niece, Jeane Hart, whom he began to tutor in art during the 1920s. In December of 1932, just nine months before his death, Hart's artistic achievements were honored in his home state with a one-man exhibition at the New Jersey State Museum in Trenton. After spending many months in various sanitariums, the artist died of cancer on September 9, 1933. His funeral services were attended by his friends Frank Weitenkampf and Jerome Myers, among others. Upon Hart's death, Jeane Hart became the

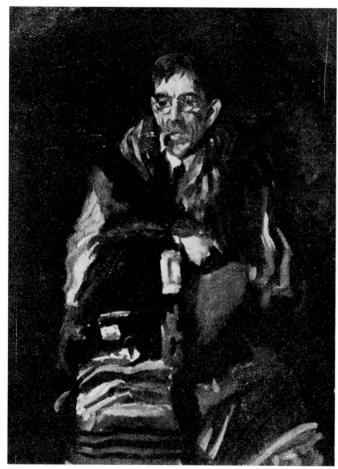

fig. 119 Wayman Adams, *GEORGE "POP" HART*, 1932.
As reproduced in *The Art Digest*, October 1, 1933

sole beneficiary of her uncle's estate, which included the bulk of his work. For the remainder of her life she tirelessly promoted his work. Her efforts, through a number of exhibitions that she helped to organize in the decades following World War II, were largely responsible for maintaining interest in his work.

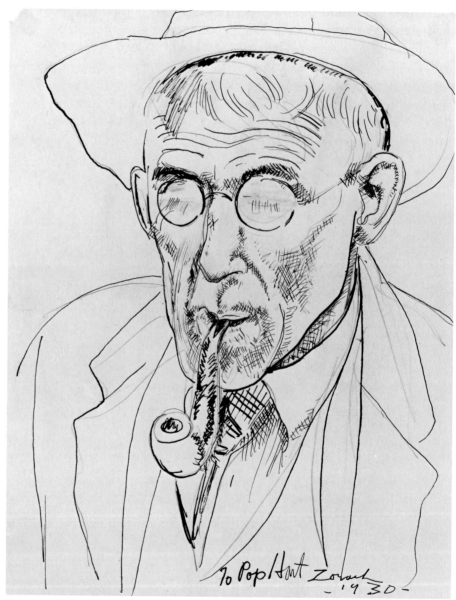

fig. 120 William Zorach, *"POP" HART*, 1930, pen and ink, 11 × 8½"

On the occasion of Hart's death, numerous obituaries appeared in newspapers and art journals. A large number of galleries and museums including the Downtown Gallery, the Grand Central Gallery, the Art Institute of Chicago, the Brooklyn Museum, the New York Public Library, and the Detroit Institute of Arts honored Hart's career by mounting memorial exhibitions of his work. The official recognition of Hart's artistic achievements appeared in 1935 with the Newark Museum's massive retrospective exhibition of his work.

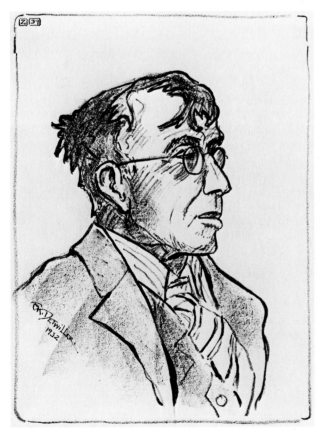

fig. 121 F. K. Detwiller, *"POP" HART,* 1932, lithograph, 11 × 8″

NOTES

(Author's note—the designation "George Hart Papers" refers to the George Hart Papers that are located in the Special Collection and Archives Department of the Archibald S. Alexander Library, Rutgers, The State University of New Jersey. "Hart Microfilm" is a shortened term for the George Hart Microfilm that is in the collection of George Hart Papers.)

INTRODUCTION

1. Calvin Tompkins, *Off the Wall: Robert Rauschenberg and the Art of Our Time* (Garden City: Doubleday and Company, Inc., 1980), 179.

2. See the following books for references to Hart: Edward Alden Jewell, *Modern Art: Americans* (New York: Alfred A. Knopf, 1930), 34; Thomas Craven, *Modern Art: The Men, the Movements, the Meaning* (New York: Simon and Schuster, 1934), 326; Sheldon Cheney, *The Story of Modern Art* (New York: The Viking Press, 1941), 583; Holger Cahill and Alfred H. Barr, Jr., eds., *Art in America in Modern Times* (New York: Museum of Modern Art, 1934), 32.

3. "George O. Hart, Artist, is Dead," *New York Herald Tribune,* 10 September 1933; "George O. Hart, Artist, Buried," *Newark Evening News,* 10 September 1933; "George O. Hart Dies; American Painter, Etcher," *New York Sun,* 10 September 1933; " 'Pop' Hart, Artist, Philosopher, Dies," *New York Times,* 10 September 1933; "Services Held for 'Pop' Hart," *New York American,* 11 September 1933; "Three Who Have Gone: George Luks, Pop Hart and Gari Melchers," *New York Times,* 14 November 1933.

4. " 'Pop' Hart, Creative American Genius and Philosopher is Dead," *The Art Digest* 8, 1 October 1933, 13.

5. *Ibid.*

6. Edward Alden Jewell, "The Realm of Art: On the Passing of Pop Hart," *New York Times,* 17 September 1933.

7. Helen Appleton Read, " 'Pop' Hart Memorials," *Brooklyn Daily Eagle,* 3 December 1933.

8. Letter to the author, from Irving Stone, October 18, 1985. Also, the George Hart Papers contain correspondence between Irving Stone and Jeane Hart that concerns Stone's interest in writing a biography or an article on Hart; this correspondence dates from the late 1930s and early 1940s.

9. See Alfred H. Barr, Jr., *Paintings by Nineteen Living Americans* (New York: The Museum of Modern Art, 1930), 28–31; *American Painting and Sculpture 1862–1932* (The Museum of Modern Art, 1932), 17; Holger Cahill and Alfred H. Barr, Jr., eds., *Art in America: A Complete Survey* (New York: Halycon House, 1939), 105; Cahill and Barr, *Art in America,* 32; Jewell, *Modern Art,* 34; in the 1930s Hart's work was included in an exhibition entitled "Five Americans" that was mounted at the Smith College Museum of Art. The other artists included in the show were Charles Burchfield, Charles Demuth, Edward Hopper, and John Marin; Peyton Boswell, Jr., *Modern American Painting* (New York: Dodd, Mead and Company, 1940), 50.

10. "The Social Viewpoint in Art," John Reed Club of New York, February, 1933.

11. Oliver W. Larkin, *Art and Life in America* (New York: Holt, Rinehart and Winston, 1960), 390; E.P. Richardson, *Painting in America: The Story of 450 Years* (New York: Thomas Y. Crowell Company, 1956), 368, 369; Lloyd Goodrich, *American Art of Our Century* (New York: Whitney Museum of American Art, 1961), 279.

12. William H. Pierson, Jr. and Martha Davidson, eds., *Arts of the United States: A Pictorial Survey* (New York: McGraw-Hill Book Company, Inc., 1960).

13. Una Johnson, *Golden Years of American Drawings 1905–1956* (Brooklyn: The Brooklyn Museum, 1957), 23; Theodore E. Stebbins, Jr., *American Master Drawings and Watercolors: A History of Works on Paper from*

Colonial Times to the Present (New York: Harper and Row, Publishers, 1976), 297; William H. Gerdts, Jr., *Painting and Sculpture in New Jersey* (Princeton: D. Van Nostrand Company, Inc., 1964), 211–213.

14. Gerdts, *Painting and Sculpture in New Jersey*, 211.

15. Frank Weitenkampf, *American Graphic Art* (New York: The Macmillan Company, 1924), 31; James Laver, *A History of British and American Etching* (New York: Dodd, Mead and Company, 1929), 150.

16. Carl Zigrosser, *Prints and Their Creators: A World History* (New York: Crown Publishers, Inc., 1974), 93; Cahill and Barr, *Art in America: A Complete Survey*, 105.

17. Wilhelm Weber, *A History of Lithography* (New York: McGraw-Hill Book Company, 1966), 134; Fritz Eichenberg, *The Art of the Print* (New York: Harry N. Abrams, Publishers, 1976), 518–519. See also Robert Flynn Johnson, ed., *American Prints: 1870–1950* (Chicago: The University of Chicago Press, 1976), 18.

18. Una E. Johnson, *American Prints and Printmakers* (Garden City: Doubleday and Company, Inc., 1980), 21, 30–35, 71, 152; Burr Wallen, ed., *The Gloria and Donald B. Marron Collection of American Prints* (Santa Barbara: Santa Barbara Museum of Art, 1981), 122–124 (entry on Hart by Patricia Eckert Boyer).

19. See catalogue for this exhibition by Clifford S. Ackley, *American Prints: 1914–1941* (Boston: Museum of Fine Arts, 1985); Riva Castleman, *American Impressions: Prints Since Pollock* (New York: Alfred A. Knopf, 1985), 14.

20. Hart has been related to the New York Realist and American Scene movements in the following sources: John I.H. Baur, *Revolution and Tradition in Modern American Art* (Cambridge: Harvard University Press, 1951), 82; *American Painting and Sculpture*, 17; Cahill and Barr, *Art in America*, 32; Cahill and Barr, *Art in America: A Complete Survey*, 105; Boswell, *Modern American Painting*, 50; Cheney, *Story of Modern Art*, 583; Richardson, *Painting in America*, 368; Stebbins, *American Master Drawings*, 297; Gerdts, *Painting and Sculpture in New Jersey*, 212.

21. James Schuyler, "Reviews and Previews: George Overbury Hart," *Art News* 58, February, 1960, 14.

22. The following selected articles have stressed Hart's lack of formal training and his reclusive nature: George O. ("Pop") Hart, " 'Pop' Hart, Artist, Who Quit Civilization for Corner Where He Can Work and Suffer, Picks Oaxaca, Land of Beautiful Women," *Brooklyn Daily Eagle,* 17 January 1926; see article titled "Hart, Noted Etcher, Flees Civilization," which can be found in the George Hart Papers; Edgar Cahill, "The Odyssey of George Hart," *Shadowland* 8, June 1923, 11; "Obituaries," *Art News* XXXI, September 1933, 6; Mildred J. Prentiss, "A Memorial Exhibition of George Overbury Hart, *Bulletin of the Art Institute of Chicago* 27, November 1933, 100. It should be noted that the emphasis on Hart's lack of formal training has been overstressed. For example, as a child he was tutored in art by his grandfather, Samuel Overbury Hart. This was followed by formal training in a New York art school in the late 1800s, and he took classes at the School of the Art Institute of Chicago in 1894–95 and in 1896–97, and he studied for a summer at the Académie Julian in Paris in 1907. He also took sketching classes through the Penguin Club and the Whitney Studio Club in the late 1900s and early 1920s.

23. The following scholars have also stressed Hart's artistic independence in their art historical studies: Boswell, *Modern American Painting;* Thomas Craven, *Modern Art: The Men, the Movements, the Meaning* (New York: Simon and Schuster, 1934), 326; Larkin, *Art and Life in America*, 390.

24. Tompkins, *Off the Wall*, 179.

25. Larkin, *Art and Life in America*, 390.

26. Edgar Cahill, "The Odyssey of George Hart," 11.

27. "Obituaries," *Art News* XXXI, 16 September 1933, 6.

ONE 1868–1900

1. According to 1886 Cairo City Directory, Henry L. Hart was employed as a dispatcher. This information was provided in a letter to the author from Louise P. Ogg, Cairo Public Library, November 20, 1985. Little is known of Henry L. Hart, except that as a young man he served in the Union army during the Civil War, having enlisted in 1861 in Centralia, Illinois. At the time of his enlistment, his occupation was listed as farmer, Rochester, Monroe County. In 1865, he was discharged. See letter, Military and Naval Department, Springfield, Illinois, Hart Microfilm, George Hart Papers, frame 3690. His name appeared in the Cairo City Directory for the first time in 1866 and his occupation was listed as engineer.

2. Biographical outline, compiled by Jeane Hart, George Hart Papers. This biographical outline lists 1876 as the date that Henry Hart established his printers' roller business; however, this business is first listed in the Rochester City Directory in 1881, p. 640. In the 1895 Rochester Directory, an advertisement listed W.C. Hart and M.J. Zugelder as successors to Henry L. Hart. Henry Hart is not listed in any directories after 1895, and since there is no known record of his death, this may be a clue to his death date.

3. See letter, Jeane Hart to Frederick Coburn, February 6, 1942, George Hart Papers.

4. *Ibid.*

5. In her letter to the author, Louise P. Ogg noted that in the 1866 Cairo City Directory, Henry L. Hart's residence is listed as Kelsey's Boarding House, which indicates that he was probably not married at this time; however, in 1868 he was listed as having a private home address, suggesting that he was probably married sometime between 1866 and 1867.

6. See letter, Jeane Hart to Frederick Coburn, February 6, 1942, George Hart Papers.

7. *Ibid.*

8. Cahill, "The Odyssey of George Hart," 11.

9. The artist made this comment in an autobiographical essay. See Hart Microfilm, George Hart Papers, frame 3791 (whereabouts of original material unknown).

10. Blake McKelvey, *Rochester: The Flower City 1855–1890* (Cambridge: Harvard University Press, 1949), 331.

11. *Ibid.,* 331.

12. See autobiographical essay, Hart Microfilm, George Hart Papers, frame 3791.

13. Mention of this incident appears in many articles on Hart, but detailed accounts of it can be found in the following sources: "'Pop' Hart's Book," *The Art Digest,* mid-January 1929, 24; George ("Pop") Hart, "'Pop' Hart, Artist, Who Quit Civilization for Corner Where He Can Work and Suffer, Picks Oaxaca, Land of Beautiful Women," *Brooklyn Daily Eagle,* 17 January 1926; Holger Cahill, *George O. "Pop" Hart: Twenty-four Selections of His Work* (New York: The Downtown Gallery, 1928), 3; this incident was also cited in an unpublished biography of George Hart, "Over the Top with 'Pop,'" that was written by Jeane Hart, George Hart Papers (typewritten); autobiographical essay, Hart Microfilm, George Hart Papers, frame 3791.

14. Biographical essay on George Hart by Jeane Hart from interview with William C. Hart, George Hart Papers.

15. Hart, "'Pop' Hart, Artist, Who Quit Civilization," 12A.

16. *Ibid.* Although Hart states in this article that he was enrolled in drawing classes during this period, he does not indicate which school he attended. Since some thirteen art schools existed in New York at this time, such as the Cooper Union and the Art Students League, it is difficult to determine at which institution he would have studied; however, of these various schools, it is very likely that Hart attended classes at the Art Students League, as it was a liberal organization controlled and managed by students—such a school would no doubt have appealed to a fledgling artist like Hart.

17. For information on Hart's voyage to London see the following sources: Guillermo Rivas, "George 'Pop' Hart….A Yankee Gauguin," *Mexican Life,* 4 June 1928, 27; biographical outline, compiled by Jeane Hart, George Hart Papers; Hart Microfilm, George Hart Papers, frames 3791–3796.

18. This information taken from biographical timeline, compiled by Jeane Hart, George Hart Papers.

19. Wallen, *Gloria and Donald B. Marron Collection,* 122.

20. These sources state that Hart painted campaign portraits of James G. Blaine: Rivas, "Yankee Gauguin," 27; outline for "Over the Top," George Hart Papers, 1.

21. Since James Blaine's son, Emmons Blaine, was residing in Chicago during the 1890s, it is very possible that he was responsible for commissioning these campaign portraits—see David Saville Muzzey, *James G. Blaine: A Political Idol for Other Days* (New York: Dodd, Mead and Company, 1934), 471.

22. Hart discussed his experiences as a sign painter in Chicago in an autobiographical essay, Hart Microfilm, George Hart Papers, frame 3797. Mildred J. Prentiss reported that Hart worked as a sign painter at the Columbian World's Fair in her article "A Memorial Exhibition of George Overbury Hart," *Bulletin of the Art Institute of Chicago,* 27 November 1933, 100.

23. This information was provided in a letter to the author from Elizabeth D. Hoover, Registrar, The School of the Art Institute of Chicago, August 16, 1985.

24. Letter to the author, from Elizabeth D. Hoover, September 5, 1985.

25. See Donald J. Irving, Katherine Kuh, and Norman Rice, *100 Artists 100 Years: Alumni of the School of the Art Institute of Chicago–Centennial Exhibition* (Chicago: The Art Institute of Chicago, 1979), 63.

26. Roger Gilmore, *Over a Century: A History of the Art Institute of Chicago 1886–1981* (Chicago: The School of the Art Institute of Chicago, 1982), 70.

27. *Ibid.*

28. This quote taken from autobiographical essay, Hart Microfilm, George Hart Papers, frames 3797–3798.

29. *Ibid.,* frame 3798.

30. The Hart Collection in the Jane Voorhees Zimmerli Art Museum contains approximately 300 figure studies by Hart, the majority of which are undated.

31. Albert Parry, *Garrets and Pretenders: A History of Bohemianism in America* (New York: Dover Publications, Inc., 1960), 136.

32. See biographical outline, compiled by Jeane Hart, George Hart Papers; outline for "Over the Top," George Hart Papers, 2.

33. According to information in an unpublished journal by Charles Sarka,

he met George Hart in New York sometime before or during 1900. Charles Sarka Papers, Archives of American Art, 1000, 488.

TWO 1900–1910

1. Arthur F. Egner, Harry Wickey, and Elinor Robinson, *George Overbury "Pop" Hart* (Newark: The Newark Museum, 1935), 22; "Prints by 'Pop,'" *The Art Digest* 17, 1 October 1942, 10.

2. Charles Sarka Papers, Archives of American Art, 1000, 479 and 499; the following sources on Sarka also make reference to his travels with Hart to Egypt: *Tahiti, 1903: Watercolours by Charles Sarka* (New York: Bernard Black Gallery, 1963), no pagination; *Sarka Journal* (New York: Davis Gallery, n.d.), no pagination.

3. For biographical information on Sarka, see *Tahiti, 1903*; Charles Sarka Papers, 1000, 479.

4. *Tahiti, 1903*, Bernard Black Gallery, 1963.

5. Charles Sarka Papers, 1000, 488 and 491.

6. *Ibid.*, 488.

7. *Ibid.*, 491; also, see Dirks Family Papers, Archives of American Art, 854, 660. It is known that in the mid-1910s Hart was a close associate of Gus Mager.

8. Charles Sarka Papers, 1000, 488.

9. *Ibid.*, 489–491.

10. Egner et al., *George Overbury "Pop" Hart*, 22.

11. *Ibid.*

12. See the catalogue for the exhibition "Sarka Journal."

13. Charles Sarka Papers, 1000, 479 and 499; see also *Exhibition of Watercolours by Sarka: Tahiti* (New York: Julius G. Hass Fine Arts, 1929), no pagination.

14. See outline for "Over the Top," George Hart Papers, 2; *Tahiti, 1903*.

15. Egner et al., *George Overbury "Pop" Hart*, 22; "Wide World a Studio for Jersey Artist–Wanderer," *Newark Evening News*, 10 January 1925, 8.

16. Egner et al., *George Overbury "Pop" Hart*, 22.

17. Biographical outline, George Hart Papers, 1; William Weer, "Shaky Painter Feeds Cannibal on His Art," *Brooklyn Daily Eagle*, 18 May 1930; "Pop Hart, Artist, Who Quit Civilization," 12A.

18. *Tahiti, 1903*; in addition to this letter, Sarka noted that there was another letter from Hart urging him to travel to Tahiti—Charles Sarka Papers, 1000, 502: "Letters arrived now and then from the West Indies then stopped altogether. The summer passed. One clear, blue crisp morning in the autumn a missive postmarked Tahiti arrived. It displayed a colored sketch on the envelope, depicting Pop as a South Sea Island King, welcoming a traveler, presumably me. The return address read 'From the most wonderful discoverer and explorer—Tahiti.' [the letter then read] 'Chas: When are you coming down: Have been waiting three months for you, expecting you every time a ship arrives, which is once in thirty-six days. I pity you in the North in the snow and cold. No tourists or beggars here. Hurry up or I'll get the crown and leave nothing for you. Bring along some spoon hooks and I'll show you how to catch some fish. Your Old Pal.'"

19. Charles Sarka Papers, 1000, 505, 514.

20. *Ibid.*, 554. It should also be noted that in addition to the holdings of the Zimmerli Museum, the collection of the Achenbach Foundation for the Graphic Arts and the Fine Arts Museums of San Francisco contain six excellent examples of Hart's tropical portrait studies.

21. *Ibid.*, 532.

22. Mary Ann Goley, *In Search of the Picturesque: American Artists on Tour 1875–1914* (Washington, D.C.: Library of Congress, 1985), 19.

23. Douglas Dreishpoon and Susan E. Menconi, *The Arts of the American Renaissance* (New York: Hirschl & Adler Galleries, Inc., 1985), 10.

24. Henry La Farge, "John La Farge and the South Sea Idyll," *Journal of the Warburg and Courtauld Institutes* 7, 1944, 34.

25. Charles Sarka Papers, 1000, 488.

26. La Farge, "La Farge and the South Sea Idyll," 35.

27. Charles Sarka Papers, 1000, 555.

28. Richard Guy Wilson, Dianne H. Pilgrim, and Richard N. Murray, *The American Renaissance* (Brooklyn: The Brooklyn Museum, 1979), 34.

29. Although Stevenson was Scottish, he was married to an American and resided for part of his life in the United States.

30. Roy Albert Riggs, "The Vogue of Robert Louis Stevenson in America, 1880–1900," (unpublished Ph.D. dissertation, Ohio State University, 1953), 265.

31. *Ibid.*

32. For a discussion of American Impressionism, see the following sources: Donelson F. Hoopes, *The American Impressionists* (New York: Watson-Guptill Publications, 1972), 8–9; Patricia Hills, *Turn–of–the–Century America: 1890–1910* (New York: Whitney Museum of American Art, 1977), 73–75; Matthew Baigell, *A Concise History of American Painting and Sculpture* (New York: Harper and Row, Publishers, 1984), 124, 163.

33. Quoted in Baigell, *Concise History of American Painting*, 163.

34. For a discussion of these ideas, see Barbara Novak, *American Painting of the Nineteenth Century: Realism, Idealism, and the American Experience*

(New York: Harper and Row, Publishers, 1969), 243–244; Baigell, *Concise History of American Painting,* 124; Hills, *Turn–of–the–Century,* 124.

35. Baigell, *Concise History of American Painting,* 124.

36. William Gerdts discussed the impact of the World's Columbian Exposition on the development of the Impressionist movement in the United States in his *American Impressionism* (New York: Abbeville Press, Publishers, 1984), 275.

37. John Maxon, *The Art Institute of Chicago* (New York: Harry N. Abrams, Inc., 1970), 15–16.

38. David F. Burg, *Chicago's White City of 1893* (Lexington: The University of Kentucky Press, 1976), 57.

39. *Ibid.,* 59.

40. Charles Sarka Papers, 1000, 515.

41. See letter, George Hart to William Hart, February 21, 1904, Hart Microfilm, George Hart Papers, frames 3736–3744.

42. "Pop Hart, Who Painted Pigs in Samoa, is Back Again with a Yen for Spinach," *New York World,* 1 June 1930. Also, many articles on Hart have related a celebrated episode that occurred during his stay in Samoa; apparently, Hart became romantically involved with the daughter of a tribal chieftain, who indicated to the artist that he should make plans to marry his daughter. Hart wanted to evade this responsibility and several times he tried unsuccessfully to leave the area; however, one night he was able to slip away undetected and he made his "escape" by swimming out to a departing schooner. For a detailed account of this anecdote, see "Pop Hart, Artist, Who Quit Civilization," 12A.

43. Charles Sarka Papers, 1000, 630–631.

44. Egner et al., *George Overbury "Pop" Hart,* 23.

45. This anecdote is discussed in Arthur Strawn's article " 'Pop' Hart," *Outlook and Independent,* 155, 20 August 1930, 634.

46. Biographical chart, compiled by Jeane Hart, George Hart Archives; Egner et al., *George Overbury "Pop" Hart,* 23.

47. Although one article on Rudolph Dirks states that he traveled with Hart in Iceland in 1908 ("Rudolph Dirks," *Cartoonist Profiles* 1, September, 1974, 42, Dirks Family Papers, 854, 915), other sources indicate that this trip was made in 1907. See Egner et al., *George Overbury "Pop" Hart,* 23; entry on George Overbury Hart, *American Biography: A New Cyclopedia* (New York: The American Historical Society, Inc., 1934), 192; the most important source is a postcard from George Hart to his brother William Hart that is postmarked and dated Stockholm, 1907. It reads: "Hello Billy Leave Today for Iceland You ought to see Europe. To see happy people beautiful pictures America has nothing."

48. Rudolph Dirks' paintings done in Iceland have been photographed and appear on microfilm, Dirks Family Papers, 854.

49. Egner et al., *George Overbury "Pop" Hart,* 23.

50. This discussion of the Académie Julian was taken from the following sources: Catherine Fehrer, "New Light on the Académie Julian and Its Founder (Rodolphe Julian)," *Gazette des Beaux Arts,* 103, May/June, 1985, 208, 211; William Innes Homer, *Robert Henri and His Circle* (Ithaca: Cornell University Press, 1969), 40–43; also, see Herold Martine, *Académie Julian: 1868–Historique* (Paris: Académie Julian, 1985). It has not been possible to confirm Hart's attendance at the Académie Julian, nor the courses that he took there, since the school's records were lost during World War II. This information was provided to the author in a letter from R.C. Cellier, Assistant Director of the Académie Julian (Ecole Superieure d'Arts Graphiques ESAG), December 17, 1985.

51. Homer, *Robert Henri and His Circle,* 42–43.

52. *Ibid.*

53. This was noted in Cahill, "Odyssey of Hart," 22.

54. "Commentary on George Overbury Hart," written by Jeane Hart, George Hart Archives (typewritten).

55. Cahill, *George O. "Pop" Hart,* 11.

56. *Ibid.,* 10.

57. *Ibid.*

58. Carol Arnold Nathanson, "The American Response, in 1900–1913, to the French Modern Art Movements After Impressionism" (unpublished Ph.D. dissertation, Johns Hopkins University, 1973), 132.

59. *Ibid.*

60. In 1939, The American Salon sponsored the only known exhibition that was devoted to Hart's work in oil. See the catalogue for this exhibit, *Oil Paintings by Pop Hart: Sculpture Exhibitions by Humbert Albrizio, C. Letaiyo, Burr Miller, Henry Van Wolf and Theodore C. Barbarossa* (New York: The American Salon, 1939), no pagination.

61. Cahill, *George O. "Pop" Hart,* 12.

62. The author was alerted to this fact by Ellie Vuilleumier, Registrar, Carnegie Institute, in a letter, November 27, 1985.

63. Egner et al., *George Overbury "Pop" Hart,* 23.

64. Biographical material on George Hart, compiled by Jeane Hart, George Hart Archives (typewritten).

65. Gerdts, *Painting and Sculpture in New Jersey,* 200, 215.

THREE 1910–1920

1. Gerdts, *Painting and Sculpture in New Jersey,* 224.

2. This photograph was reproduced in *The Art Digest,* 16, 1 May 1942, 13.

3. It is not known exactly when Hart met Kuhn. According to a biographical outline compiled by Jeane Hart, George Hart Papers, 2, Hart was invited to join Walt Kuhn, Arthur B. Davies, and Rudolph Dirks in Copenhagen in 1905 while he was traveling in Cuba; however, no other sources exist to verify this information. It is possible that Hart was acquainted with Kuhn before 1910, as Kuhn was associated with a group of artists (i.e., Mager, Dirks, Tom Powers) that Hart was familiar with around 1900. Also, in a biographical chart that was compiled by Jeane Hart, George Hart Papers, there is an entry which indicates that Hart knew Kuhn in 1908. Yet, the only source outside of the Hart Papers that provides the earliest date for their acquaintance is a letter to Frank Weitenkampf, Feb. 27, 1934, Hart File, Prints Division, New York Public Library, which indicates that in 1910 Hart was related to a circle of artists that included Dirks, Gus Mager, Rudolph Block, Morgan Robertson, Tom Powers, and Walt Kuhn.

4. Gerdts, *Painting and Sculpture in New Jersey*, 223.

5. Walt Kuhn discussed his friendship with Hart in a letter to Jeane Hart, March 29, 1948, George Hart Papers. Two published sources that discuss Hart's relation to Kuhn are Gerdts' *Painting and Sculpture in New Jersey*, 213; and Philip Rhys Adams, *Walt Kuhn, Painter: His Life and Work* (Columbus: Ohio State University Press, 1978), 116.

6. Adams, *Walt Kuhn*, 8–9.

7. *Ibid.*, 18.

8. For the most complete account of the history of the Armory Show, see Milton W. Brown, *American Painting from the Armory Show to the Depression* (Princeton: Princeton University Press, 1955) and the exhibition catalogue *Armory Show, 50th Anniversary Exhibition, 1913–1963* (Utica: Munson Williams—Proctor Institute, 1963).

9. Elizabeth McCausland, "The Daniel Gallery and Modern American Art," *Magazine of Art*, 44, November 1951, 282.

10. *Ibid.*, 285.

11. Charles Sarka Papers, 1000, 491.

12. Discussion of this incident appears in a biographical chart compiled by Jeane Hart, George Hart Papers. It is also mentioned in Edgar Cahill, "The Odyssey of George Hart," 11.

13. This incident was related by Jeane Hart in an unpublished essay "American and French Painter Comparison," George Hart Papers, 2. According to Jeane Hart, this information was given to her by Kuhn in an interview in 1946.

14. *Ibid.*

15. Kuhn's role as art advisor to Quinn has been noted in Adams, *Walt Kuhn*, 34 and in Judith Zilczer's study *"The Noble Buyer": John Quinn, Patron of the Avant-Garde* (Washington, D.C.: Smithsonian Institution Press, 1978), 34. Quinn had also assisted with the organization of the Armory Show.

16. Zilczer, *"The Noble Buyer,"* 162.

17. Adams, *Walt Kuhn*, 93.

18. *Ibid.*, 96.

19. *Ibid.*, 29.

20. Frederick James Gregg, "Characteristic Show by George Hart Opens Season of Art Exhibitions," *New York Herald Tribune*, 6 October 1918.

21. James How, " 'Pop' Hart," *Art Review*, 1, January 1922, 16. This information found in a rough draft of a letter to Walt Kuhn from Jeane Hart, dated March 12, 1948, George Hart Papers. Jeane Hart asked Kuhn what year he wrote the article signed James How.

22. Adams, *Walt Kuhn*, 67.

23. Egner et al., *George Overbury "Pop" Hart*, 23.

24. This discussion of the New Jersey film industry and the history of World Pictures is taken from Paul Spehr's *The Movies Begin: Making Movies in New Jersey 1887–1920* (Newark: The Newark Museum, 1977). For additional information on World Pictures, see Benjamin B. Hampton, *A History of the Movies* (New York: Covici Friede Publishers, 1931), 131–135.

25. Spehr, *The Movies Begin*, 156.

26. The National Gallery of Art, Washington, D.C. has one of Hart's West Indies works, *A Hut in Trinidad*, in its collection.

27. Other museum collections have similar works by Hart. The Columbus Museum of Art owns an excellent watercolor, *West Indies Market*; a 1916 watercolor *Market Place, Trinidad* is in the holdings of the Marion Koogler McNay Art Museum, San Antonio, Texas; The Los Angeles County Museum of Art owns *Market Place, San Fernando, Trinidad*, 1917, which was in the collection of William Preston Harrison.

28. There is a fine portrait study by Hart from this period, *Portrait Sketch of Akajee*, 1917, in the collection of the Hood Museum of Art, Dartmouth College.

29. Henry Tyrrell related Hart to Gauguin in his article "From Gauguin to 'Pop' Hart: Evolution of a Gentle Savage," *New York World*, 6 August 1922; and Hart was dubbed the "Yankee Gauguin" by such writers as Rivas, "Hart … A Yankee Gauguin." In Laver's *A History of British and American Etching*, 150, he noted "The plates of "Pop" Hart have a primitive intensity reminiscent of Gauguin."

30. This statement is based on the author's study of the entire body of Hart's South Sea works in the Zimmerli Museum, not just the pieces reproduced in this monograph.

31. Richard Alan Nelson, *Florida and the American Motion Picture Industry 1898–1980* (New York: Garland Publishing, Inc., 1983), 135.

32. *Ibid.*

33. A stylistic connection between George Luks' works and Hart's was noted in Stebbins, *American Master Drawings*, 288.

34. Hart's association with Pascin has been noted in the following sources: Alfred Werner, "Pascin's American Years," *The American Art Journal*, 4, Spring 1972, 95; Tom L. Freudenheim, *Pascin* (Berkeley: The Regents of the University of California, 1966), no pagination; George Biddle, *An American Artist's Story* (Boston: Little, Brown and Company, 1939), 233–34.

35. For information on Pascin's career, see Freudenheim, *Pascin*, and Alfred Werner, *Pascin* (New York: Harry N. Abrams, Inc. Publishers, n.d.).

36. Freudenheim, *Pascin*, no pagination.

37. *Ibid.*

38. *Ibid.*

39. Werner, "Pascin's American Years," 95.

40. *Ibid.*

41. *Ibid.*

42. The lithograph *Springtime, New Orleans* was based on Hart's 1924 charcoal drawing *Spring in New Orleans* which is in the collection of the Sheldon Memorial Art Gallery, University of Nebraska. In his book *An American Artist's Story*, 234, Biddle discussed Hart's creation of the print: "On the original proof in bold architectural lettering he had traced the words 'Veau Carre.' Pascin had questioned his orthography. Then it became 'The Early Morning Razor.' But had razor one or two z's? 'Oh hell,' said Pop, 'call it "Spring Time in New Orleans."'"

43. Additional New Orleans works can be found in the following collections: the holdings of the Metropolitan Museum of Art include Hart's watercolor *Old Courtyard, New Orleans*, and the 1917 mixed media work *Old French Market, New Orleans* is in the collection of The Brooklyn Museum.

44. Stebbins, *American Master Drawings*, 136–173.

45. Gerdts, *American Impressionism*, 14.

46. Note the following studies of Homer's watercolors: Donelson F. Hoopes, *Winslow Homer Watercolors* (New York: Watson-Guptill Publications, 1969) and Helen A. Cooper, *Winslow Homer Watercolors* (Washington: National Gallery of Art, 1986).

47. See "The Sardeau Gallery," *Boston Christian Science Monitor*, 10 March 1923. The writer noted of Hart's watercolors that "their strength and accuracy of statement recall similar studies by Winslow Homer, yet in a much lighter, more whimsical mood." Guy Pène du Bois noted in his article "Review of Exhibition at Knoedlers," *New York Evening Post Magazine*, 19 October 1918, that "Sometimes we are reminded, as in the *Native Baptism, Trinidad…* of Sargent."

48. Cahill and Barr, *Art in America*, 32.

49. For many American watercolorists in the first decade of the twentieth century, particularly those that were more committed to representational values in their art, Homer's achievements in watercolor were still viewed as the apogee of the craft. As Lloyd Goodrich made clear in his catalogue *American Watercolor and Winslow Homer* (Minneapolis: The Walker Art Center, 1945), Homer's methods and his insistence on spontaneity, formal directness, and personalized expression became a model that informed the efforts of succeeding generations of artists, i.e., Maurice Prendergast, John Marin, Charles Burchfield, and Reginald Marsh. Sargent remained active in watercolor until the late 1910s and was, perhaps, as influential as Homer in popularizing the medium in the United States during the late 1800s and early 1900s. As Stebbins pointed out in *American Master Drawings*, 249, more conservative contemporary American watercolorists have continued to emulate Sargent's (and Homer's) handling of the medium up to the present day. For a major reference to Sargent's watercolors, see Donelson F. Hoopes, *Sargent Watercolors* (New York: Watson-Guptill Publications, 1970).

50. Albert Ten Eyck Gardner included Hart in his selective *History of Watercolor Painting in America* (New York: Reinhold Publishing Corporation, 1966), 107 and, in his definitive study *American Master Drawings and Watercolors*, 295, Theodore E. Stebbins discussed Hart's innovative mixed media works in which he combined watercolor and charcoal to give some of his pieces a gritty realism that was inspired by the Ashcan School.

51. Margaret Breuning, "Contemporary Water Color Painters," *International Studio*, LXXXIII, January 1926, 21.

52. William H. Gerdts, *American Impressionism* (Seattle: Henry Art Gallery, 1980), 111.

53. Wanda Corn and John Wilmerding, "The United States," in *Post-Impressionism: Cross-Currents in European and American Painting 1880–1906* (Washington: National Gallery of Art, 1980), 217–221.

54. *Ibid.*, 220.

55. Cheney, *Story of Modern Art*, 583.

56. Adams, *Walt Kuhn*, 64. Adams related the style of the painting to that of the fauve painter Raoul Dufy, as Kuhn emulated Dufy's decorative vocabulary, rendering the elements of the scene in bright, planar areas of color that were boldly inscribed with a flat outline.

57. *Ibid.*, 73.

58. Corn and Wilmerding, *Post-Impressionism*, 221.

59. Henry Geldzahler, *American Painting in the Twentieth Century* (New York: The Metropolitan Museum of Art, 1965), 76.

60. For a complete study of Prendergast's art, see Eleanor Green et al., *Maurice Prendergast: Art of Impulse and Color* (College Park: The University of Maryland, 1976).

61. In a pamphlet for the exhibition "The Advent of Modernism: Post-Impressionism and North American Art, 1900–1918," High Museum of Art, 1986, Alice Schille, David Milore, and Edward Middleton Manigault were cited as being followers of Prendergast.

62. The only reference known by this author that relates Hart's work to that of Prendergast is "This Week Around the Galleries: George ('Pop') Hart," *New York Times*, 24 November 1963.

63. Adams, *Walt Kuhn*, 64.

64. Zilczer, "*The Noble Buyer*," 36.

65. Clark S. Marlor, *The Society of Independent Artists: The Exhibition Record 1917–1944* (Park Ridge: Noyes Press, 1984), 284, 448.

66. Zilczer, "*The Noble Buyer*," 162.

67. Gregg, "Characteristic Show by Hart."

68. See Abraham A. Davidson, "Cubism and the Early American Modernist," *Art Journal*, 27, Winter 1966–67, 122–129, 165.

69. See Adams, *Walt Kuhn*, 118 and Geldzahler, *American Painting in the Twentieth Century*, 82. Baigell also noted in his *Concise History of American Painting*, 219, that even artists involved with more radical modes of cubist art "employed [them] ... to express mood rather than to probe the limits of formal arrangements."

70. Zigrosser, *Prints and Their Creators*, 93; "Modern American Graphic Art," *Creative Art*, 9, November 1931, 371.

71. Joshua C. Taylor, *The Fine Arts in America* (Chicago: The University of Chicago Press, 1979), 168.

72. Zigrosser, *Prints and Their Creators*, 93.

73. Jane Dixon, "Artist Knows Where Life is Easy on $10 a Week," *New York Telegram*, 4 May 1926; Marlor, *The Society of Independent Artists*, 284.

74. *Ibid.*

75. William Innes Homer, "The Exhibition of 'The Eight': Its History and Significance," *The American Art Journal*, 1, Spring 1969, 62.

76. Quoted in the survey history by Milton W. Brown et al., *American Art* (New York: Harry N. Abrams, Inc., 1979), 352.

77. Amy Goldin, "The Eight's Laissez-Faire Revolution," *Art in America*, 61, July-August 1973, 45.

78. Baur, *Revolution and Tradition*, 82; Richardson, *Painting in America*, 368; Baur, *Art in America in Modern Times*, 32; Stebbins, *American Master Drawings*, 295; Boswell, *Modern American Painting*, 50; Gerdts, *Painting and Sculpture in New Jersey*, 212.

79. Nelson Junius Springer, "International Art Notes–New York," *Creative Art*, 2, February 1928, 141.

80. Arthur F. Egner and Harry Wickey, " 'Pop' Hart," *Parnassus*, 7, November 1935, 21.

81. Brown et al., *American Art*, 358.

82. Grant Holcomb, "The Forgotten Legacy of Jerome Myers, (1867–1940): Painter of New York's Lower East Side," *The American Art Journal*, 9, May 1977, 83.

83. Jerome Myers, *Artist in Manhattan* (New York: American Artists Group, 1940), 100.

84. Bruce St. John, ed., *John Sloan's New York Scene: From the Diaries, Notes and Correspondence 1906–1913* (New York: Harper and Row, Publishers, 1965), 328.

FOUR 1920–1933

1. Biographical outline, compiled by Jeane Hart, George Hart Papers, 5.

2. Adams, *Walt Kuhn*, 69.

3. Sidney Geist, "The Fireman's Ball for Brancusi," *Archives of American Art Journal*, 16 November 1976, 9. For information on Gaylor, see Wood Gaylor, "Wood Gaylor: Diary of the Carefree Years," *Art in America*, vol. 50, 1963. Gaylor often did paintings of Penguin Club activities in his characteristic folk art style. Also note that there is a published cartoon of the mock wedding festival in the George Hart Papers.

4. This discussion of the Whitney Studio Club is taken from Lloyd Goodrich, *The Whitney Studio Club and American Art 1900–1932* (New York: Whitney Museum of American Art, 1975).

5. Avis Berman, "Juliana Force," *Museum News*, November–December 1976, 45.

6. Roberta Tarbell and Janet Flint, *Peggy Bacon: Personalities and Places* (Washington, D.C.: National Collection of Fine Arts, Smithsonian Institution, 1975), 24.

7. Letter, George Hart to Juliana Force, May 24, 1933, Artists File–George Hart, Whitney Museum of American Art Library.

8. Gaylor, "Wood Gaylor," 62.

9. For a history of the American Watercolor Society, see Ten Eyck

Gardner, *History of Watercolor Painting in America*, 11–15. For a discussion of the Brooklyn Society of Etchers, see Pauline Winchester Inman, "A History of the Society of American Graphic Artists," *Artists Proof*, Fall–Winter 1963–64, 3.

10. The following selected articles have stressed Hart's reclusive nature: " 'Pop' Hart, Artist, Who Quit Civilization," *Brooklyn Daily Eagle;* "Hart, Noted Etcher, Flees Civilization," which can be found in the George Hart Papers.

11. "Indian Princess calls 'Pop' Hart: Exhibit A: Misogynist in Chains," *New York Evening Post*, 8 November 1927.

12. Egner and Wickey, " 'Pop' Hart," 15.

13. See article titled " 'Pop' Hart to Boom Oaxaca with His Art," which can be found in George Hart Papers.

14. Cahill, *George O. "Pop" Hart*, 15.

15. Jose Clemente Orozco listed in Hart's address book, George Hart Papers; for indication of Hart's association with Laurent, see letter, George Hart to Robert Laurent, May 25, 1923, Robert Laurent Papers, Archives of American Art, N68–3, 32; author learned of Hart's association with Max Weber through an interview with George Price, April 28, 1986; Peyton Boswell listed in Hart's address book, George Hart Papers; for indication of Hart's association with Henry McBride, see letter, October 20, 1927, Henry McBride Papers, Archives of American Art, NMcB10, 504; for indication of Hart's association with Margaret Breuning, see letter, Margaret Breuning to George Hart, Hart Microfilm, George Hart Papers, frame 3801.

16. Matthew Baigell, *Dictionary of American Art* (New York: Harper and Row, Publishers, 1979), 154–155.

17. Only a few terse remarks by Hart on his art can be found, such as "Passion is the moving force of art" and "My sketch pad was my best passport in any land." These remarks compiled by Jeane Hart, George Hart Papers.

18. Zilzcer, "The Noble Buyer," 57.

19. Taylor, *Fine Arts in America*, 179–180.

20. Egner et al., *George Overbury "Pop" Hart*, 23–24.

21. Lyle Saxon, "Pop Hart Caught in Meshes of Love by Indian Princess," (New Orleans newspaper) 18 April 1926. Can be found in George Hart Papers.

22. For articles referring to Hart's Mexican travels and his relationship to Juanita, see Dixon, "Artist Knows Where Life is Easy on $10 a Week"; Saxon, "Hart Caught in Meshes of Love"; Margery Rex, "Brooklyn Artist Finds Raving 'Beauties' in Mexico," *New York Evening Journal*, 14 June 1926; "Indian Princess Calls 'Pop' Hart"; Elizabeth Smith, "Hart Mystified Mexicans by Painting During Revolt," *New York Times*, 12 May 1925.

23. Excellent examples of Hart's Mexican subjects can be found in the following collections: Museum of Fine Arts, Springfield; Museum of Art, Rhode Island School of Design; The Newark Museum; The Detroit Institute of Arts; The Corcoran Gallery of Art; Hood Museum of Art, Dartmouth College.

24. For a discussion of this trend of American artists visiting Mexico, see Guillermo Rivas, "Some American Painters in Mexico," *Mexican Life*, June 1942, 18, 27–31, 41–42. Hart is discussed, 28–29.

25. For the most recent study of the Taos and Santa Fe American artists' colonies, see Charles C. Eldredge, Julie Schimmel, and William Truettner, *Art in New Mexico, 1900–1945: Paths to Taos and Santa Fe* (Washington, D.C.: National Museum of American Art, Smithsonian Institution, 1986).

26. Rudolph Dirks was the originator of the "Katzenjammer Kids" comic strip and Gus Mager created the comic series "Groucho the Monk" and "Hawkshaw the Detective" in the early 1900s. Walt Kuhn did humorous illustrations during the early 1900s.

27. For a reference to an article in which Emily Genauer links Pascin to Hart, see draft of letter to James Porter from Jeane Hart, April 25, 1957, George Hart Papers. Also see E.M. Benson, "Exhibition Reviews," *The American Magazine of Art* 28, December 1935, 742.

28. Alfred Werner, "Jules Pascin in the New World," *College Art Journal* 19, Fall 1959, 35.

29. H.H. Arnason, *History of Modern Art* (New York: Harry N. Abrams, Inc., 1977), 286.

30. Aside from his adoption of a style related to Pascin's art, Kuhn also experimented with an expressionist figural mode in 1916 that can be related to German expressionist art; see Adams, *Walt Kuhn*, 68.

31. For a reference to The Eight's interest in Daumier's work, see Marianne Doezema, *American Realism and the Industrial Age* (Cleveland: Cleveland Musuem of Art, 1982), 51.

32. The following selected articles relate Hart's works to the art of Daumier: Benson, "Exhibition Reviews," 742; Martha Davidson, "Vital Impressions in Three Mediums by 'Pop' Hart," *The Art News*, 18 December 1937, 14; Marya Mannes, "Gallery Notes," *Creative Art* 1, December 1927, 5; Holger Cahill, "The Vagabond Artist," *Charm* 10, December 1928, 22.

33. "A Glimpse into the Colorful Life of Pop Hart," *The Art Digest* 12, 15 December 1937, 22.

34. Ralph E. Sikes and Steven Heller, "The Art of Satire: Painters as Caricaturists and Cartoonists from Delacroix to Picasso," *Print Review* 19, 1984, 9. Hart's caricature-like style can be considered in relation to the practice of many modern European and American artists including Picasso, Feininger, Jules Pascin, and George Grosz who, occasionally, appropriated aspects of caricature to enhance the emotional, psychological, or humorous impact of their images.

Such scholars as Werner Hofman and Edward Lucie-Smith have written extensively on the active dialogue between various modernist developments and caricature; see Lucie-Smith, *The Art of Caricature* (Ithaca: Cornell University Press, 1981), 121, 124; and Hofman, *Caricature: From Leonardo to Picasso* (London: John Calder, 1957), 50–57.

35. Cahill, "Odyssey of George Hart," *Charm*, 11.

36. Cahill, *George O. "Pop" Hart*, 14.

37. *Ibid.*

38. Cahill, *George O. "Pop" Hart*, 14.

39. Wallen, *Marron Collection of American Prints*, 122.

40. For a detai' study of Davies' prints, see Merrill Clement Reuppel, "The Graphic Art of Arthur Bowen Davies and John Sloan" (unpublished Ph.D. dissertation, University of Wisconsin, 1955).

41. Chine collé is a process in printmaking whereby a paper of a different color or texture is applied to the dampened sheet, usually during the actual process of printing. This allows the printer to incorporate tonal or textural effects into his work without altering the inking or the work done on the plate. The following selected prints discussed in this monograph were executed with chine collé: *Jack and Jill; Sea Waves; Landscape, Santo Domingo.*

42. Harry Wickey, "The Vital Genius of Pop Hart," *Prints*, 6, 1935, 24.

43. Cahill, *George O. "Pop" Hart*, 14.

44. *Ibid.*, 14–15.

45. *Ibid.*, 15.

46. For an indication of Hart's association with Weitenkampf, see correspondence from Hart to Weitenkampf, George Hart File, Print Division, New York Public Library.

47. Cahill, *George O. "Pop" Hart*, 14.

48. David W. Kiehl, "Monotypes in America in the Nineteenth and Early Twentieth Centuries" in *The Painterly Print: Monotypes from the Seventeenth to the Twentieth Century* (New York: The Metropolitan Museum of Art, 1980), 40.

49. *Ibid.*, 45–46.

50. The following sources have noted Hart's innovative work in monotype: Eichenberg, *The Art of the Print*, 518; Flynn Johnson, *American Prints and Printmakers*, 152.

51. See a listing for a monotype version of *The Poultry Man* in Egner et al., *George Overbury "Pop" Hart*, 55, no. 201.

52. Prentiss, "Memorial Exhibition of Hart," 101.

53. Hart's printing press and seventy-two of his etchings and zinc litho plates are in the collection of the Newark Museum.

54. For a reference to Miller's printing of Hart's 1924 lithograph *The Gallery, French Opera House, New Orleans*, see Janet Flint, *George Miller and American Lithography* (Washington, D.C.: National Collection of Fine Arts, Smithsonian Institution, 1976), no pagination. Also see Daryl R. Rubenstein, *Max Weber: A Catalogue Raisonné of His Graphic Work* (Chicago: The University of Chicago, 1980), 90, for mention of J.E. Rosenthal's printing of some of Hart's lithographs.

55. Flint, *Miller*, no pagination.

56. *Ibid.*

57. Rubenstein, *Weber*, 90.

58. *Ibid.*, 106.

59. Flynn Johnson, *American Prints*, 18.

60. Charles C. Eldredge, *American Imagination and Symbolist Painting* (New York: Grey Art Gallery and Study Center, 1979), 113.

61. Kiehl, "The Painterly Print," 171, 176–177.

62. James Watrous, *A Century of American Printmaking: 1880–1980* (Madison: The University of Wisconsin Press, 1984), 192.

63. Castleman, *American Impressions*, 14.

64. For a reference to Davies' color lithographs, see Clinton Adams, *American Lithographers: 1900–1960: The Artists and Their Printers* (Albuquerque: The University of New Mexico Press, 1983), 39. For a discussion of Weber's color relief prints, see Alan Fern, *American Graphics: 1860–1940* (Philadelphia: Philadelphia Museum of Art, 1982), 46.

65. Watrous, *A Century of American Printmaking*, 44.

66. For a selected listing of these articles, see Walter Gutman, "American Lithography," *Creative Art* 5, November 1929, 800; Carl Zigrosser, "Modern American Etching," *The Print Collectors Quarterly* 16, October 1929, 385; Carl Zigrosser, "Modern American Graphic Art," *Creative Art* 9, November 1931, 373; Elisabeth Luther Cary, "Reflections on Modern Prints, *Parnassus* 8, April 1936, 13.

67. Zigrosser, "Modern American Etching," 385, and "Modern American Graphic Art," 373.

68. For a discussion of innovative developments in American lithography during this period, see Gutman, "American Lithography," and Janet Flint, *Two Decades of American Prints: 1920–1940* (Washington, D.C.: National Collection of Fine Arts, Smithsonian Institution, 1974), no pagination.

69. This information supplied to the author through correspondence with Janet Flint, January 17, 1986.

70. Inman, "A History of the Society of American Graphic Artists," 41. Hart was also recognized as being an innovative printmaker by other graphic artists during this period, as in 1927 he was sent the following letter by Edward

Hopper, dated October 27, 1927, asking him to help form a society of printmakers dedicated to more radical values:

My Dear Hart:

Lahey was in to see me today and talked of trying to form a new society of etchers lithographers and printmakers trying to include those of a more liberal way of thinking than those who have usually made up the membership of etchers society's [sic].

There is a need for such a group. The only obstacles that I can see in the way of forming such a society is the work that all would have to share. And also to find a way to finance such a thing without to [sic] heavy a burden on its members.

I suggested your name as one who would probably be interested to help form such a group.

Let me know what you think of it.

Yours sincerely,

Edward Hopper

It is possible that the group to which Hopper refers in the letter developed into the Society of American Printmakers, which was established in 1927 and held annual exhibitions at the Downtown Gallery. Hart was on the selection committee for these exhibitions, along with other progressive printmakers such as Ernest Fiene, Walt Kuhn, and Yasuo Kuniyoshi. For a list of references on this group, see Adams, *American Lithographers*, 55.

71. Weitenkampf, *American Graphic Art*, 31; Laver, *A History of British and American Etching*, 150; Ralph Flint, *Contemporary American Etching* (New York: American Art Dealers Association, 1930), 7, 10, 29, 30.

72. Cahill and Barr, *Art in America: A Complete Survey*, 104–105.

73. Ingrid Marr, *The Pennell Legacy: Two Centuries of Printmaking* (Washington, D.C.: The Library of Congress, 1984), no pagination.

74. Egner, *Parnassus*, 23.

75. Biddle, *An American Artist's Story*, 233–234.

76. A brief discussion of Hart's association with Ganso, Fiene, Pascin, Davis, and Halpert appears in the auction catalogue *Highly Important Nineteenth and Twentieth Century American Paintings, Drawings, Watercolors and Sculpture: From the Estate of the Late Edith Gregor Halpert* (New York: Sotheby Parke Bernet, Inc., 1973), no pagination, no. 158.

77. Craven, *Modern Art: The Men, the Movements, the Meaning*, 326.

78. Wallen, *Marron Collection of American Prints*, 123.

79. For reviews of these exhibitions that cite Hart's inclusion in the show, see Gertrude Benson, "Art and Social Theories," *Creative Art* 12, March 1933, 216, and Anita Brenner, "Revolution in Art," *The Nation*, 8 March 1933, 267–268.

80. For information on Halpert and the Downtown Gallery, see Avis Berman, "Edith Halpert," *Museum News*, November–December 1975.

81. See Aline B. Sarrinen, *The Proud Possessors* (New York: Random House, 1958), 362, and Dorothy C. Miller, "Contemporary American Paintings in the Collection of Mrs. John D. Rockefeller, Jr.," *The Art News* 36, 26 March 1938, 106, for a discussion of Rockefeller's collection of Hart's work.

82. For a reference to Nakian's bust, which is in the collection of the Museum of Modern Art, see Gerald Nordland, *Nakian: Reuben Nakian Sculpture and Drawings* (Milwaukee: Milwaukee Art Museum, 1985), 12, and Wayne Craven, *Sculpture in America* (Newark: University of Delaware Press, 1968), 640. The bust illustrated in fig. 118 was destroyed by Nakian in the mid-forties along with a large number of his sculptures that were executed between 1920 and 1940. This information provided in a letter, February 24, 1986, to the author from Paul S. Nakian.

CHRONOLOGY

1868	Born on May 10, 1868.
1886	Leaves home due to his involvement in the accidental explosion in father's printing factory. After leaving home, takes first trip abroad, traveling to London by cattle boat.
1892	Arrives in Chicago. Does campaign portraits for James G. Blaine. Begins to work as a sign painter.
1893	Paints signs for World's Columbian Exposition.
1894–1895	Attends School of the Art Institute of Chicago.
1896–1897	Attends School of the Art Institute of Chicago.
1897–1900	Travels down Mississippi River to St. Louis; visits Kansas City and Louisville. In Louisville, purchases houseboat to sail to New Orleans. Sells houseboat for passage to Naples in 1900.
1900	Sails to Naples. Travels through Egypt with Charles Sarka, visiting Alexandria, Cairo, and Luxor.
1900–1903	Travels in the United States, Cuba, Central America, Mexico, Vera Cruz, El Paso, Los Angeles, and San Francisco.
1903	Travels to Tahiti, where he is joined by Charles Sarka.
1904	Travels in Samoa and Honolulu. Establishes sign painting business in Samoa.
1905–1907	Embarks on an extensive trip to Cuba, Denmark, and Iceland. Is accompanied by Rudolph Dirks through Iceland. Also visits Germany.
1907	Studies at Académie Julian during summer of 1907. Returns to United States, purchases land in Coytesville, New Jersey, and builds home. His painting *Sandscape-Meulan* exhibited in Carnegie International exhibition.
1907–1912	Establishes sign painting business in New Jersey and receives many commissions for signs at Palisades Amusement Park.
	Around this time becomes acquainted with Walt Kuhn and Gus Mager in Fort Lee area.
1912–1920	Designs and paints stage sets for World Pictures film studio based in Fort Lee, New Jersey. Begins to travel to West Indies in 1912.
1914	Exhibits his work in Daniel Gallery show.
1916	Travels to West Indies—Trinidad.
1917	Travels to West Indies—Dominica and Trinidad. Also visits Florida with location crew of World Pictures. Lives for a brief period with Jules Pascin in New Orleans.
1918	Travels to West Indies—Trinidad. First one-man exhibition of his work at the Knoedler Gallery; Arthur B. Davies and Dikran Kelekian purchase some of his work.
1919	Has Penguin Club "Summer Outing" at his home in Coytesville.
1920	Travels to West Indies—Santo Domingo and Dominica.
1921	Makes first prints in this year. Continues to work with prints for rest of his life, often using sketches made during former years as basis for prints. Earns a large income from prints after this point.
1922	Travels to Santo Domingo.
1923	Travels to Mexico—Jalapa. Awarded etching prize at Brooklyn Society of Etchers Eighth Annual Exhibition. Awarded landscape prize at the Brooklyn Museum Exhibition of 1923–24 for print *Landscape, Santo Domingo*.
1924	Lithograph *The Gallery, French Opera House, New Orleans* printed by George Miller. Receives first prize for watercolor at group exhibition Palisades Art Association.
1925	Travels to Mexico—Orizaba. Elected president of Brooklyn

Society of Etchers. The Metropolitan Museum of Art purchases the watercolor *Old Courtyard, New Orleans.*

1926 Travels to Mexico; resides in Tehuantepec. Awarded bronze medal at the Sesquicentennial Exhibition in Philadelphia for lithograph *Springtime in New Orleans.* Nominated a second time as president of Brooklyn Society of Etchers.

1927 Travels to Mexico—Oaxaca, Patzcuaro, Xochimilco. Downtown Gallery begins to represent him.

1928 Travels to Mexico—Orizaba. Downtown Gallery issues Holger Cahill monograph on Hart. Abby Aldrich Rockefeller organizes one-man show of her collection of Hart's work, at Topside Gallery, which first makes public her activity as a collector of modern American art.

1929 Travels to Mexico—Urapan. Also visits France, Spain, North Africa.

1930–1931 Travels to Cuba.

1932 Reuben Nakian executes notable busts of Hart as part of series of artist portraits. Wayman Adams paints portrait of Hart in oil which is awarded second prize at National Academy of Design. New Jersey State Museum at Trenton honors Hart's career with one-man show. Hart treated for cancer in sanitarium in Battle Creek, Michigan.

1933 Dies September 9, 1933. Funeral services attended by Frank Weitenkampf and Jerome Myers.

SELECTED LIST OF EXHIBITIONS

(Author's note—the designation "o.m." indicates one-man exhibitions.)

1907 *PITTSBURGH*/ Carnegie International

1914 *NEW YORK*/ Daniel Gallery

1917 *NEW YORK*/ Montross Gallery

1918 *NEW YORK*/ Knoedler Gallery, "Watercolors of New Orleans, Florida and West Indies by George O. Hart" o.m. (October); Top Side Gallery, "Watercolors and Prints by George O. Hart" o.m. (December)

1922 *BROOKLYN*/ Brooklyn Museum, "Brooklyn Society of Etchers, Seventh Annual Exhibition" (December–January); *NEW YORK*/ Keppel Gallery, "Etchings by George Hart" o.m. (October); School of Design and Liberal Arts, "Watercolors, Lithographs and Etchings by George Hart" o.m. (November)

1923 *BROOKLYN*/ Brooklyn Museum, "Second Exhibition of Watercolors, Paintings, Pastels, Drawings and Sculptures by American and European Artists" (November–December); Brooklyn Society of Etchers, Eighth Annual Exhibition" (December–January); *LOS ANGELES*/ Cornell and Chappin Gallery, "Drypoints and Aquatints by George Hart" o.m. (Summer); *NEW YORK*/ Brown Robertson Gallery, "Yearly Salon of American Etchers" (March); Junior Art Patrons Gallery, "Exhibit of Watercolors by George O Hart" o.m. (February); Marie Sterner Gallery, "Watercolors by George O. Hart" o.m. (March); Salons of America, "Spring Salon in Cooperation with American Museum of Natural History and Brooklyn Institute of Arts and Sciences"; Sardeau Gallery, "Etchings of George O. Hart and Edward Hopper" (February); Whitney Studio Club, "Annual Exhibition" (April)

1924 *BROOKLYN*/ Brooklyn Museum, "Brooklyn Society of Etchers, Ninth Annual Exhibition" (December–January); *NEW YORK*/ J. B. Neumann's Print Room, "The Graphic Works by 'Pop' Hart" o.m. (November–December); Salons of America (October); Weyhe Gallery, "Etchings, Monotypes and Other Prints by 'Pop' Hart and Drawings by Adolph Dehn and Etchings by Frelaut" (July); *PARIS*/ Chambre Syndicale de la Curiosité de Beaux Arts, under the auspices of the Art Patrons of America, "Exhibition of American Art" (June–July)

1925 *BROOKLYN*/ Brooklyn Museum, "Brooklyn Society of Etchers, Tenth Annual Exhibition" (November); *CHICAGO*/ Art Institute of Chicago, "Chicago Society of Etchers, Fifteenth Annual Exhibition" (January); *LONDON*/ "Exposition Trinationale" (October); *NEW YORK*/ American Institute of Graphic Arts, "Fifty Prints of the Year, Third Annual Traveling Exhibition" (November); Art Students League, "Fiftieth Birthday Jubilee Exhibition" (January–February); Anderson Gallery, "Brooklyn Society of Etchers, Fourth Annual International Exhibition of Etching" (April); Neumann's Print Room, "Graphic Works by 'Pop' Hart" o.m. (December); New York Watercolor Club and American Watercolor Society, combined exhibition (January); Salons of America, "Spring Salon" (April–May), "Autumn Salon" (October); Whitney Studio Club, "Annual Exhibition" (May); *PARIS*/ "Exposition Trinationale" (June)

1926 *CHICAGO*/ Chicago Art Institute, "Exhibition of Watercolors and Drawings and Prints by 'Pop' Hart" o.m. (October–November); *NEW ORLEANS*/ Arts and Crafts Club, "Mexican Sketches by 'Pop' Hart" o.m. (April); *NEW YORK*/ Wildenstein Gallery "Exposition Trinationale" (January–February); *PHILADELPHIA*/ American Institute of Graphic Arts, "Fifty Prints of the Year, Third Annual Traveling Exhibition" (January)

1927 *BROOKLYN*/ Brooklyn Museum, "Fourth Exhibition of Watercolors, Paintings, Pastels and Drawings by American and European Artists" (January–February); *LOS ANGELES*/ Los Angeles Museum, "Modern French and American Exhibition" (November), "Exhibition of Hart and Kilgore" (October); *NEW YORK*/ American Printmakers Society, "Exhibition of Etchings, Lithographs and Woodcuts" (December); Downtown Gallery, "Paintings and Drawings by George Hart" o.m. (November); Our Gallery, "Exhibition of Etchings, Watercolor, Lithographs and Drawings by 'Pop' Hart" o.m. (February)

1928 *CHICAGO*/ Chicago Society of Etchers, "Annual Exhibition" (February); *DETROIT*/ Detroit Institute of Arts, "American Printmakers Exhibition" (October); *LOS ANGELES*/ Los Angeles Museum, "Water Color Collection" (August–September); *NEW YORK*/ American Printmakers Society, "Second Annual Exhibition" (December); Keppel Gallery, "Exhibition of Etchings and Watercolors by 'Pop' Hart" o.m. (March–May); Salons of America, "Spring Salon" (May)

1929 *CLEVELAND*/ Gage Gallery, "Watercolor and Lithographs by 'Pop' Hart" o.m. (April); *NEW YORK*/ American Watercolor Society and New York Watercolor Club, combined exhibition; The Museum of Modern Art, "Paintings by Nineteen Living Americans" (December–January); Salons of America, "Spring Salon" (April–May); Society of Independent Artists, "Thirteenth Annual Exhibition" (March); Wanamaker Gallery, "Exhibition of Etchings and Lithographs by 'Pop' Hart" o.m. (March); *PHILADELPHIA*/ Print Club, "Second Annual Exhibition of Society of Etchers" (February); *SARATOGA SPRINGS*/ Skidmore College, "Paintings and Etchings by 'Pop' Hart" o.m. (May)

1930 *BROOKLYN*/ Brooklyn Museum, "Brooklyn Society of Etchers, Fourteenth Annual Exhibition" (January); *BUFFALO*/ Albright Art Gallery, "Twenty-Fourth Annual Exhibition of Selected Paintings by American Artists" (April–June); *CHICAGO*/ Chicago Art Institute, "International Exhibition of Lithographs and Woodcuts" (December); *CLEVELAND*/ Cleveland Museum of Art, "Eighth Annual Exhibition of Watercolors and Pastels" (November); *MILWAUKEE*/ Milwaukee Art Institute, "Tenth International Watercolor Exhibition" (May); NEW YORK/ American Print Makers, "Annual Exhibition" (December); American Watercolor Society and New York Watercolor Club, annual combined exhibition (November); Downtown Gallery,

"Exhibition of New Paintings and Drawings by 'Pop' Hart" o.m. (May–June); Grand Central Gallery, "Thirty-three Moderns" (January–February); Salons of America, "Spring Salon" (April–May)

1931 *BROOKLYN*/ Brooklyn Museum, "Sixth Annual Biennial Exhibition of Watercolors, Pastels, Drawings and Miniatures by American and Foreign Artists" (January–February); Brooklyn Society of Etchers, "Fifteenth Annual Exhibition" (January); Brooklyn Society of Etchers, "Sixteenth Annual Exhibition" (November–December); *NEW YORK*/ Grand Central Gallery, "Fourth Annual Exhibition, Philadelphia Society of Etchers" (January); Salons of America, "Spring Salon"; Society of American Etchers, "Annual Exhibition" (December); *PHILADELPHIA*/Philadelphia Society of Etchers, "Fifth Annual Exhibition" (December)

1932 *BROOKLYN*/ Brooklyn Society of Etchers, "Seventeenth Annual Exhibition" (November–December); *CLEVELAND*/ Cleveland Museum of Art, "Twelfth Annual Exhibition of Contemporary American Painting" (June–July); *NEW YORK*/ American Printmakers Society, "Sixth Annual Exhibition" (December); American Institute of Graphic Arts, "Seventh Annual Exhibition. Fifty Prints of the Year"; Grand Central Gallery, Philadelphia Society of Etchers, "Fifth Annual Exhibition" (December); Museum of Modern Art, "Exhibition of American Painting (1862–1932)" (October–January 1933); *TRENTON*/ New Jersey State Museum, "Exhibition of Watercolors, Etchings and Lithographs by George O. 'Pop' Hart" o.m. (October); *WASHINGTON*/ Corcoran Gallery of Art, "Thirteenth Biennial Exhibition of Contemporary Painting" (December–January 1933)

1933 *BROOKLYN*/ Brooklyn Museum, "Memorial Exhibition of Prints by 'Pop' Hart" (November–December); *CHICAGO*/ Chicago Art Institute, "Memorial Exhibition of Prints by George Overbury 'Pop' Hart" (November–January 1934); *DALLAS*/ State Fair of Texas, Department of Art (October); *KANSAS CITY*/ W. R. Nelson Gallery of Art, "Inaugural Exhibition" (December–February 1934); *NEW YORK*/ American Print Makers Society, "Seventh Annual Exhibition" (December); American Watercolor Society, "Sixty-Seventh Annual Exhibition" (November); Downtown Gallery, "Exhibition of Drawings by 'Pop' Hart" (November–December); Grand Central Gallery, "Prints by 'Pop' Hart" o.m. (October), Grand Central Gallery, Philadelphia Society of Etchers, "Seventh Annual Exhibition"(December); New York Public Library, "Memorial Exhibition of Prints of 'Pop' Hart"

o.m. (November); New York Water Color Club, "Forty-fourth Annual Exhibition" (April–May); John Reed Club, "The Social Viewpoint in Art" (February); Salons of America, "Spring Salon" (May); Society of American Etchers, "Eighteenth Annual Exhibition" (November–December); *SPRINGFIELD, MASSACHUSETTS/* Museum of Fine Arts, "Opening Exhibition" (October–November)

1934 *NEW YORK/* College Art Association, "Traveling Exhibition, American Painters Memorial Exhibition Since 1900" (1934–1935); Museum of Modern Art, "Fifth Anniversary Exhibition" (November–January 1935); National Academy of Design, "One Hundred and Ninth Anniversary Exhibition" (March–April); The New York Public Library, Prints Division, "The Prints of George O. ('Pop') Hart" o.m. (Fall); New York Water Color Club, "Forty-fifth Anniversary Exhibition" (April–May)

1935 *BROOKLYN/* "Eighth Biennial Exhibition. Watercolors, Pastels and Drawings by American and Foreign Artists" (February); *NEWARK/* The Newark Museum, "Memorial Exhibition" o.m. (October–December); *NEW YORK/* Museum of Modern Art, "Watercolors and Drawings by 'Pop' Hart and Charles Demuth" (June–September); *SAN DIEGO/* Palace of Fine Arts, "Official Art Exhibition, California-Pacific Exposition" (May); *SAN FRANCISCO/* M. H. de Young Memorial Museum, "Exhibition of American Painting from Beginning to Present Day" (June–July)

1936 *PHILADELPHIA/* Art Alliance, "Three Americans" (November–December)

1937 *NEW YORK/* Frederick Keppel Gallery, "Watercolors, Prints and Drawings by 'Pop' Hart" o.m. (Fall)

1938 *NEW YORK/* Frederick Keppel Gallery, "Watercolors, Prints and Drawings by 'Pop' Hart" o.m. (Fall)

1939 *PHILADELPHIA/* Art Alliance, "Watercolors by 'Pop' Hart" o.m. (January–February); Print Club, o.m. (Winter)

1940 *JERSEY CITY/* Jersey City Public Library, o.m.

1941 *MANCHESTER, NEW HAMPSHIRE/* Currier Gallery of Art, o.m.; *ROCHESTER/* Rochester Print Club, o.m.; *CLEVELAND/* Cleveland Museum of Art, o.m.

1942 *WASHINGTON, D.C./* United States National Museum, o.m. (September)

1943 *NEW YORK/* Museum of Modern Art, "Romantic Painting in America"

1949 *WASHINGTON, D.C./* United Nations Club, o.m.

1951 *KEW GARDENS, NEW YORK/* Kew Gardens Art Center, o.m.

1956 *WASHINGTON, D.C./* Howard University, "Retrospective Exhibition" o.m. (October–November)

1957– *FOREST HILLS, NEW YORK/* Forest Hills Womens Club, o.m.
1958 *AKRON/* Akron Art Institute, o.m.; *BROOKLYN/* Brooklyn Museum, "Golden Years of American Drawings"; *YOUNGSTOWN/* The Butler Institute of American Art, o.m.; *CANTON/* Canton Art Institute, o.m.

1960 *NEW YORK/* Zabriskie Gallery, o.m. (February)

1961 *NEW YORK/* Zabriskie Gallery, o.m. (April–May)

1962 *NEW YORK/* Crystal Gallery, "Arthur B. Davies, 'Pop' Hart and Yasuo Kuniyoshi" (March)

1963 *NEW YORK/* Lee Malone Gallery, o.m. (November)

1964 *SCOTTSDALE/* R.M. Light Gallery, o.m.

1965 *CHATTANOOGA/* George Thomas Hunter Gallery of Art, "Watercolors of 'Pop' Hart" o.m. (November); *MONTCLAIR/* Montclair Art Museum, "Watercolors by 'Pop' Hart" o.m. (January–February), Montclair Art Museum, Paintings and Drawings from the Grant Reynard Collection; *NEW YORK/* The Gallery of Modern Art, "The Twenties Revisited" (June–September); *SCRANTON/* Everhart Museum, "Watercolors of 'Pop' Hart" o.m. (April)

1966 *MONTCLAIR/* Montclair Art Museum, "20th Century Watercolors and Sculpture" (February–March)

1969 *LOS ANGELES/* Los Angeles County Museum of Art, "American Pastels and Watercolors" (February–March)

1974 *NEW YORK/* Kennedy Galleries, "Graphic Work of 'Pop' Hart" o.m. (March); *WASHINGTON, D.C./* National Collection of Fine Arts, "Two Decades of American Prints: 1920–1940" (June–September)

1976 *DARTMOUTH/* Carpenter Gallery, "Gifts of Abby Aldrich Rockefeller" (June–July); *WASHINGTON, D.C./* National Collection of Fine Arts, "George Miller and American Lithography" (February–April)

1979 *CHICAGO/* The Art Institute of Chicago, "100 Artists 100 Years: Alumni of the School of the Art Institute of Chicago–Centennial Exhibition"

1981 *SANTA BARBARA/* Santa Barbara Museum of Art, "The Gloria and Donald B. Marron Collection of American Prints"; *NEW ORLEANS/* Tahir Gallery, "American Self-Portraits"

1983 *NEW BRUNSWICK/* Zimmerli Art Museum, "Watercolors of 'Pop' Hart" o.m. (Fall)

1984 *BETHESDA*/ Bethesda Art Gallery, "The Prints of George Overbury 'Pop' Hart" o.m. (May); *WASHINGTON, D.C.*/ The Library of Congress, "The Pennell Legacy: Two Centuries of Printmaking" (December–May)

1985 *BOSTON*/ Museum of Fine Arts, "American Prints: 1914–1941" (April–July)

1986 *BALTIMORE*/ Baltimore Museum of Art, "American Etchings from the Collection" (January–March); *NEW YORK*/ Museum of Modern Art, "American Prints" (Spring); *NEW BRUNSWICK*/ Zimmerli Art Museum, retrospective exhibition, o.m. (Fall)

MUSEUM COLLECTIONS CONTAINING
WORK BY HART

(Author's note—the following designations are used to indicate the holdings of each institution: P = print; W = watercolor; D = drawing; O = oil painting. It should also be noted that many of the watercolors are mixed media works that contain various combinations of charcoal, pen and ink, and gouache.)

Achenbach Foundation for the Graphic Arts, California Palace of the Legion of Honor—The Fine Arts Museums of California, San Francisco, California *(W, D, P)*

Akron Art Museum, Akron, Ohio *(P)*

Allen Memorial Art Museum, Oberlin College, Oberlin, Ohio *(O)*

Art Institute of Chicago, Chicago, Illinois *(P)*

Baltimore Museum of Art, Baltimore, Maryland *(P)*

Bibliothèque Nationale, Paris, France *(P)*

British Museum, London, England *(P)*

Brooklyn Museum, Brooklyn, New York *(W,P)*

Butler Institute of American Art, Youngstown, Ohio *(P)*

Cincinnati Art Museum, Cincinnati, Ohio *(P)*

Cleveland Museum of Art, Cleveland, Ohio *(W,D,P)*

Columbus Museum of Art, Columbus, Ohio *(W)*

Corcoran Gallery of Art, Washington, D.C. *(W,P)*

Detroit Institute of Art, Detroit, Michigan *(W,P)*

Georgia Museum of Art, The University of Georgia, Athens, Georgia *(W)*

Hirshhorn Museum and Sculpture Garden, Washington, D.C. *(W,P)*

Honolulu Academy of Art, Honolulu, Hawaii *(P)*

Hood Museum of Art, Dartmouth College, Hanover, New Hampshire *(W,D,P)*

Indianapolis Museum of Art, Indianapolis, Indiana *(P)*

Library of Congress, Prints and Photographs Division, Washington, D.C. *(P)*

Los Angeles County Museum of Art, Los Angeles, California *(W,P)*

Marion Koogler McNay Art Museum, San Antonio, Texas *(W,P)*

Memorial Art Gallery of the University of Rochester, Rochester, New York *(P)*

Metropolitan Museum of Art, New York, New York *(W,P)*

Minneapolis Institute of Arts, Minneapolis, Minnesota *(P)*

Montclair Art Museum, Montclair, New Jersey *(W,P)*

Museum of Art, Carnegie Institute, Pittsburgh, Pennsylvania *(P)*

Museum of Art, Rhode Island School of Design, Providence, Rhode Island *(D,W)*

Museum of Fine Arts, Boston, Massachusetts *(W,P)*

Museum of Fine Arts, Springfield, Massachusetts *(W)*

Museum of Modern Art, New York, New York *(W,P)*

National Gallery of Art, Washington, D.C. *(W,D)*

Nelson–Atkins Museum of Art, Kansas City, Missouri *(W,P)*

Newark Museum, Newark, New Jersey *(P,W,D, Tempera painting)*

Newark Public Library, Art and Music Department, Newark, New Jersey *(D,P)*

New Britain Institute of American Art, New Britain, Connecticut *(W,P)*

New Jersey State Museum, Trenton, New Jersey *(P)*

New York Public Library, Print Division, New York, New York (*P*)

Pennsylvania Academy of the Fine Arts, Philadelphia, Pennsylvania (*P*)

Phillips Collection, Washington, D.C. (*P*)

Santa Barbara Museum of Art, Santa Barbara, California (*D,P*)

Seattle Art Museum, Seattle, Washington (*P*)

Sheldon Memorial Art Gallery, University of Nebraska, Lincoln, Nebraska (*W,D,P*)

J.B. Speed Art Museum, Louisville, Kentucky (*W,P*)

Victoria and Albert Museum, London, England (*P*)

Whitney Museum of American Art, New York, New York (*W,P*)

Wichita Art Museum, Wichita, Kansas (*D*)

Yale University Art Gallery, Yale University, New Haven, Connecticut (*W,P*)

Jane Voorhees Zimmerli Art Museum, Rutgers–The State University of New Jersey, New Brunswick, New Jersey (*W,O,D,P*)

BIBLIOGRAPHY

(Author's note—for easy reference the following sources have been listed in alphabetical order: archival sources; dictionaries, encyclopedias, and indices; books and exhibition catalogues; however, for purposes of research and for an historical overview of the pertinent literature on Hart, periodical and newspaper sources and selected exhibition catalogues of Hart's work have been listed in chronological order.)

ARCHIVAL SOURCES

The following museum and library collections contain exhibition catalogues, publications and clipping/artist files pertaining to Hart:

Archibald S. Alexander Library, Special Collections and Archives Department, Rutgers, The State University of New Jersey, New Brunswick, New Jersey (George Hart Papers—this is a vast collection of archival material that includes correspondence, photographs, scrapbooks, clipping files, and biographical manuscripts. There is also a copy of the George Hart Microfilm in the Hart Papers, which contains photographs of Hart's work, personal correspondence, and autobiographical manuscripts).

Archives of American Art, Washington, D.C. (from the Collection of Exhibition Catalogues on microfilm through the Archives: Br 13, 722; N43, 176-218; N433, 590; D–176, 307–310).

The Brooklyn Museum (Library), Brooklyn, New York.

Harvard University Fine Arts Library, Cambridge, Massachusetts.

The Museum of Modern Art (Library), New York.

The Newark Museum (Office of the Registrar), Newark, New Jersey.

Newark Public Library (Art and Music Collection—Collection of Prints).

The New York Public Library (Art and Architecture Division and Prints Division).

Ryerson Library, The Art Institute of Chicago, Chicago, Illinois.

Important archival material relating to Hart is held at:

Archives of American Art, Washington, D.C. (below is a list of the various manuscript collections that contain material on Hart):

Robert Laurent Papers, N68-3, 32.

Downtown Gallery Papers, ND/4, 427-668; ND/5, 154; ND/10, 132-324; ND/58, 252-310.

Henry McBride Papers, NMcB10, 504 and 597-598.

J.B. Neumann Papers, NJBN 1, 546.

Brooklyn Museum Papers, BR 22, 142-161.

John Laurent Papers, 497, 513.

Sidney C. Woodward Collection (papers), D194, 690.

Philadelphia Archives of American Art, Philadelphia Museum of Art (George Biddle correspondence), P17, 606–607.

Helen Appleton Read Papers, N736, 385.

Walt Kuhn Papers, 2918, 288.

Charles Sarka Papers, 1000.

Dirks Family Papers, 854.

The Jane Voorhees Zimmerli Art Museum, Department of Prints and Drawings, Rutgers, The State University of New Jersey, New Brunswick, New Jersey. (The Zimmerli Museum maintains records and correspondence pertaining to the Hart Collection and also owns a copy of the George Hart Microfilm

that can be found in the George Hart Papers.)

The New York Public Library, Prints Division (artist file containing Library correspondence that pertains to Hart and his work, and an extensive clipping file).

The Whitney Museum of American Art (Library), New York (artist file containing correspondence from Hart, clippings, and museum records).

DICTIONARIES, ENCYCLOPEDIAS, AND INDICES

American Biography: A New Cyclopedia. New York: The American Historical Society, Inc., 1934.

Baigell, Matthew. *Dictionary of American Art.* New York: Harper and Row, Publishers, 1979.

The Britannica Encyclopedia of American Art. Chicago: Encyclopedia Britannica Education Corporation, n.d.

Dictionary of American Artists: 19th and 20th Century. Poughkeepsie: Apollo Book, 1982.

Falk, Peter Hastings, ed. *Who Was Who in American Art.* Madison: Sound View Press, 1985.

The Index of Twentieth Century Artists 1933–1937. New York: Arno Press, 1970.

Keaveney, Sydney Starr. *American Painting: A Guide to Information Sources.* Detroit: Gale Research Company, 1974.

Mallett, Daniel Trowbridge. *Mallet's Index of Artists.* New York: Peter Smith, 1948.

Mantle Fielding's Dictionary of American Painters, Sculptors and Engravers. Poughkeepsie: Apollo Book, 1983.

Mason, Lauris, and Ludman, Joan. *Print Reference Sources: A Selected Bibliography 18th–20th Centuries.* Millwood: KTO Press, 1977.

Who's Who in America. Vol. 17, Chicago: The A.N. Margus Co., 1932.

SELECTED EXHIBITION CATALOGUES OF HART'S WORK

An Exhibition of Water Colors by George O. Hart, exhibition catalogue. New York: M. Knoedler and Company, 1918.

Exhibitions by Hart and Kilgore, exhibition catalogue. Los Angeles: Los Angeles Museum, 1927.

Recent Drawings of Mexico: Oils, Watercolors, Lithographs by "Pop" Hart, exhibition catalogue. New York: Downtown Gallery, 1927.

Exhibition of Drypoints, Etchings, Aquatints, Lithographs and Watercolors by George "Pop" Hart, exhibition catalogue (introduction by Ralph Flint). New York: Frederick Keppel and Company, 1928.

Master Prints by George (Pop) Hart and Other International Moderns, auction catalogue. New York: Rains Galleries, 1935.

Egner, Arthur F.; Wickey, Harry; and Robinson, Elinor. *George Overbury "Pop" Hart,* exhibition catalogue. Newark: The Newark Museum, 1935.

Exhibitions of Etchings and Drawings by Pop Hart, exhibition catalogue. New York: Frederick Keppel and Company. 1938.

Oil Paintings by "Pop" Hart, exhibition catalogue. New York: The American Salon, 1939.

Prints–Watercolors by "Pop" Hart: 1868–1933, exhibition catalogue. Washington, D.C.: The United Nations Club, 1949.

Watercolors: "Pop" Hart, exhibition catalogue. Kew Gardens: Kew Gardens Art Center, 1950.

A Retrospective Exhibition of Paintings, Prints and Drawings by George Overbury "Pop" Hart: 1868–1933, exhibition catalogue. Washington, D.C.: Howard University Gallery of Art, 1956.

George Overbury Hart: 1868–1933, exhibition catalogue. New York: Zabriskie Gallery, 1960.

George O. Hart: Drawings, exhibition catalogue. New York: Zabriskie Gallery, 1961.

"Pop" Hart: The Four Corners, exhibition catalogue. New York: Lee Malone, 1963.

Pop Hart, exhibition catalogue. Scottsdale: R.M. Light Gallery, 1964.

Watercolors by Pop Hart: 1868–1933, exhibition catalogue. Washington, D.C.: Smithsonian Institution.

BOOKS AND EXHIBITION CATALOGUES WHICH DISCUSS AND/OR FEATURE WORKS BY HART

Ackley, Clifford S. *American Prints: 1914–1941.* Boston: Museum of Fine Arts, 1985.

Adams, Clinton. *American Lithographers 1900–1960: The Artists and Their Printers.* Albuquerque: The University of New Mexico Press, 1983.

Adams, Philip Rhys. *Walt Kuhn, Painter: His Life and Work.* Columbus: Ohio State University Press, 1978.

American and European Prints. New York: Christie's, 1985.

American Art: Catalogue Number 16. Philadelphia: John F. Warren, Bookseller, n.d.

American Art in the Newark Museum: Paintings, Drawings, and Sculpture. Newark: The Newark Museum, 1981.

American Art in the 1920s by Eighteen American Contemporaries. New York: Downtown Gallery, 1937.

American Master Prints II. New York: Associated American Artists, 1971.

American Painting and Sculpture: 1862–1932. New York: The Museum of Modern Art, 1932.

The American Painting Collection of the Montclair Art Museum. Montclair: Montclair Art Museum, 1977.

American Posters and Prints, Drawings and Watercolors. New York: Christie's, 1980.

American Posters and Prints, Drawings and Watercolors. New York: Christie's, 1981.

An American Perspective: Selections from the Bequest of Frank McClure. Washington, D.C.: National Museum of American Art, 1981.

An Exhibition of Graphic Arts by Ten New Jersey Artists. Trenton: New Jersey State Museum, 1933.

Arms, John Taylor. *Three Centuries of Printmaking in America.* New York: IBM Gallery, n.d.

Art and Commerce: American Prints of the Nineteenth Century. Boston: Museum of Fine Arts, 1978.

Arts in America: A Bibliography. Washington, D.C.: Smithsonian Institution Press, 1979.

Barr, Alfred H., Jr. *Paintings by Nineteen Living Americans.* New York: The Museum of Modern Art, 1932.

Baur, John I.H. *Revolution and Tradition in Modern American Art.* Cambridge: Harvard University Press, 1951.

Beall, Karen F. *American Prints in the Library of Congress: A Catalog of the Collection.* Baltimore: The Johns Hopkins Press, 1970.

Biddle, George. *An American Artist's Story.* Boston: Little, Brown and Company, 1939.

Boswell, Peyton Jr. *Modern American Painting.* New York: Dodd, Mead and Company, 1940.

Cahill, Holger, and Barr, Alfred H., Jr., eds. *Art in America in Modern Times.* New York: The Museum of Modern Art, 1934.

————. *Art in America: A Complete Survey.* New York: Halcyon House, 1939.

Castleman, Riva. *American Prints: 1913–1963.* Brussels: Bibliothèque Royale Albert, 1976.

————. *American Impressions: Prints Since Pollack.* New York: Alfred A. Knopf, 1985.

Catalogue Five: European Master Prints and Drawings–16th through 20th Century–American Prints and Drawings–19th and 20th Century. New York: Paul McCarron, 1982.

Catalogue Five: One Hundred Prints, One Hundred Books: 18th, 19th and 20th Centuries–With a Section on Early Photography. Los Angeles: Victoria Keilus Dailey, n.d.

Catalogue of an Exhibition of American Painting from 1860 Until Today at the Cleveland Museum of Art. Cleveland: Cleveland Museum of Art, 1937.

Catalogue of Paintings and Drawings in Watercolor. Boston: Museum of Fine Arts, 1949.

Catalogue of the Collection. Columbus: Columbus Museum of Art, 1978.

Catalogue of the Permanent Collection of American Art. Youngstown: The Butler Art Institute, 1951.

Catalogue Six: Fine Prints and Drawings by Old and Modern Masters. New York: Paul McCarron, 1983.

Catalogue Three: A Selection of Fine Prints and Books–18th and 20th Centuries. Los Angeles: Victoria Keilus Dailey, n.d.

Cheney, Sheldon. *A Primer of Modern Art.* New York: Liveright Publishing Corporation, 1932.

————. *The Story of Modern Art.* New York: The Viking Press, 1941.

Cox, Richard. *American Self-Portraits.* New Orleans: Tahir Gallery, 1981.

Craven, Thomas. *Modern Art: The Men, the Movement, the Meaning.* New York: Simon and Schuster, 1934.

The Detroit Institute of Arts: Catalogue of Paintings. Detroit: The Detroit Institute of Arts, 1944.

Eichenberg, Fritz. *The Art of the Print.* New York: Harry N. Abrams, Publishers, 1976.

The Eva Underhill Holbrook Memorial Collection of the Georgia Museum of Art. Athens: The University of Georgia, 1953.

Field, Richard S. *American Prints 1900–1950.* New Haven: Yale University Press, 1983.

Fine Prints. Hauppauge N.Y.: Egon and Joan Teichert, Fall 1983.

Fine Prints. Hauppauge N.Y.: Egon and Joan Teichert, Spring-Summer 1984.

Fine Prints. Hauppauge N.Y.: Egon and Joan Teichert, Fall-Winter 1984.

Five Americans. Northampton: Smith College Museum of Art, n.d.

Five Centuries of Fine Prints. New York: Kennedy Galleries, Inc., 1956.

Flint, Janet A. *George Miller and American Lithography.* Washington, D.C.: National Collection of Fine Arts, Smithsonian Institution, 1976.

Flint, Ralph. *Contemporary American Etching.* New York: American Art Dealers Association, 1930.

Force, Juliana, and Burroughs, Alan. *A History of American Watercolor Painting.* New York: Whitney Museum of American Art, 1942.

Gardner, Albert Ten Eyck. *History of Watercolor Painting in America.* New York: Reinhold Publishing Corporation, 1966.

Gerdts, William H., Jr. *Painting and Sculpture in New Jersey.* Princeton: D. Van Nostrand Co., Inc., 1964.

Gilmore, Roger, ed. *Over a Century: A History of the School of the Art Institute of Chicago.* Chicago: The School of the Art Institute of Chicago, 1982.

Goodrich, Lloyd, and Baur, John I.H. *American Art of Our Century.* New York: Whitney Museum of American Art, 1961.

Handbook of the American and European Collections. Springfield: Museum of Fine Arts, 1979.

Handbook of the Cleveland Museum of Art. Cleveland: Cleveland Museum of Art, 1966.

Handbook of the Cleveland Museum of Art. Cleveland: Cleveland Museum of Art, 1978.

Harrison, Preston. *A Catalogue of the Mr. and Mrs. William Preston Harrison Galleries of American Art.* Los Angeles: Los Angeles Museum, 1934.

Heil, Walter. *Exhibition of American Painting.* San Francisco: M.H. De Young Memorial Museum California Palace of the Legion of Honor, 1935.

Highly Important 19th and 20th Century American Painting, Drawings, Watercolors and Sculpture: From the Estate of the Late Edith Gregor Halpert. New York: Sotheby Parke Bernet, Inc., 1973.

The Hirshhorn Museum and Sculpture Garden. New York: Harry N. Abrams, Inc., Publishers, 1974.

International Exhibition of Etching and Engraving. Chicago: The Art Institute of Chicago, 1932.

Irving, Donald J.; Kuh, Katherine; and Rice, Norman. *100 Artists 100 Years: Alumni of the School of the Art Institute of Chicago.* Chicago: The Art Institute of Chicago, 1979.

Jewell, Edward Alden. *Modern Art: Americans.* New York: Alfred A. Knopf, 1930.

Johnson, Robert Flynn, ed. *American Prints: 1870–1950.* Chicago: The University of Chicago Press, 1976.

Johnson, Una. *Golden Years of American Drawings, 1905–1956.* Brooklyn: The Brooklyn Museum, 1957.

————. *American Prints and Printmakers.* Garden City: Doubleday and Company, Inc., 1980.

Larkin, Oliver W. *Art and Life in America.* New York: Holt, Rinehart and Winston, 1949.

Laver, James. *A History of British and American Etching.* New York: Dodd, Mead and Company, 1929.

Leeper, John Palmer. *The Marion Koogler McNay Art Institute: A Selective Catalogue.* San Antonio: The Marion Koogler McNay Art Institute, 1954.

Lewisohn, Sam A. *Painters and Personality: A Collectors View of Modern Art.* New York: Harper and Brothers, Publishers, 1937.

Marlor, Clark S. *The Society of Independent Artists: The Exhibition Record 1917–1944.* Park Ridge: Noyes Press, 1984.

McDonald, Robert. *An Exhibition of One Hundred Prints and Drawings from the Collection of James H. Lockhart, Jr.* Pittsburgh: Carnegie Institute, 1939.

Mellquist, Jerome. *The Emergence of an American Art.* New York: Charles Scribner's Sons, 1942.

Modern French and American Exhibition. Los Angeles: Los Angeles Museum, 1927.

Moskowitz, Ira, ed. *Great Drawings of All Time.* New York: Shorewood Publishers, 1962.

Myers, Jerome. *Artist in Manhattan.* New York: American Artists Group, Inc., 1940.

Nineteenth and Twentieth Century Prints. New York: Sotheby Parke Bernet, Inc., 1973.

O'Connor, Francis V., ed. *The New Deal Art Projects: An Anthology of Memoirs.* Washington, D.C.: Smithsonian Institution Press, 1972.

Painting and Sculpture in the Museum of Modern Art: 1929–1967. New York: The Museum of Modern Art, 1977.

Paintings, Prints, Drawings from the Grant Reynard Collection. Montclair: Montclair Art Museum, 1965.

Parry, Albert. *Garrets and Pretenders: A History of Bohemianism in America.* New York: Dover Publications, Inc., 1933.

The Pennell Legacy: Two Centuries of Printmaking. Washington, D.C.: Library of Congress, 1983.

The Phillips Collection: A Summary Catalogue. Washington, D.C.: The Phillips Collection, 1985.

Pierson, William H., Jr., and Davidson, Martha, eds. *Arts of the United States: A Pictorial Survey*. New York: McGraw-Hill Book Company, Inc., 1960.

Prasse, Leona E. *Catalog of an Exhibition of the Art of Lithography: Commemorating the Sesquicentennial of Its Invention, 1878–1948*. Cleveland: Cleveland Museum of Art, 1948.

Richardson, E.P. *Paintings in America: The Story of 150 Years*. New York: Thomas Y. Crowell Company, 1956.

Sarka Journal. New York: Davis Galleries, n.d.

Sarrinen, Aline B. *The Proud Possessors: The Lives, Times and Tastes of Some Adventurous American Art Collectors*. New York: Random House, 1958.

Sesquicentennial International Exposition, 1926: Paintings, Sculpture and Prints in the Department of Fine Arts. Philadelphia: Philadelphia Museum of Art, 1926.

Shapiro, David, ed. *Social Realism: Art as a Weapon*. New York: Frederick Ungar Publishing Co., 1973.

Simmons, Linda Crocker. *American Drawings, Watercolors, Pastels and Collages in the Collection of the Corcoran Gallery of Art*. Washington, D.C.: Corcoran Gallery of Art, 1983.

Soby, James Thrall, and Miller, Dorothy C. *Romantic Painting in America*. New York: The Museum of Modern Art, 1943.

Stebbins, Theodore E., Jr. *American Master Drawings and Watercolors: A History of Works on Paper from Colonial Times to the Present*. New York: Harper and Row, Publishers, 1976.

Tahiti, 1903: Watercolours by Charles Sarka. New York: Bernard Black Gallery, 1963.

Tarbell, Roberta K., and Flint, Janet A. *Peggy Bacon: Personalities and Places*. Washington, D.C.: National Collection of Fine Arts, Smithsonian Institution, 1975.

The Thirteen Collection: Televised Auction of Art and Antiques. New York: Thirteen, 1979.

Tomkins, Calvin. *Off the Wall: Robert Rauschenberg and the Art World of Our Time*. Garden City: Doubleday and Company, Inc., 1980.

The Twenties Revisited. New York: The Gallery of Modern Art, 1965.

Twentieth Century Artists: A Selection of Paintings, Sculpture and the Graphic Arts from the Museum's Permanent Collection. New York: Whitney Museum of American Art, 1939.

Two Decades of American Prints: 1920–1940. Washington, D.C.: National Collection of Fine Arts, Smithsonian Institution, 1974.

Wallen, Burr, ed. *The Gloria and Donald B. Marron Collection of American Prints*. Santa Barbara: Santa Barbara Museum of Art, 1981.

Water Color Collection. Los Angeles: Los Angeles Museum, 1928.

Watrous, James. *American Printmaking: A Century of American Printmaking 1880–1980*. Madison: University of Wisconsin Press, 1984.

Weber, Wilhelm. *A History of Lithography*. New York: McGraw-Hill Book Company, 1966.

Weitenkampf, Frank. *American Graphic Art*. New York: The Macmillan Co., 1924.

The Whitney Museum and Its Collection: History, Purpose and Activities. New York: Whitney Museum of American Art, 1954.

Whitney Museum of American Art: Catalogue of the Collection. New York: Whitney Museum of American Art, 1961.

Zigrosser, Carl. *Prints and Their Creators: A World History*. New York: Crown Publishers, Inc., 1974.

————. *The Artist in America: Contemporary Printmakers*. New York: Hacker Art Books, 1978.

Zilczer, Judith. *The Noble Buyer: John Quinn, Patron of the Avant-Garde*. Washington, D.C.: Smithsonian Institution Press, 1978.

PERIODICALS

Cahill, Edgar. "The Odyssey of George Hart." *Shadowland* 8, June 1923, 11, 70.

Breuning, Margaret. "Contemporary Watercolor Painters." *International Studio* LXXXIII, January 1926, 21–26.

Hart, Geroge O. "Pop". "Vagabond Artist, Indian Princess and Gold Mine." *The World Magazine*, July 1926, 10.

Craven, Thomas. "American Month in the Galleries." *The Arts* XI, March 1927.

"It is Springtime Now–in New Orleans." *The Art Digest* 10, March 15, 1927, 1.

"'Pop' Hart Will Soon Be Wending His Way." *The Art Digest* II, November 1927, 12.

"Exhibitions in New York: Pop Hart–Downtown Gallery." *Art News* XXVI, November 1927, 9.

Mannes, Marya. "Gallery Notes." *Creative Art* 1, December 1927, V.

Springer, Nelson Junius. "International Art Notes–New York." *Creative Art* 2, February 1928, 140–141.

Rivas, Guillermo. "George 'Pop' Hart … A Yankee Gauguin." *Mexican Life* 4, June 1928, 25–27.

Cahill, Holger. "The Vagabond Artist." *Charm* 10, December 1928, 21–22, 80.

"The News and Opinion of Books on Art: 'Pop' Hart's Book." *The Art Digest,* mid-January 1929, 24.

Rusk, William Sener. "Book Reviews." *Creative Art* (supplement) 4, May 1929, 46.

Zigrosser, Carl. "Modern American Etching." *The Print Collectors Quarterly* 16, October 1929, 381–397.

"American Lithography." *Creative Art* 5, November 1929, 800–804.

G.P.B. "Gallery Reviews." *The New Yorker* VI, May 1930, 54.

Strawn, Arthur. " 'Pop' Hart." *Outlook and Independent* 155, August 1930, 634–635.

Zigrosser, Carl. "Modern American Graphic Art." *Creative Art* IX, November 1931, 369–374.

"Nakian's 'Pop' Hart Is Praised by Critics." *The Art Digest,* October 1932, 6.

Shelley, Melvin Greer. "Around the Galleries: Downtown Gallery." *Creative Art* XI, November 1932, 223, 226.

"National Academy Opens Winter Show with SIS Works on View." *The Art Digest* VII, December 1932, 5–6.

Jewell, Edward Alden. "Three Winter Shows." *The American Magazine of Art* XXVI, February 1933, 64, 67.

Benson, Gertrude. "Art and Social Theories." *Creative Art* 12, March 1933, 216–218.

Brenner, Anita. "Revolution in Art." *The Nation* 8, March 1933, 267–269.

"Obituaries." *Art News* XXXI, September 1933, 6.

" 'Pop' Hart, Creative American Genius and Philosopher, Is Dead." *The Art Digest* VIII, October 1933, 13–14.

Prentiss, Mildred J. "A Memorial Exhibition of George Overbury Hart." *Bulletin of the Art Institute of Chicago* 27, November 1933, 100–101.

Weitenkampf, Frank. "The Prints of 'Pop' Hart." *Bulletin of the New York Public Library* 37, November 1933, 947–948.

" 'Pop' Hart Drawings." *The Art Digest* VIII, November 1933, 16.

"Exhibitions in New York: 'Pop' Hart–Downtown Gallery." *The Art News* XXXII, November 18, 1933, 6.

"Another 'Pop' Hart Memorial." *The Art Digest* VIII, December 1933, 40.

"Brooklyn Holds 'Pop' Hart Show." *The Art News* XXXII, December 1933, 6.

Wellman, Rita. "Gallery Notes." *Parnassus* 5, December 1933, 9.

"The Prints of 'Pop' Hart." *Antiques* XXV, January 1934, 27.

"Library Exhibits 'Pop' Hart Prints." *The Art News* XXXII, January 1934, 6.

" 'Pop' Hart as a Good Artist and as a Poor One." *Prints* IV, March 1934, 21.

"Prints Division." *New York Public Library Bulletin,* May 1934.

"Exhibition Shows How Artists Have Enriched the Color Print." *The Art Digest* IX, May 1935, 5.

"The 'Pop' Hart Memorial." *The Art Digest* 9, September 1935.

" 'Pop' Hart Show Will Soon Open." *The Art News* XXXIV, October 1935, 13.

"Newark Organizes Great Memorial Show of Work of Pop Hart." *The Art Digest* X, October 1935, 12–13.

"Ex-Sign Painter's Art on View." *The Literary Digest* CXX, October 1935.

Eglington, Laurie. "Hart Holds Own in Retrospective at Newark Museum." *The Art News* XXXIV, October 1935, 8.

Lane, James W. "Current Exhibitions." *Parnassus* VII, November 1935.

Egner, Arthur F., and Wickey, Harry. " 'Pop' Hart." *Parnassus* VII, November 1935.

Benson, E.M. "Exhibition Reviews— " 'Pop' Hart Memorialized in a Retrospective at Newark." *The American Magazine of Art* XXVIII, December 1935, 741–742.

Cary, Elisabeth Luther. "Reflections on Modern Prints." *Parnassus* VIII, April 1936, 12–15.

Abell, Walter. "Form Through Representation." *The American Magazine of Art* 29, May 1936.

"Three Americans." *Art Alliance Bulletin,* November 1936, 2–3.

"A Glimpse into the Colorful Life of Pop Hart." *The Art Digest* XII, December 1937, 25.

Davidson, Martha. "Vital Impressions in Three Mediums by 'Pop' Hart." *The Art News* XXXVI, December 1937, 13–14.

Miller, Dorothy C. "Contemporary American Paintings in the Collection of Mrs. John D. Rockefeller, Jr." *The Art News* XXXVI, March 1938, 105–106, 182–184.

J.L. "New Exhibitions of the Week–'Pop' Hart: Watercolors and Drawings." *The Art News* 13, December 1938, 13.

"The Popular Hart." *Philadelphia Art Alliance Bulletin,* January 1939, 5.

"He Couldn't Shave Off 'Pop'." *The Art Digest* XIII, January 1939, 17.

"The Popular Hart." *Art Alliance Bulletin,* February 1939, no pagination.

Richter, Jane. "Hart and Biddle: People and Places." *Arts in Philadelphia,* February 1939, 11, 14.

"Shades of the Past." *The Art Digest* 16, May 1942. (Photo of Pop Hart, Walt Kuhn, and Gus Mager in 1912 at Albigs Pavilion on the Palisades at Fort Lee, New Jersey.)

Rivas, Guillermo. "Some American Painters in Mexico." *Mexican Life* XVIII, June 1942, 27–31, 41–42.

"Prints by 'Pop'." *The Art Digest* 17, October 1942, 10.

McCausland, Elizabeth. "The Daniel Gallery and Modern American Art." *Magazine of Art* 44, November 1951, 280–285.

Schuyler, James. "Reviews and Previews: George Overbury Hart." *Art News* 58, February 1960, 14.

Dennison, George. "George Overbury Hart." *Arts Magazine* 34, February 1960, 57.

Campbell, Lawrence. " 'Pop' Hart." *Art News* 60, April 1961, 15.

Raynor, Vivien. "George O. Hart." *Arts* 35, May–June 1961, 90.

Sandler, Irving H. "Arthur B. Davies, 'Pop' Hart and Yasuo Kuniyoshi." *Art News* 61, March 1962, 50.

"Widely Overlooked Master." *The Art Market Advisory*, May 1962, 4.

"Wood Gaylor: Diary of the Carefree Years." *Art in America* 51, November 1963, 60–69.

Beck, James H. "Reviews and Previews: 'Pop' Hart." *Art News* 62, November 1963, 48.

Fern, Alan. "A Half Century of American Printmaking: 1875–1925." *Artists Proof* III, Fall-Winter 1963–1964, 14–25.

Inman, Pauline Winchester. "A History of the Society of American Graphic Artists." *Artists Proof* III, 40–44.

Raynor, Vivien. " 'Pop' Hart." *Arts Magazine* 38, January 1964, 39.

"Watercolors by 'Pop' Hart." *Montclair Art Museum Bulletin*, January 1965.

"Art Gallery–Watercolors by George Overbury Hart." *The Everhart Museum Newsletter*, April 1965.

Editors. "A Portfolio of Animals in Art." *American Artist* 29, June 1965, 73–79.

" 'Pop' Hart." *George Thomas Hunter Gallery of Art News* 13, November 1965.

"20th Century Watercolors and Sculpture." *Montclair Art Museum Bulletin*, February 1966.

Werner, Alfred. "Pascin's American Years." *The American Art Journal* IV, Spring 1972, 87–101.

Tannenbaum, Judith. " 'Pop' Hart." *Arts* 48, May 1974, 61.

NEWSPAPER ARTICLES

McBride, Henry. "Sale at Mrs. Albert Sterner's." *New York Herald Tribune*, 18 February 1918.

Gregg, M. Frederick James. "Characteristic Show by George Hart Opens Season of Art Exhibitions." *New York Herald Tribune*, 6 October 1918.

Du Bois, Guy Pène. "Review of Exhibition at Knoedlers." *New York Evening Post Magazine*, 19 October 1918.

"Southern Artist Shows Watercolors at Knoedler's." *Brooklyn Daily Eagle*, 20 October 1918.

Bowdoin, W.G. "George O. Hart Holds Exhibition at Knoedlers." *Brooklyn Evening World*, 22 October 1918.

Tyrrell, Henry. "Picture Lane in August–From Gauguin to 'Pop' Hart: Evolution of a Gentle Savage." *New York World*, 6 August 1922.

"Review of Exhibit at Frederick Keppel & Company Galleries." *New York Times*, 15 October 1922.

"Exhibit at Gallery of Mrs. Albert Sterner." *New York American*, 18 February 1923.

"(Illustration) *Boat Yard, Edgewater* by George O. Hart." *New York Herald Tribune*, 18 February 1923.

Article. *New York Herald Tribune*, 18 February 1923.

"Review of Exhibit at Mrs. Sterner's Gallery." *New York World*, 18 February 1923.

"George Hart and Edward Hopper–Exhibit at the Sardeau Gallery." *New York Times*, 21 February 1923.

"Watercolors by George Hart." *New York Times*, 25 February 1923.

Article. *Boston Christian Science Monitor*, 28 February 1923.

Article. *New York Globe*, 28 February 1923.

Article. *New York Evening Post*, 3 March 1923.

"The Sardeau Gallery." *Boston Christian Science Monitor*, 10 March 1923.

"Artist Gives up Love of Princess in Fear He 'Couldn't Rock the Boat with a Wife'." *New York Evening Telegram*, 9 May 1923.

"Sign-Paints His Way Around the World to Fame and Wealth as Great Artist." *New York Evening Telegram*, 15 July 1923.

"In Print Room at Brooklyn Museum." *New York Times*, 22 July 1923.

"Hart Water Colors in Brooklyn Museum." *New York Times*, 18 November 1923.

"Comment on Exhibit at Brooklyn Museum" (magazine section). *New York Times*, 15 June 1924.

(Illustration–caption) "Awaiting the Boat's Return, Trinidad by George Hart in Print Exhibition at the Brooklyn Museum." *New York Times Magazine*, 6 July 1924.

"Award for 'Natives Washing Clothes'." *New York Times*, 26 July 1924.

"Wide World a Studio for Jersey Artist-Wanderer." *Newark Evening News*, 10 January 1925, 8.

"Hart Mystified Mexicans by Painting During Revolt." *New York Times*, 12 May 1925.

"Summer Exhibit at Weyhe Gallery." *New York Times*, 28 June 1925.

Matthias, Blanche C. "A Rainy Evening with 'Pop' Hart, Globe Trotter." *Chicago*

Evening Post–Magazine of the Art World, 22 September 1925, 1, 7.

"Exhibit at Fine Arts Building, University of Pennsylvania." *Philadelphia Inquirer,* 8 November 1925.

"Pop Hart, Exhibit at Neumann Print Room." *New York Evening Post,* 18 December 1925.

"Civilization No Place for Artist, He Says." *Ohio State Journal,* 27 December 1925.

"Pop Hart, Artist, Who Quit Civilization for Corner Where He Can Work and Suffer, Picks Oaxaca, Land of Beautiful Women." *Brooklyn Daily Eagle,* 17 January 1926, A12, A18.

Frost, Meigs O. " 'Women are Hell' Says Noted Artist in Exile." *New Orleans States,* 4 April 1926.

Saxon, Lyle. " 'Pop' Hart Caught in Meshes of Love by Indian Princess." *New Orleans Times-Picayune,* 18 April 1926, 1, 12.

"Pop Hart to Boom Oaxaca with His Art." *New York Evening Post,* 27 April 1926.

Dixon, Jane. "Artist Knows Where Life is Easy on $10 a Month." *New York Evening Telegram,* 4 May 1926.

" 'Pop' Hart Returns from Mexico." *New York Sun,* 22 May 1926.

Rex, Margery. " 'Pop' Hart, New York Artist, Finds a Raving Beauty and a Cheap Gold Mine on Mexican Vacation." *New York Evening Journal,* 14 June 1926.

Hart, George O. "Vagabond Artist, Indian Princess and Gold Mine." *New York World* (magazine), 11 July 1926.

McCauley, Lena M. "Pop Hart's Prints Reveal Old Mexico." *Chicago Evening Post–Magazine of the Art World,* 5 October 1926.

Williams, Marguerite B. "Here and There in the Art World: 'Pop' Hart, His Princess and His Art." *Chicago Daily News,* 6 October 1926.

Jewett, Eleanor. "Pop Harte [sic] Paints Life in the Tropics." *Chicago Tribune,* 17 October 1926.

"Hart Water Color Exhibition Now at Chicago Institute." *Chicago Illinois American,* 25 October 1926.

"Pop Hart–Exhibit at Our Gallery." *New York Sun,* 12 February 1927.

"Sociable Cannibals." *New York Sun,* 21 March 1927.

" 'Pop' Hart Showing at Exposition Park." *Los Angeles Times,* 18 September 1927.

"Indian Princess Calls 'Pop' Hart." *New York Evening Post,* 8 November 1927.

"Pop Hart." *New York Evening Post,* 12 November 1927.

"Review of Exhibit at Downtown Gallery." *New York Times,* 13 November 1927.

Tablada, José Juan. "Un Amigo de Mexico: George 'Pop' Hart." *Rotografico,* January 1928.

Cortissoa, Royal. "George Hart, Review of Keppel Show." *New York Herald Tribune,* 22 April 1928.

"George Hart, Review of Show at Keppel's." *New York Herald Tribune,* 28 April 1928.

"Large Exhibition by 'Pop' Hart Shown at Keppel's–Sculpture by Harriet Frishmuth at Grand Central Galleries and Other Notes on Current Activities." *New York Evening Post,* 28 April 1928.

McBride, Henry. " 'Pop' Hart Introduced Uptown." *New York Sun,* 5 May 1928.

"Prince of Bohemians Pictures Varied Scenes–Reviews of Exhibit at Keppels." *New York World,* 6 May 1928.

"Coytesville's Own 'Pop' Hart Famous." *New Jersey Sentinel* (Fort Lee), 14 May 1928.

"Monograph in Preparation on Life of George O. Hart." *New York World,* 16 June 1928.

"Pop Hart Steps into the Limelight and Looks Well in It." *New York Evening Post,* 22 December 1928.

"Notes on Current Events in the Local Art World–Review of Cahill Monograph." *New York Sun,* 22 December 1928.

"Holiday Exhibitions: Pop Hart Steps into the Limelight and Looks Well in It–Holiday Sale at Whitney Studio Gallery–Watercolors and Drawings at De Hauke's." *New York Sun,* 23 December 1928.

Jewell, Edward Alden. "Attractive Monograph on George O. (Pop) Hart and His Work Has Coming-out Party." *New York Times,* 23 December 1928.

"Pop Hart's Life Achieves Print." *New York Sun,* 29 December 1928.

" 'Pop' Hart, Artist Rover, Honored by Monograph." *New York World,* 30 December 1928.

"Newark Man's Book on Famous Artist Out." *Newark Star Eagle,* 19 January 1929.

"Review of Cahill Monograph." *Boston Transcript,* 26 January 1929.

Article. *New York Times,* 27 January 1929.

"New Books–Pop Himself. Review of Cahill Monograph." *Brooklyn Standard Union,* 30 January 1929.

Hansen, Harry. "The First Reader–Review of Cahill Monograph." *New York World,* 4 February 1929.

"Hart, Artist Recognized–Review of Cahill Monograph." *New York Telegraph,* 5 February 1929.

"An Artist of the People." *Newark Evening News,* 18 February 1929.

"Pop Hart. Review of Cahill Monograph." *Boston Transcript*, 23 February 1929.

"Pop Hart–Exhibit at Wanamaker Gallery." *New York Evening Post*, 16 March 1929.

"Pop Hart Exhibits Work at Skidmore." *New York Sun*, 25 May 1929.

"Pop Hart in Text and Pictures." *New York American*, 16 June 1929.

Cary, Elisabeth Luther. "Americans Abroad Hold Annual Show." *New York Times*, 13 October 1929.

Weer, William. "Pop Hart, for 30 Years a Painter, to Play Now." *Brooklyn Daily Eagle*, 25 April 1930.

Bordages, Asa. "Pop Hart May Go Back to Rachma, Only Girl Who Cared for His Pipe." *New York Evening Telegram*, 13 May 1930.

" 'Pop' Hart Back with New Spoils (African trip)." *New York Sun*, 17 May 1930.

Weer, William. "Shaky Painter Feeds Cannibal on His Art." *Brooklyn Daily Eagle* 18 May 1930.

Burrows, Carlyle. "Review of Downtown Gallery Show." *New York Herald Tribune*, 18 May 1930.

"Downtown Gallery Show of African Paintings by Pop Hart." *New York Times* (Brooklyn), 18 May 1930.

Cary, Elisabeth Luther. "Review of Exhibit at Downtown Gallery." *New York Times*, 18 May 1930.

"Review of Downtown Gallery Show." *Chicago Evening Post–Magazine of the Art World*, 20 May 1930.

"Breath of Africa in Vagabond's Art. Review of Downtown Gallery Exhibition." *New York Times* (Brooklyn), 22 May 1930.

"Pop Hart, Who Painted Pigs in Samoa, is Back Again with a Yen for Spinach." *The World*, 1 June 1930.

Kelley, Grace V. "The Long Road and the Hard Road–The Restless Hart." *Cleveland Plain Dealer*, 19 October 1930.

Strawn, Arthur. "The Vagabond of Art." *New York Herald Tribune*, 18 January 1931, 14–15, 27.

"Zorach Drawings." *New York Times*, 15 February 1931.

" 'Pop' Hart, Famous Artist, Seeks Rest from Barking Dog." *New Jersey Sentinel* (Fort Lee), 23 June 1932.

" 'Pop' Hart's Brush is Busy After Long Hospital Siege." *New York World Telegram*, 30 June 1932.

Britt, George. "Home of 'Pop' Hart is Sold for Taxes Paid in Advance." *New York World Telegram*, 15 August 1932.

"Back from Hospital, Finds Property Sold." *Hudson Dispatch*, 16 August 1932.

Britt, George. " 'Pop' Hart Paid Taxes, Couldn't Hold Property." *New York World Telegram*, 16 August 1932.

" 'Pop' Hart Pays His Taxes, but Loses Property." *New York Herald Tribune*, 17 August 1932.

"Dispute Over Taxes Worries 'Pop' Hart: Artist Complains It Keeps Him From Work." *New York Times*, 28 August 1932.

"Mrs. Moore to be at Museum Today: New Jersey Artist to be Honored at Observance." *Trenton State Gazette*, 7 October 1932.

"Hart's Art Work at State Museum." *Sunday Times-Advertiser* (Trenton), 9 October 1932.

" 'Pop' Hart, Wandering Artist" (Trenton Exhibit). *Hudson Dispatch*, 14 October 1932.

"Pop Hart, Artist, Will Regain Land Sold by Fort Lee for 'Unpaid Tax'." *Hudson Dispatch*, 14 October 1932.

McBride, Henry. "Wayman Adam's Complimentary Portrait of 'Pop' Hart Feature of Academy." *New York Sun*, 3 December 1932.

"Portrait of Pop Hart by Wayman Adams." *New York Times*, 11 December 1932.

"Pop Hart, Nearing 65, Quite Unimpressed Finds Radio 'Lousy,' Beer Just Hogwash." *Bergen Evening Record*, 8 May 1933.

"65th Birthday Has 'Pop' Hart Right Worried." *New York Herald Tribune*, 8 May 1933.

" 'Pop' Has a Big Day." *New York Sun*, 10 May 1933, 1.

"Coytesville Artist Subject of Portrait." *New Jersey Sentinel* (Fort Lee), 23 June 1933.

"George O. Hart, Artist, is Dead." *New York Sun*, 9 September 1933.

"George O. Hart, 65 Artist and World Traveler, Dead." *New York American*, 10 September 1933.

"George O. Hart Dies; American Painter, Etcher." *New York Herald Tribune*, 10 September 1933.

Jewell, Edward Alden. "The Realm of Art: On the Passing of Pop Hart." *New York Times*, 10 September 1933.

" 'Pop' Hart, Artist, Philosopher, Dies." *New York Times*, 10 September 1933.

"Artist Born in Cairo Dies in New York." *Illinois Evening Citizen* (Cairo), 11 September 1933.

"Services Held for 'Pop' Hart." *New York American*, 11 September 1933.

"Art World Mourns George O. (Pop) Hart." *New York Evening Post*, 16 September 1933.

"Niece Hart's Heir." *New York Sun*, 23 September 1933.

Read, Helen Appleton. " 'Pop' Hart Memorials." *Brooklyn Daily Eagle*, 3 October 1933.

Article. *New York Sun,* 12 November 1933.

Cary, Elisabeth Luther. "Three Who Have Gone: George Luks, Pop Hart and Gari Melchers." *New York Times,* 14 November 1933.

Jewell, Edward Alden. "Work of Pop Hart in Memorial Show–Downtown Gallery Show." *New York Times,* 16 November 1933.

Jewell, Edward Alden. "Work of Pop Hart in Memorial Show." *New York Post,* 18 November 1933.

Breuning, Margaret. "Pop Hart Exhibition." *New York Evening Post,* 18 November 1933.

McBride, Henry. "Comment on Memorial Exhibits." *New York Sun,* 18 November 1933.

Burrows, Carlyle. "The Drawings of 'Pop' Hart." *New York Herald Tribune,* 19 November 1933.

Jewell, Edward Alden. "Short Comment." *New York Times,* 19 November 1933.

"Review of Downtown Gallery Show." *Massachusetts Republican* (Springfield), 19 November 1933.

"Comment on Brooklyn Exhibit." *New York Sun,* 25 November 1933.

Cary, Elisabeth Luther. "Review of Downtown Gallery Show." *New York Times,* 26 November 1933.

Jewell, Edward Alden. "Short Comment." *New York Times,* 10 December 1933.

Cary, Elisabeth Luther. "Recent Lithography: Some Artists of Quality." *New York Times,* 23 December 1934.

"Dartmouth Gets $35,000 Gift of Rockefeller Art." *New York Herald Tribune,* 12 March 1935.

Jewell, Edward Alden. "In the Realm of Art: Summer Exhibition." *New York Herald Tribune,* 9 June 1935.

Burrows, Carlyle. "Native and Foreign Art–A Museum Show." *New York Times,* 9 June 1935.

"Newark Art Show Memorial to Hart." *New York Times,* 8 September 1935.

"Memorial Exhibits of Paintings of 'Pop' Hart in Newark Soon." *New Jersey Times* (Palisades Park), 13 September 1935.

" 'Pop' Hart Art on Display." *Newark Ledger,* 25 September 1935.

" 'Pop' Hart Exhibited at Newark Museum." *Massachusetts Republican* (Springfield), 29 September 1935.

"Pop Hart's Hand Press in Action at Newark Museum." *New Jersey Citizen* (Roseville), 10 October 1935.

Jewell, Edward Alden. "Memorial Exhibit Honors 'Pop' Hart." *New York Times,* 10 October 1935.

"Pop Hart's Work on Exhibit at Museum, Shows Caliber of Man." *Newark Evening News,* 11 October 1935.

"Exhibit of Pop Hart's Work Opened." *Newark Ledger,* 11 October 1935.

Vaughn, Malcolm. "Pop Hart's Memorial." *New York American,* 12 October 1935.

Klein, Jerome. "Pop Hart's Art Shown in Newark." *New York Evening Post,* 12 October 1935.

Upton, Melville. "Pop Hart's Art in Retrospect–Newark Exhibit." *New York Sun,* 12 October 1935.

Genauer, Emily. "Open Memorial Exhibit of Pop Hart's Work." *New York World Telegram,* 12 October 1935.

Burrows, Carlyle. "A Hart Memorial Show at Newark." *New York Herald Tribune,* 13 October 1935.

Jewell, Edward Alden. "Pop Hart, the Artist and the Man." *New York Times,* 13 October 1935.

Cary, Elisabeth Luther. "An American Individualist: The Art of Pop Hart." *New York Times,* 20 October 1935.

Fried, Hanna. "Works of Pop Hart Shown at Museum." *Newark Ledger,* 20 October 1935.

"In Memory of Pop Hart–Newark Exhibit." *Texas News* (Dallas), 20 October 1935.

Sherburne, E.C. "He Bought One Way Tickets." *Christian Science Monitor,* 22 October 1935.

"A South Seas Watercolor." *New York Sun,* 12 December 1935.

Jewell, Edward Alden. "Pop Hart's Works on Exhibition Here." *New York Times,* 2 December 1937.

"The 'Beloved Vagabond'." *New York Times,* 5 December 1937.

"Bracketing Rowlandson and Pop Hart–Recent Work by Lawson and Others." *New York Herald Tribune,* 5 December 1937.

Jewell, Edward Alden. "Gallery Exhibits Art by Americans." *New York Times,* 30 June 1939.

"Museum Ass'n Plans Contest, Exhibition and Pilgrimage." *Jersey Journal,* 1 February 1940.

"To Exhibit Prints of Artist Who was Once a Sign Painter." *Jersey Journal,* 30 March 1940.

" 'Pop' Hart Water Colors Exhibited." *Jersey Journal,* 4 April 1940.

"Pictures of 'Pop' Hart Exhibited." *Jersey Journal,* 9 April 1940.

"Jeanne Overbury Hart to Lecture Before Local Print Club." *Rochester Democrat Chronicle,* 16 February 1941.

Kelley, Grace V. "Vivid Impressions of World as George (Pop) Hart Saw It

Revealed in New Exhibition." *Cleveland Plain Dealer,* 16 March 1941, B16.

Genauer, Emily. "Water Colors by Living Americans." *New York World Telegram,* 18 October 1941.

Berryman, Florence. "Paintings on View: Hart Retrospective." *Sunday Star* (Washington, D.C.), 21 October 1956.

Portner, Leslie Judd. "Art in Washington." *Washington Post-Times Herald,* 28 October 1956.

Kitner, Harold. "Muted Palette Has Beauty." *Akron Beacon Journal,* 17 November 1957.

Singer, Clyde. "Subtle Coloring Marks Hart's Work at Butler." *Youngstown Indicator,* 19 January 1958, B6.

"George Hart Works Due at Art Institute." *Ohio Repository* (Canton), 26 January 1958.

Canaday, John. "Davies, Others, and Jazz." *New York Times,* 7 February 1960.

"Americans Abroad." *New York Times,* 6 March 1960.

Burrows, Carlyle. "Spurs for Prints." *New York Herald Tribune,* 23 April 1961.

"This Week Around the Galleries: George ('Pop') Hart." *New York Times,* 24 November 1963.

"George O. 'Pop' Hart." *Art Voices from Around the World,* December 1963, 25.

"Colorful Vagabond." *Arizonian,* 6 February 1964, 6.

Hale, J. Douglas, "Pop Hart's Works Don't Depend on Dates." *Arizona Republic,* 9 February 1964.

Miller, Marian. "Three Shows in Scottsdale." *Phoenix Gazette,* 14 February 1964.

"Watercolors by Pop Hart Exhibit to Open at Museum." *Montclair Times,* 14 January 1965.

Lenson, Michael. "The Realism of Art." *Newark Sunday News,* 31 January 1965.

Reed, J. Bradley. " 'Pop' Hart's Paintings Go on Exhibit February 24." *Citizen Journal* (Columbus), 12 February 1965, 6.

Piper, Frances. "Watercolors by 'Pop' Hart Shown at Columbus Gallery." *Columbus Dispatch,* 21 February 1965, 3.

"Museum to Show Hart Watercolors." *Sun Dial* (El Paso), 2 January 1966, 30.

Sheridan, Lee. "Small Gem of Watercolor Says Much of 'Civilization'." *Springfield Daily News,* 10 July 1970.

NEWSPAPER ARTICLES WITHOUT DATES

Weinberg, Daisy. "Hart Work Exhibited. Memorial Show of Etchings." *New Orleans Tribune.*

Bulliett, C.J. "Returning to Normal with Pop Hart." *Chicago Evening Post–Magazine of the Art World.*

Bulliett, C.J. "Art Without Cake is Pop Hart's Practice." *Chicago Evening Post–Magazine of the Art World.*

Index